PATTERNS OF EXCHANGE

Patterns of Exchange

Navajo Weavers and Traders

Teresa J. Wilkins

University of Oklahoma Press : Norman

Library of Congress Cataloging-in-Publication Data

Wilkins, Teresa.
 Patterns of exchange : Navajo weavers and traders / Teresa J. Wilkins.
 p. cm.
 Includes bibliographical references and index.
 ISBN 978-0-8061-3757-5 (hardcover : alk. paper)
 1. Navajo weavers—History. 2. Navajo Indians—Commerce. 3. Navajo
textile fabrics—History. 4. Trading posts—Southwest, New, History.
I. Title.
 E99.N3W55 2008
 746.7'2041—dc22

 2007039349

The paper in this book meets the guidelines for permanence and dura-
bility of the Committee on Production Guidelines for Book Longevity
of the Council on Library Resources. ∞

1 2 3 4 5 6 7 8 9 10

*To the loving memories of Maybell Mitchell Wilkins
and Margaret McCallum Wilkins, who always believed*

To the memory of Dr. Joe Ben Wheat, who gave generously

CONTENTS

ILLUSTRATIONS

COLOR PLATES

FIGURES

MAP

ACKNOWLEDGMENTS

Many people, questions, and experiences go into a book. In this case, those elements include childhood memories of relatives, places, and interests I pursued long before I ventured into anthropology. The list is long, and I apologize for any inadvertent omissions.

I have been intrigued by people and their creative endeavors since I was four, when I came across *A New Wonder World*, a set of 1920s encyclopedias that belonged to my father. I still have the set, including my favorite volumes, *Story and Art* and *The World and Its Peoples*. Many years later, I still wonder what role these books played in my fascination with the nineteenth- and early-twentieth-century trading period and the various people who carved out a unique existence in the American Southwest. Of course, I now view these books with the trained eye of an anthropologist and am amazed at the ways the theories we now so easily critique were presented so cogently and authoritatively to young and curious minds. I want to thank my parents and my grandparents for always encouraging my pursuit of wonder. We have all traveled a long and rich path.

Along the way, I have met many wonderful Navajo women weavers and have heard stories of others who lived incredible lives. I hope this book does justice to such strong Navajo weavers as 'Asdzą́ą́ Tsé dits'áhí, 'Asdzą́ą́ Beekaagashi, Ta'asbah Slivers, Rose Morgan, Rose Slivers, and others who persevered in leading their families through the new terrain of making a living in colonial circumstances. And I hope their descendants, who have been so generous with their stories, see in what I've

written something of their lives, along with the pride and respect I feel for them, their families, and their life choices. Some are named in this text, but others preferred an anonymity I have tried to respect. Still others offered lessons only indirectly and which I only later understood. Some weavers told me what would help them most. I hope they see their convictions accurately represented in these pages.

None of my work on the American Southwest and textiles would have been possible without the help of the late Dr. Joe Ben Wheat. For the ten years preceding his death in 1997, Joe Ben shared his vast knowledge of the Southwest, textiles, and textile history. When I was in the field, I challenged myself to find small gifts that would, perhaps, be new examples of material culture for him to enjoy. On my return trips to Boulder, he could always tell me where the objects were made, the source of the materials and, often, the identities of the makers. His unassuming personality and tremendous breadth of knowledge and understanding made him a perfect advisor for me and other working-class women trying to make their way into an anthropological career. I am also grateful to count his wife, Barbara Kyle Wheat, among my dearest of friends and supporters.

Charles Piot's guidance through economic and globalization theory and his meticulous skill and attention to the art and pleasure of writing were equally important to my work. His focus, encouragement, tremendous intellectual energy, and generosity of spirit often kept me going during difficult times. Like Joe Ben, Charlie is one of those all too rare individuals who has read widely and synthesized lines of thought from many different and seemingly disparate sources.

Linda Cordell's role as mentor began when she became director of the University of Colorado Museum of Natural History in 1993. I very much admire her proficiency at explicating the most complex academic theories and insights while also writing and speaking to a general audience. She continues to be a most important model and friend.

Paul Shankman and Erika Doss read earlier drafts of this manuscript and offered many valuable insights and observations. Steve Lekson also offered many valuable comments, and Debbie Confer at the university museum continues to be a source of support and valuable assistance.

Many people at the University of New Mexico's Gallup campus have contributed directly and indirectly to this work. My colleague and close

friend Alyse Neundorf taught me more about the Navajo language and life than I could have hoped to learn. Liz Gilbert and Pamela Stovall have been extraordinary colleagues and sources of encouragement and support. I owe a special thank you to Linda Thornton for her interest and support. Jack Crowl commented on an earlier version of this manuscript and could always be counted on for interesting conversation. Caleb Bush generously helped me with a last-minute question. Sawa Becker was a great graduate student colleague and continues to be a treasured colleague and friend.

Many students at the University of New Mexico have contributed to my work. Some challenge my perspective on anthropology in ways that our academic discourses have not imagined. Others broaden and confirm my understanding of the research material. Still others inspire me through their hard work as mothers, fathers, workers, and full-time students. The relationships between our students and faculty continue to shape me as writer, anthropologist, and person. I owe special thanks to Cy Benally for reading and commenting on this manuscript and to Christine Curtis for her interest and enthusiasm in continuing research.

Ann Lane Hedlund has supported my work over many years, offering insight into the practicalities of field study and valuable comments on works in progress. I also thank Les Wilson, a trader at Two Grey Hills, for reading and commenting on an earlier version of this manuscript.

Field study was conducted under Navajo Nation Cultural Resources Investigation Permit Numbers C9505-E and C9602-E. I am very grateful to Lillie Lane and Timothy Begay of the Navajo Nation Historic Preservation's Traditional Culture Program for their long and continuing advice and friendship. Ron Maldonado contributed valuable comments on the manuscript. At Hubbell Trading Post, Kathy Tabaha and Shirley Harding helped me access archival material, and Kathy was an extraordinary fieldwork friend and assistant. Martha Blue and Geno Bahe generously shared their knowledge of trade and of J. L. Hubbell in particular. Laura Marcus shared knowledge and the camaraderie of field work, dissertation writing, and Gallup experiences. I thank Octavia Fellin for sharing the *Pioneer* article on J. B. Moore's work. There are many others who have stimulated my personal and professional growth. I hope they all find some value in this work.

My study was supported through several sources. I received funding from the University of Colorado Museum's Joe Ben Wheat Research Fund and the Walker Van Riper fund. I also received a University of Colorado Graduate Student Creative Research Award. The University of Colorado Museum employed me through my graduate years, and since 1997 I have taught anthropology at the University of New Mexico's Gallup Campus.

I thank the reviewers from the University of Oklahoma Press, David Brugge and Lisa Aldred, for their thorough reviews and extremely insightful comments. I also thank Jeff Burnham, Jo Ann Reece, Alessandra Jacobi Tamulevich, Julie Shilling, and copyeditor Jay Allman for seeing this manuscript to production.

To all, I owe a tremendous *'Ahe'hee shik'is*!

PATTERNS OF EXCHANGE

CHAPTER ONE

INTRODUCTION

I tell you my life story and you tell me yours. This is how we
become relatives.

Irene Clark, 1992

I began meeting Navajo weavers in the late 1980s and early 1990s while
working at the University of Colorado Museum of Natural History. I
was studying anthropology and working with the museum's collection
of nineteenth and early twentieth century southwestern textiles. Each
time I encountered a weaver I learned some lesson that ultimately
shaped the direction of my study of the weaving process, cultural and
economic value, and aesthetic negotiations. I had already learned to
weave as an art student in college, and I took lessons in Navajo tech-
niques from weavers in the Boulder, Colorado, region, who told me
stories of selling their rugs in the area. I would then find those rugs in
shops, see the difference between the weavers' price and the retail
price, and hear dealers' stories of their interactions with the weavers. In
1992 I also hosted weavers as visiting artists at the Denver Art Museum.
Discussions with the artists about the museum's activities and their time
in Denver highlighted the connections and disconnections that exist
between weavers and their markets. I saw some of the ways that weavers
shape the nature of their market relationships. I began to realize that
the textile world that encompasses weavers, traders and dealers, collec-
tors and consumers, and scholars and aficionados is a complex one.

My own interest in Navajo weavers corresponds to some current trends in anthropology. Many cultural anthropologists now take the position that we can best explain our interpretations to readers by discussing how our personal histories influence our understanding of field experience. Textile production is, in fact, a recurring theme in my own life. I was raised in a large, extended rural southern family of Scottish and Irish descent, and weaving is a part of the Scottish, Irish, and colonial southern heritage. From my earliest days, my grandmother encouraged my interest in textiles, art, and music. She taught me to crochet when I was five years old. In my memory she was always doing something—cooking, braiding rugs, or fashioning textiles with leftover clips from my grand-father's mill. That hosiery mill, which he established and managed despite having no formal education, employed many of the people in a small North Carolina community until the 1960s. My grandfather's life made me aware of many nuances in the local expressions of early twentieth century capitalism. Stories from his work helped shape my under-standing of the relationships between Navajo weavers and reservation traders. When one of his employees died suddenly, leaving behind a young wife and three small children, my grandfather kept him on the payroll for years so that his family could continue receiving the weekly income. (Such an arrangement would not be possible under today's business laws.) As my grandparents helped many extended family members and friends in ways now considered unconventional in Euro-American society, I heard stories of the possibility that a trader, J. L. Hubbell in this case, often did the same.

Very few weavers are able to make a living at weaving. Beginning in the Victorian era, society increasingly began to prefer the ease, standardi-zation, and greater leisure afforded by the use of manufactured conven-iences. But early twentieth century preservationists encouraged guilds like the Goodwin Weavers and Seagrove Potters (both of North Carolina) that promoted and continued craft traditions. In Navajo land, the traders and demonstrators largely accomplished similar feats. Navajo textiles then took their significant place in a growing and evolving Indian craft and art market.

From the time I first experienced the artistry of Navajo textiles, I was intrigued by the lives of people who made weaving central to their lives and their lands. Navajo weaving is not an evolutionary holdover

from a more so-called primitive era. I found myself curious about the worldwide market for these textiles, the weavers' relationships to that market, and the consumer desires that drove it all. Wondering what the market had been like in its formative years, I read literature about the rug trade, much of which described exploitation of the weavers by traders and dealers in a context of colonial domination.

But my early encounters with Navajos taught me that the relationships described in the literature were much more complex and that they continue to be important. I wondered about the fundamental understandings of meaning and value that Navajo weavers brought with their rugs to the apparently capitalist trading post counter.

Under the direction of Professor Joe Ben Wheat at the University of Colorado, I studied the materials, designs, collection histories, and other documentation associated with Navajo, Pueblo, and Spanish textiles produced during the nineteenth and twentieth centuries. I learned how these characteristics and changes to the textiles reflect historical conditions. Early Pueblo and Navajo weavers wove garments of handspun cotton decorated with clan motifs. With Spanish colonization, *churro* wool fleece, indigo dyes, red trade cloth, and serrate central diamond motifs appeared in the Southwest. The Anglo-American period saw the introduction of commercial cotton and wool yarns, synthetic dyes, and an efflorescence of design forms in Navajo items, while Pueblo weavers mostly adhered to the forms used in their religious ceremonies. Textiles also reflect such southwestern cultural changes as the availability of Euro-American-style clothing, a move away from pastoralist livelihoods, and, contrary to the religious traditions, depiction of sacred Navajo deities in permanent forms for sale to tourists and collectors. I was extremely interested in weavers' intercultural relationships throughout this history and thought about the ways contemporary theory, which models cultural relationships as conversations or dialogue, might illuminate the context of these relationships in ways scholars have not previously understood. With Wheat's encouragement, I prepared to study trading relationships in the late nineteenth and early twentieth centuries by looking at archival information and the textiles themselves. All the while, I knew that I also wanted to work with living weavers.

In 1993, I spent three weeks at Hubbell Trading Post National Historic Site in Ganado, Arizona, where I read oral history interviews of local

Navajos conducted by anthropologist and ethnohistorian David Brugge in the early 1970s. I also talked with as many local Navajos as possible. These conversations directed me to compare and contrast chronological time with relational time and written histories with oral histories. Navajo concepts of self, family, land, and livelihood do not lend themselves well to chronological analyses, instead current understandings and memories are more likely expressed in terms of family and life events rather than calendar dates. Hence, the term "relational" time. Though I obviously was educated in a tradition of chronological understanding of events and places, I was also familiar with time and space being expressed through relationships with people due to my rural southern background. The conversation that makes up relationships between weavers and traders encompasses all of these.

Thus, the style of this book reflects my efforts to integrate an ethnographic field study with living weavers, oral history interviews, archival documents, and a study of blanket paintings and textiles. Though sections tack back and forth between the chronological past and the present, they also interweave more traditional ethnographic prose with something closer to oral or experiential narrative traditions. I hope that this synthesis will illuminate and reflect the complexity of the relationships discussed herein.[1]

In October 1994, I began my ethnographic field study and archival research at Hubbell Trading Post in Ganado, where ideas, practices, and goods have been exchanged for over one hundred years. In its early days the post was a busy site of intercultural relationships. J. L. Hubbell, his extended Spanish family, American Indians, and non-Indian travelers traded, conducted community business, and socialized there. Many relationships were created through exchanging material objects and ideas. All parties constructed meanings and values and imagined their markets as they communicated in several languages, such as Navajo, Spanish, English, and sometimes Hopi and Zuni. These conversations, exchanges of ideas, and the construction of market identities continued for well over one hundred years.

Today, the post exists today as something like a living museum owned by the National Park Service (NPS), which is federally mandated to continue some of the early "traditional" trading activities and roles while functioning as a retail business catering to a multinational tourist market.

Although English is the primary public language, employees and local visitors often converse in Navajo, and I frequently heard tourists speaking French, German, or Japanese. As a quasi-museum, the post employs two full-time weavers to demonstrate the art, and it showcases some traditions that are no longer consistent with the needs, values, and, in some cases, memories of local residents.

The resulting clash between the unavoidable reliance upon modern tourism and the desire to honor local community memories and experiences triggered a community-wide cycle of storytelling. Some Navajos, knowing I wanted to study the community relationships, sought an outlet for this cultural tension by telling stories about trade, cooperation, conflict, and social relationships that illuminated the complex and contested nature of these long-time relationships. Thus, the daily background of my research process was itself a complex intercultural and institutional negotiation.

I came to the Hubbell Trading Post to study the nature of the relationships between Navajo weavers and reservation traders. These relationships have had a profound material and ideological impact on the lives of Navajo people, and they have shaped an economy unique to the southwestern United States. From today's perspective, late nineteenth and early twentieth century trader–Navajo relations were highly exploitative, and many Native people in the Southwest have a strong sense of the colonialist and exploitative history of both government and anthropological activities. The theory that American Indians were so-called "dying" cultures has been used to rationalize takings of land, objects, languages, and traditions through law, boarding schools, and anthropological collecting methods. Traders were no different. Some earned large amounts of money while their Navajo customers struggled to survive. I wondered how these relationships were understood by Navajos and traders alike. I also wondered how they had changed, and why they remain important even one hundred twenty years later, when so many other options are available to Navajo people.

I also quickly realized that some weavers had their own agendas concerning my project. I was sometimes told, "I'm a weaver, that's what I do. You write books. This is what you need to put in your book! This will help us." I did have chances to help those I consulted. Indeed, I was not always immediately aware of ways I was being drawn in. I

was asked to intercede with government bureaucrats and other Euro-Americans. Some stories were given to me expressly because people knew I intended to publish what I was told. I was, for example, intentionally told many stories about the sexual liaisons Hubbell and his son, Roman, had with Navajo women. I now realize the stories were shared in part to counter a park service representation that idealized Hubbell's accomplishments through a Euro-American lens while suppressing the nature of his daily human interactions with local people. While it is possible to understand some of the weaver–trader obligations in Hubbell's exchange relationships, I continue to learn about my own place as a helping "friend" to many weavers.

My fieldwork moved into another dimension when I began to teach at the University of New Mexico in Gallup, where approximately 75 percent of my students were Navajo. While I teach ways anthropologists have represented American Indian cultural backgrounds and histories, my central task is to teach the tools anthropology offers for understanding humanity. I want my students to master the tools they find useful in articulating their own cultural positions and understanding others. However, the boundaries of field and classroom are not easily drawn. Many students are relatives or acquaintances of people I consulted in my research. Traditionally, anthropologists relate to consultants in the field as people while treating them as subjects of discussion in the classroom. My two contexts are not mutually exclusive. When I discuss examples from my research, I am acutely aware of possible repercussions in their home communities. This accountability strengthens my own sense of anthropological ethics and the possible implications of research on the actions and lives of individuals. I attempt to practice an anthropology that is centered on people's lives rather than on structures and institutions.

Trading Posts at the Crossroads

Trading posts are often described in the literature as either sites of acculturation to the dominant society or sites of exploitation.[2] M'Closkey, for instance, has recently applied a neo-Marxist perspective to analyze the papers from Hubbell's trading operations and emphasized the exploitation of Navajo people by Hubbell for his own monetary gain.[3] It is, of

course, imperative to recognize the roles of trading posts and traders in mediating Navajo relations with a rapidly changing Anglo-American society and the ways trading activities constructed and reinforced power relationships between traders and the Navajo people. But M'Closkey's perspective is nevertheless limited in that it assumes a total lack of agency on the part of Navajo people. Instead, such an analysis privileges Euro-American capitalist ideas about value—and its exploitation—and fails to explore Navajo ideas. Thus, it does not take into account Navajo registers of value, and does not recognize the significance of the forms these complex Navajo and Euro-American relationships assumed. It offers only partial and sometimes misleading accounts.

Similarly, an emerging literature in globalization and transcultural relationships builds on acculturation studies and world systems theory, resulting in an extensive body of literature on cultural contact and change.[4] "Acculturation" as defined by anthropologists Redfield, Linton, and Herskovits, is change that occurs when "groups of individuals having different cultures [come] into first-hand contact, with subsequent changes in the original culture of either or both groups."[5]

Navajo society has often been characterized in the anthropological literature as functioning by "incorporation"—any new elements the society encountered were absorbed into a Navajo core structural framework, which then elaborated them from within.[6] The concepts of accultura-tion and incorporation examine how both dominant and subordinate groups may be changed by contact situations. Though acculturation did not originally imply a one-way transfer of ideas or materials, analyses employing the concept focused largely on the incorporation of subordi-nant groups into dominant social structures or institutions and on the ways in which subordinant/colonized cultures were changed through culture contact. Studies rarely examined ways that dominant groups or institutions changed, nor did they explore the role of individual agency or negotiation.

In light of the history of Navajo textile exchange, it is unlikely that we could think in terms of the Navajo people generally, and weavers in particular, as ever having been contained within a bounded culturally and ethnically distinct group that was uninfluenced by contact with "others." Indeed, according to scholars, Navajos learned the technical skills of weaving through their relationships with the Pueblos.[7]

Many Navajos, however, believe that Spider Woman taught the Twins to weave and Navajo women completed and still continue their work. Furthermore, Wheat's research on changing Navajo textile materials and designs demonstrates that Navajo weavers originally utilized an aesthetic that developed from or alongside their sacred basketry traditions depicting earth, sky, and rain. Later, they incorporated Puebloan, Spanish, Anglo-American, and Middle Eastern ideas. The influence runs the other way, too. During the twentieth century, many markets have developed to meet a consumer demand for Navajo textile designs. Zapotec and other textiles produced in Mexico, as well as many produced in the Middle East and Asia, show Navajo design influences. Often they are direct copies of existing Navajo styles that, in some cases, originated in the Middle East.

Markets, of course, are developed through and sustained by social relationships. In today's global society, people maintain many kinds of relationships across cultural boundaries. These may include familial, economic, religious, political, or organizational associations that blend the many cultural contexts and meanings in which they operate. These relationships influence many individual decisions and interactions. Emerging literature on transcultural relationships and resulting hybrid interactions offers theories on understanding ways that local societies maintain their vitality and develop creative responses as their members participate in global systems. The literature explains and celebrates new forms of social relationships that help redefine our understandings of categories such as ethnicity, race, class, gender, nation, and society.[8] As we shall see, some reservation traders and many of their Navajo customers established and maintained transcultural relationships over one hundred years ago. These relationships bore some similarity to today's relationships and relocations associated with multi-national and transnational capitalism formed by globalization processes and pressures. However, they are politically unique in the sense that the Navajo Nation exists in a sovereign, albeit domestic dependent, relationship to the United States. For example, enrolled members of the Navajo Nation have rights as citizens of both the Navajo Nation and the United States. And the Navajo Nation and other federally recognized tribes have sovereign legal codes and governments that answer directly to the federal

government and not state governments. Thus the Navajo Nation has some jurisdiction over trade and trading post operations on reservation lands.

Rather than portray the trading post as merely a site of acculturation, then, I find it more productive to think of it as a junction or a crossroads at which both trader and Navajo identities are shaped. Such a stance is consistent with Navajo self-conceptions. Anthropologist John Farella has argued that the acculturation concept resulted from a Euro-American emphasis on the material world at the expense of valuing the relationship between ideas and culture. He further argued that Navajo culture itself embraces the idea of adaptation and change. Therefore it is consistent with a Navajo worldview for people to readily adapt to and incorporate changing material conditions. Thus, what might appear to be acculturation to Euro-American society is, in fact, very much in keeping with a Navajo worldview.[9]

Much of the previous literature on Navajo weavers and traders and dealers has focused on a single group—weavers,[10] traders,[11] or consumers.[12] While valuable, these studies nevertheless have little to say about the interactions between these groups. It is precisely these interactions—or "conversations"[13] —that have shaped and defined the specific groups and, therefore, the culture of the Navajo trading post.

Studies that situate the actual textiles in the historical context of their development or collection support this idea.[14] It is precisely this detailed literature on the historical development of the art, primarily Wheat's focus on explaining the changing materials and designs, that has exposed the influences of traders and other non-Navajos on Navajo weavers' work and on weavers' interpretations of new inspirational forms.

CHAPTER TWO

Exchanging Spaces

A Brief History of Southwestern Trading

The first trading posts were established after the 1860s Long Walk and internment of Navajos at Bosque Redondo, and successful posts quickly became the centers of new and growing communities. Trade among southwestern Natives has a complex history. It ranged between neighboring camps and over great distances. It could be conducted with a few shared words or through Native and non-Native languages. The kinds of goods and services exchanged varied from ancient times to the twentieth century, but the act of trade persisted, and it continues today.

Stories about trading posts and trading encounters provide opportunities to make important statements about traditional values and relationships associated with making a living. In the Navajo world, family histories and trading post histories are often entwined, and for Euro-Americans, trading posts exist in an imagination of a wild, uncontrollable "primitive" history. Once, Euro-Americans primitivized Navajo people and looked upon traders as eccentric western heroes. Today's traders and trading posts are still part of the perception of a vanishing primitive past, and trading post identities are now marketable. In fact, trading posts, traders, and their customers were and are caught up in ever-changing processes of industrial society resulting in social, economic, and material changes. When examining the historical development of trading posts and Navajo economies, the Ganado community and the Hubbell Trading Post offer a rare perspective over time. The National Park Service maintains an archive of documents relating to the post's operations that includes oral history interviews with Navajo elders during the 1970s.

Ethnographic field study reinforces the stories told by Navajos and traders, validating experiences and perspectives not found in archives or published literature.

THE HISTORICAL DEVELOPMENT OF SOUTHWESTERN TRADE

Intercultural trade has a long history in the American Southwest.[1] A lively trade relationship existed between 'Anaasází people prior to the sixteenth century Spanish colonization of the area. Here I use the term 'Anaasází as explained by linguist Alyse Goodluck Neundorf to refer to the ancient ones all around us. The items they exchanged included hides, beads, turquoise, pottery, basketry, and, of course, food.

Textiles were among the most important trade items for Navajos for hundreds of years. Ancient trade flourished long before Spanish colonization and continued after Spanish domination into the period during which the Navajos were interned at Bosque Redondo or *Hweeldí*—a time known in Navajo land as the "Long Walk"—and was modernized with the establishment of "permanent" trading posts on and around the Navajo reservation that largely replaced the itinerant traveling traders.

Early 'Anaasází people exchanged obsidian and saltwater shells brought into the Rio Grande area from the west. Cotton textiles were traded from southern Arizona until cotton was cultivated further north. Pottery was exchanged in complex networks throughout the entire region. By A.D. 1000, turquoise, copper, and macaw feathers also circulated throughout the region. Patterns of exchange appeared to vary from informal contacts to longer-term trade partners. They sometimes traveled from the Rio Grande area to the Colorado River and down into Mexico, and trade routes connected western Mexico, southern California, eastern New Mexico around the Pecos Pueblo, and the Great Plains. Spanish accounts mention Plains Indians exchanging buffalo hides and dried meat at Rio Grande pueblo villages for corn, cloth, and turquoise. Historic photographs show Plains Indians wearing Navajo chief pattern blankets. Hopi cotton robes and Plains buffalo hides were traded into what is now southern Arizona.

Exchanges also included native plants and knowledge about their healing properties, eagle and other bird feathers, minerals, pigments,

and stone for ceremonial and other uses. Songs, prayers, and dances were sometimes exchanged. Intermarriage was not unusual.[2]

Mechanisms for exchange varied along a dimension of social distance. Exchange within a village or family operated according to one set of protocols, but people also adapted to the expectations of outsiders and non-relatives. Within small groups, exchange consisted of mutual assistance, gambling and gaming, ceremonial redistribution, and trading parties.[3] Mutual assistance—sharing or "helping out," as it is called by many Navajos today—was daily and constant, based on an understanding that all individuals were part of the family. Any wealth that came to one individual was ideally shared among the family, an ideal that is still upheld, though not always practiced, in modern Navajo society. Gambling took the form of horse racing and card and other games; later, trading posts often sponsored "chicken pulls"—an early type of rodeo racing. Gambling and games were usually held in summer. Relatives and community members contributed food, material goods, and today they also contribute money for ceremonies. They in turn received blessings and material goods. Both Hopis and Zunis engaged in markets in which goods were displayed and exchanged publicly.[4] Today, flea markets, roadside stands and booths at feast days, and formal occasions and ceremonies are common throughout the Southwest because they are popular means for both intra- and intercultural exchange.

Intercommunity trade sometimes involved exchange with relatives, but it was more often carried out between non-relatives and Natives with different cultural practices.

> The visitor placed himself into the custody of a stranger. This was done by making an initial gift. Since each gift was actually a request to trade, to accept the gift obligated the recipient to feed and protect his guest. The two might trade or the host might inform others about his guest's desires. Upon the visitor's leaving, the host would give a present. If he wanted to obligate his visitor in the future, he might give something of greater value than the initial gift. Conversely, he could guarantee the termination of the association by giving something of lesser value. This type of visitation was common throughout the Southwest, and the process of making a formal friend is well illustrated by the Hopi.[5]

Exchanges continued over generations, and long periods of time often elapsed between payment and repayment. "Friends" did not often bargain. They knew the unspoken expected equivalency of the relationship, and so their trades were more like gifts that respected the equivalencies, which were based on the friend's ability to meet expectation. This concept of friends remains an important part of modern exchange.

Intercultural exchange, while economically and socially necessary and gratifying, also involved risk. Many people who accepted traders in their villages sought protection from the risks of being associated with strangers through prayers, ceremonies, or sacred objects. Many who traveled to trade were protected by ceremonies prior to departure, prayers and songs while traveling, and purification ceremonies upon their return.[6]

Spanish domination of the Rio Grande valley changed the nature of intertribal trade. Spanish colonists exerted control over the labor and material resources of the local Puebloans, while the more dispersed Navajos somewhat eluded domination. Spanish colonists tried to break down intertribal trading relationships. They established trade fairs at villages such as Taos and Abiquiu, and they established quantitative exchange rates that Natives had never used. The Spanish also took slaves from Pueblo villages and neighboring Navajo, Apache, and Ute settlements. Slave trade was lucrative for the Spanish. During the mid-nineteenth century, a young Native woman was sold for approximately two hundred dollars at trade fair markets. Of course, these fairs lacked the familial and ceremonial atmosphere of inter-Indian trade. They were often marked by tension and conflict, manifested in drunkenness and fighting by Natives and non-Natives both.

Navajos responded by raiding Puebloan and Spanish settlements, both to acquire necessary goods from which they had been cut off and to retrieve family members who had been stolen into slavery. Some Navajos still tell stories about family members and other Native people who were captured and enslaved, and who sometimes escaped. Some Navajo clans were formed when Native women from other tribes escaped their Spanish captors and were adopted by Navajo people. (See the story of 'Asdzą́ą́ Adee' in chapter seven.) Such raiding continued up to and during the time of the Long Walk.

Since Coronado's arrival in 1540, the Spanish had been interested in acquiring goods produced by the American Indians of the Southwest. Coronado's men acquired cotton mantas at Zuni and other Pueblos, not by trade but by a form of tribute and often by force.[7] From Spanish accounts, the numbers of textiles taken this way were staggering. The Espejo expedition of 1582–83 apparently took more than four thousand cotton mantas from the Hopis alone. Tribute continued until at least the Pueblo Revolt of 1680. Tribute collection by force was described in a 1601 account.

> Every year armed soldiers and even the governor go in person from house to house to collect a blanket from each house or each Indian. . . . The Indians, because of their poverty, part with these things with much feeling.[8]

Pueblo woven mantas were a kind of currency. By 1613, decrees for damages payable to Indians by Spanish settlers established payment in mantas and maize. Quantities of mantas as a Spanish monetary equivalent continued until at least the late 1700s. Wheat attributed this system to a lack of metal coins. It signifies the flexibility and ambiguity inherent in intercultural exchange where there are differing notions of both quantitative and qualitative standards of value.

By the 1630s Rio Grande Puebloans were forced to weave great quantities of mantas for the Spanish. Apparently, they were compensated for their work, but were given only one-sixth to one-eighth of the local values for the goods. The mantas were then shipped south to New Spain.

Native people also traded salt, game, hides, and other things for cotton mantas and other items. Not until the Juan de Oñate colony settlement in 1598 do records list items the Spanish may have bartered with the Natives. These included

> beads, combs, Bohemian knives, scissors, mirrors, shoemaker's needles, glass earrings, hawksbells, 680 medals of ally, [sic] rings, thimbles, rosaries, necklaces, amulets, Texcoco clay whistles, glass buttons, small flutes, awls, and Paris trumpets. The only textile materials specifically indicated for barter were blue and white Castillian thread, fine yarn, and nine small hats.[9]

Oñate's settlers brought with them quantities of commercially woven fabric, but they apparently did not include the red worsted wool bayeta fabric that Navajo weavers later raveled to produce their fine red yarns.[10]

By the 1620s the Franciscans were keeping sheep and weavers were beginning to use wool. By 1637 Governor Luis de Rosas had set up weaving workshops in Santa Fe that produced large quantities of Spanish woven goods. Written accounts suggest that Navajo people acquired sheep by the 1640s through retaliatory raids. By 1706, Wheat writes, Navajo weavers were producing enough finely woven wool blankets for their own use and for trade.

Wheat suggested that perhaps Navajos learned the art of weaving from those Pueblo people who took refuge with them during the 1680 revolt.[11] Navajo traditionalists tell that Spider Woman taught the Navajos to weave. They also describe weavers before the Spanish era. Wealth songs contain references to weaving with *ndik'a'*, "wild cotton," and producing kilts, mantas, and rain sashes patterned according to clan affiliation. According to many Navajo weavers, the people have always had sheep. It is often said that "since there have been Navajos there have been sheep." In fact, several Navajo consultants have criticized books on weaving because the author "said Navajos got sheep from the Spanish!" Many weavers today consider the idea that the Spanish introduced sheep as an affront. Some traditionalists tell that sheep, horses, and donkeys were created for Navajos from jewels—white shell, turquoise, abalone, and jet—at a sacred mountain in the east called *Sis Nateel*. Indeed, scholars have noted the remarkable speed with which Navajos adapted to a pastoral lifestyle and how quickly sheep became the center of Navajo life.[12] The apparent contradiction between oral traditions and the literature and material record can be difficult to write about. I have often wondered whether there was a way to reconcile the two perspectives. Archaeological and ethnohistorical accounts privilege the material and written record over oral traditions, or they analyze Navajo oral traditions through sets of Euro-American constructs and values. The ethnocentrism inherent in Euro-American interpretations and too rigid adherence to materially-based typologies are called into question by the existence of Navajo-made objects and Navajo-built architecture in so-called "Pueblo" styles. When Navajo oral traditions speak of places, people, deities, and "things," a case is made for a much earlier "Navajo"

history in the Southwest than written accounts acknowledge. This is not to say that every contradiction can or should be reconciled and, in fact, both can exist as different explanatory perspectives.

Navajos began trading with non-Spanish Euro-Americans in the early 1800s.[13] During the mid-nineteenth century, Navajos established trading relationships with Mormon settlers north and west of the Colorado River. In 1846 the United States took control of what was then the Mexican Territory, and the government began purchasing and reissuing large quantities of Mexican blankets as clothing subsidies to tribes whose economies had been devastated by wars and relocations. During this early period of United States control up until the 1863 internment at Bosque Redondo, blankets were not issued to Navajos, who were superior weavers in their own right. Between 1856 and 1874 over thirty-five thousand Mexican blankets were purchased and distributed to many groups in the greater Southwest.[14]

Inter-Indian trade relationships, though fraught with conflict, continued until the 1863 internment of Navajo people at Hweeldí. From existing literature we can infer something of the nature of these relationships. Prior to Spanish colonization, Navajos traveled long distances from their dispersed settlements to trade with the more sedentary Native people. Trading parties consisted primarily of men offering hides and blankets. Excursions were considered perilous but important journeys through which men obtained necessary subsistence and ceremonial goods for their families. Journeys were planned long in advance, with careful thought given to choosing participants in the expedition. Before leaving and after returning, ceremonies were held, and prayers and songs were an integral part of the daily journey. Expeditions generally lasted several weeks.[15]

The nature of trading transactions varied according to the parties involved. Navajos preferred trading with Ute people, with whom they stayed for several days, feasting, dancing, and sharing stories and songs. These trade relationships were friendships, often continuing in families for several generations. While Navajos did trade with Puebloan people, these were more straightforward exchanges of goods with less socializing and infrequent formation of enduring personal relationships. Trade relationships with Hopis and Zunis might have been more common, since

many stories are told of cooperation with those tribes as well as with Jemez and Santa Clara Pueblos.

For both Navajo and Euro-American people, the history of Navajo Nation trading posts begins with the Long Walk and the internment of Navajos at Hweeldí. The roundup and internment devastated the Navajos and their economy, opening up a need for goods and livestock with which to rebuild. Both the government and traders played major roles in shaping the political, economic, and material lives of Navajos after the ordeal of the 1860s.

The Long Walk and internment occurred as a result of several events involving Navajos and non-Navajos. These were the 1849 murder of Navajo Headman/Naat'áanii Narbona, a massacre at Fort Fauntleroy, the continuing slave trade, land and gold pressures, various encounters with military forces, and the Civil War. The military already distrusted Native people, and these events exacerbated the already tense conditions.

Prior to the 1863 internment, military leaders attempted to negotiate treaties with the Navajos. The Navajo political organization at that time consisted of clans or bands represented by a *naat'annii* who was usually a powerful religious leader. Military leaders mistakenly believed that each time they negotiated a treaty with a Navajo leader, he had the ability to agree on behalf of the entire tribe. In fact, naat'annii only represented their own clan members. So, when clans who had not agreed to a treaty disregarded its terms, military officials assumed that the Navajos as a whole did not adhere to established treaties. This resulted in a great deal of confusion, misinterpretation, and hostility.

The 1849 murder of Navajo Headman/Naat'áanii Narbona occurred some distance east of Narbona Pass, where Colonel John Washington and his troops met with a group of Navajos led by Narbona and Jose Largo to negotiate a treaty. The Navajos arrived in good faith with gifts, including many head of sheep and horses. At the conclusion of the negotiation, a Navajo man was accused of stealing a horse from a Mexican man traveling with the American troops. The troops demanded the horse's return. The Navajos turned to leave, at which point Narbona and six other Navajo men were shot in the back and killed. This incident instilled fear and mistrust in the minds of many Navajo people. Until the 1990s, the place near where this occurred was named Washington

Pass. The name was changed to Narbona Pass and became one of the few Native American sites to commemorate the memory of the victim of an altercation rather than the perpetrator.

In 1861, at Fort Fauntleroy (now Fort Wingate, New Mexico), twelve Navajo women and children were massacred. The occasion was a horse race in which the Navajo rider lost control of his horse. It was soon determined that his bridle had been cut, sabotaging his success in the race. Navajos protested and a military sentry fired shots. In the confusion that resulted, troops began killing Navajo bystanders.

The continuing slave trade contributed to the hostile atmosphere created by such clashes. Thousands of Native slaves, many of whom were Navajo, continued to be held in the New Mexican Territory even after the Civil War. Of 148 slaves held in two Colorado counties in 1865, 112 were Navajos.[16] Slave traders actively sought to exacerbate the conflicts between Navajos and the U.S. government because the resulting confusion made it easier to take slaves. Despite the Civil War and Emancipation Proclamation, the United States government so overlooked slavery in the Southwest that in 1865 the Superintendent of Indian Affairs for New Mexico himself owned six American Indian slaves. Meanwhile, Navajo raiding continued with efforts to reclaim stolen relatives and exact revenge on their captors.

These events illustrate the complexity and tension inherent in Anglo-Navajo relations. Moreover, non-Navajo livestock owners encroached on Navajo territory, and some Euro-Americans wanted the land for its mineral wealth. Indian agents interested in land control were often quick to blame Navajos for any disturbance. Finally, in 1862 Brigadier General James H. Carleton was named the new military commander of troops stationed in New Mexico, and charged with subjugating the Indians, protecting the territory from a Confederate invasion, and opening an overland mail route. Carleton began campaigns, first against the Mescalero Apaches and then against the Navajos. He wanted to establish a reservation for the Navajos in eastern New Mexico, against cautions of poor water, lack of wood, and the threat of floods. He envisioned a mass assimilation project in which clans with complex systems of sharing and land-use rights would be changed into self-interested, land-owning, nuclear families. His primary goal was a peculiar subjugated version of private property ownership and Christian work ethic in which self-interested

Native people were supervised and controlled by the government. Carleton envisioned a "Fair Carletonia" at which Navajo people would live sedentary lives as artisans, farmers, and individual landowners. Carleton's strategy for subjugating the Navajos was ruthless and unrelenting. He authorized a bounty for horses, mules, and sheep. He devised a scorched earth policy in which troops destroyed fields, fruit trees, water holes, livestock, and people. He enlisted Colonel Kit Carson to carry out his policy, which Carson did with assistance from Ute scouts.

During the winter of 1864, approximately 4,145 Navajos were rounded up and marched to Fort Sumner in eastern New Mexico. Many died on the way and others were taken as slaves to the Mexicans. Some fell ill and were left for dead. Carleton estimated the total number of Navajo people interned at 5,000. But by early 1865 there were 9,022 Navajos living at Fort Sumner, which the Navajos called *Hweeldí* after the Navajo word for "hardship, sorrow, and death." This number did not include several thousand Navajos who fled north and west to escape internment. Carleton intended the community to be self-sufficient from the beginning, but drought, alkaline water conditions, and raids from other tribes continually plagued the Navajos. Between early 1865 and 1868, numbers at Hweeldí decreased as prisoners died of starvation and disease. Many deserted.[17]

Forcible internment, economic devastation, starvation, death, and disease left an indelible mark on the cultural memory. Today, some Navajos who speak of the events emphasize the first person "I" or "we" in their accounts as if they themselves had been present for the ordeal. Some elders weep when telling the stories, and others will not speak of the events at all. It is little wonder that whatever attachment Navajo people had for their land prior to Hweeldí was tremendously magnified by their experience. And little wonder, too, that people, such as traders, who played the slightest positive role in rebuilding the Navajo economy would long hold a place of respect in the memories of many people, regardless of the complicated nature of the relationships.

The Establishment of Navajo Reservation Trading Posts

After the United States acquired the New Mexico Territory in 1846, licenses to trade in Navajo country were granted. By 1849 there was a

Euro-American trader at Zuni who also traded with Navajos in the area; the first recorded trader to Navajo country was Augustin Lacome. Generally, these traders were intinerant merchants who bartered hides and pelts, surplus livestock, and occasionally blankets, baskets, and pottery. Availability of goods and customers was sporadic and uncertain. The first established stores to engage in barter were those associated with the military bases, such as John Weber's store at Fort Defiance and A. W. Kavanaugh's store at Fort Fauntleroy. They depended on the military trade for their success. Indeed, it was in this role of army sutler that men like Hubbell and Thomas Keam first engaged in trading.[18]

After the Long Walk and internment at Bosque Redondo, the 1868 Treaty mandated a ten-year annuity period during which the government issued rations to the Navajos, including food, farm implements, commercial Euro-American-style clothing, sheep, dyestuffs, and commercial wool and cotton yarns for weaving.[19] The annuity period is characterized in literature as the time that Navajo people became increasingly dependent on foreign goods and government subsidy that continues today.[20] Although the literature is no doubt correct that many people attempted to exploit Navajos' needs for goods, we must also acknowledge Navajo choice in selection. Acculturation models have noted goods embraced by Navajos, such as wheat flour, Arbuckles coffee, and trade blankets, while largely ignoring those things Navajos rejected. Weavers repeatedly refused labor-saving technology such as spinning wheels, European-style looms, and drum carders. And, of course, Navajos made their own decisions about the few goods like textiles and wool that they offered in exchange.

The first permanent trading posts had their roots in two distinct historical developments. In eastern Navajo country around Fort Defiance, trading posts were an outgrowth of the government annuity system. These army sutlers, including Neale and Damon after 1868 and Keam and Hubbell in the 1870s, encouraged the Navajos to trade their surplus wool for extra rations.[21] This was a time of rapid change for Navajo weavers. With the Long Walk they had lost many of the *churro* sheep whose fleece they had spun into very fine, strong, greaseless yarns. The government issued sheep, but they were a mixed-breed churro-merino that, while larger and meatier, did not have fleece as suitable for hand spinning.[22] During the ten-year annuity period the government also

issued cotton string for warp yarns at Hweeldí. Commercial clothing, Spanish and Mexican blankets, and trade blankets were annuity issues. For Navajos, the opportunity to trade wool fleece for extra food and clothing must have been attractive.

By 1875, William Arny, the son of W. F. M. Arny, Navajo Agent at Fort Defiance, purchased wool for shipment to mills back east. Arny shipped 60,000 pounds of wool by wagon in 1875. The following year traders shipped 200,000 pounds, and by 1881, 800,000 pounds of wool was being shipped by railroad to mills back east. This was the increasingly lucrative business that attracted individuals and, later, extended families like the Damons, Days, Hubbells, Parquettes, and Shillingburgs to the trade.[23] All the while, the quality of wool for Navajo handspinning was declining due to the increasing amount of merino stock.

The second area of Navajo reservation trading post development began with Navajo–Mormon relationships in the western reservation area. These, too, were businesses owned and operated by families, such as Foutz, Hunt, Kerley, Lee, and McGee. Several descendants of the Foutz, Lee, and McGee families are still actively trading. In addition, there are other "trading families," such as the Kennedys, Simpsons, and Tanners who still operate some form of the business. The Hubbells' trading participation ceased in 1967 when Dorothy Hubbell (J. L. Hubbell's daughter-in-law) sold the Ganado post to the National Park Service.

◆ ◆ ◆

By 1876, the year Hubbell began trading at Ganado Lake, there were five trading posts operating in and around Navajo land. By the early 1880s the Atchison, Topeka and Santa Fe Railroad was fully operational throughout the New Mexico and Arizona territories. Gallup, New Mexico, quickly became a central rail depot for the area. Secondary centers later developed around Flagstaff, Arizona, Farmington, New Mexico, and Alamosa, Colorado. Gallup quickly developed an economy centered around Indian trade, alcohol sales, and government bureaucracy, which remains the case today.[24]

Meanwhile, the opportunities for trade in Navajo wool increased, and by 1890 there were forty-eight trading posts on and around Navajo land. This number grew steadily to more than two hundred posts, until around 1930–1950, after which the trading/bartering business underwent a

steady decline. In 1963 there were approximately two hundred posts catering primarily to Navajo trade. Today, it is difficult to state a figure because the roles and identities of a so-called "trading post" vary.[25]

While much has been said about the degree to which early traders exploited the Navajo clientele and capitalized off the fast and large profit potential of the wool market, it is also true that trade involved considerable risk. Reservation traders could not own their land. Licensing arrangements required them to lease land from the Navajo Nation. Licenses mandated a $10,000 bond, part of which was paid to the government to ensure a trader's credibility and standing. Further, it was the trader's responsibility under the license to provide and maintain a building structure from which to do business. Trading families, of course, needed homes in which to live, so buildings, bonds, and inventory represented a considerable capital investment with little or no guarantee of quick return. A trader in the late nineteenth and early twentieth centuries was gambling that the return on wool would be fast and profitable enough to be worth the risk.[26]

Exchanges during the 1870s were strictly on-the-spot barters of goods for goods, such as groceries for rugs. Initially, opportunities for repeat exchanges between traders and Navajo families were uncertain. Successful traders like Hubbell began building the kinds of long-term exchange relationships that characterized inter-Indian exchange, while others were more interested in immediate gain with little regard for Navajo customs and exchange preferences. Those traders who learned about and somewhat accommodated Navajo preferences generally developed flourishing businesses.

Though traders' roles in material acculturation are widely discussed, little attention is paid to the ways traders were involved in the government's plans for assimilation.[27] A significant part of assimilation policy was the conversion of Americans Indians to the American capitalist economy.

> The period from about 1890 until the beginning of World War I was the heyday of the rug trade, and in many ways marked the climax of the old style barter trading system. Later years saw a steady decline in the quantity market for Navaho [sic] rugs, a reemergence of raw wool as the basic trade commodity, and the ever-widening

institution of credit as an essential feature of the economy. . . . So gradual was the evolution toward a market economy, in fact, that it went largely unnoticed by White observers, and many of its details remain shrouded in uncertainty to the present day.[28]

In fact, the transition was not at all "uncertain." Rather, it was a conscious effort on the part of government to assimilate American Indians into Euro-American society. Under the terms of their licenses, traders were expected to adhere to all government policies. Indian agents saw trade as an opportunity to usher Native people into a capitalist economy and required traders to deal only in cash. Due to both a scarcity of currency and Native resistance, other forms of establishing value emerged. By the 1890s, some traders were conducting transactions on a credit basis or issuing credit slips, scrip, or tin money against blankets in progress or large quantities of fleece. Still later, traders made loans of cash and goods against valuables that they then held in pawn.[29] Although traders manipulated these various forms of credit to their financial advantage, Navajos quickly learned to work these systems in conjunction with their indigenous cooperative practices.

Successful traders learned to conduct their transactions largely in pidgin Navajo. Transactions were also conducted in Spanish and English. An interesting by-product of this hybrid exchange is the Navajo system for counting money. Prior to trade with Spanish settlers, there were no words in the Navajo language for expressing value in strictly quantitative terms. Navajo language words for currency developed from two sources. First, there are terms that describe the physical qualities of the currency itself. For example, a penny is *łichíí'*, "red," while two cents are *naaki łichíí*, "two reds." A second set of terms was adapted from Spanish. For example, the Navajo word for "money" is *béeso* from the Spanish *peso*. Then there are terms that reflect Spanish values in *reales*. The two systems are used interchangeably. For example, a "penny" is *sindáo*, and "ten cents" might be either *neeznáá sindáo, neeznaa łichii'*, "ten reds," or *t'ááłá' dootł'izh*, "one blue," reflecting the bluish appearance of a silver dime.[30]

In the 1880s, Navajos bartered wool, blankets, hides, and pelts. By 1900 the growth and stabilization of the market, combined with Navajo dependence on manufactured goods, resulted in a "settled down"

character for both Navajos and trading posts, after which the trading posts lost much of their "speculative, frontier character."[31] These processes were probably related. For Navajos, trading posts and traders played significant roles in creating and perpetuating Navajo life after the Long Walk. For some traders, like Hubbell, the process included image-making and marketing as they sought wider and more stable markets through the sale of Navajo blankets and silverwork. Image-making continues in the present through the marketing of the trading posts' "frontier character." The history of J. L. Hubbell's Trading Post at Ganado offers a case study.

The Hubbell Trading Post

J. L. Hubbell's second trading post cannot be separated from the place that is known to the English-speaking world as Ganado, Navajo Nation, Arizona, and to the Navajo world as *Lók'aahnteel*, "Place of Wide Reeds." Historically, there were many reeds in the area around the trading post. Reeds are significant symbols of Navajo process and life. In the stories of Navajo emergence through three or four worlds into this fourth or fifth world—the Glittering World—the opportunity to climb through the hollows of reeds to escape destructive flooding saved the people and facilitated their journey to the next world.[32] Reeds are an important symbol of Navajo survival and the continuation of life. This fact was probably not known to the founders of the trading post, but it remains a part of the cumulative local identity of the place today.

The history of Lók'aahnteel goes back long before William Leonard established the trading post, but in Navajo stories trade is inextricably entwined with the location. According to some community elders, the place has always been a site for intercultural trade. The 160 acres that eventually became Hubbell's homestead is the site of an 'Anaasází village dating to A.D. 1276 that was probably home to several families. Here ancient ones farmed maize, pumpkins, and beans until they left the area, possibly because of drought, disease, invasion, or social disintegration. Hopi Arrow and Bow clans and the Zuni Bow Priesthood might be twentieth century descendants of these people.

Dinetah pottery and remains of hogans indicate that Navajos had also occupied the site as early as the 1700s. Oral traditions tell of a

Navajo man named Jígháád, "Sound of a Rattle," who was perhaps a hataałi who settled there in the mid-to-late-1700s.[33] At that time Navajos practiced a mixed subsistence of hunting-gathering and cultivating corn and a few other crops. They lived in dispersed homesteads and were politically and economically organized according to clans, each with a naat'ánnii who was also a spiritual leader. By 1863 the Pueblo Colorado Valley was so densely populated by Navajos that Colonel Kit Carson was ordered to establish his army there.

After the Long Walk and the 1868 establishment of the Navajo reservation, many Navajos returned to the areas they had occupied before the internment, often without regard to the legal boundaries of the reservation. The site that later became Hubbell's trading post was south of the 1868 reservation boundary. Among the people to occupy the area were the clan relatives of the headman Tótsohnii Hastiin, "Man of the Big Water Clan." Hubbell called him Ganado Mucho, "Many Cattle." The Long Walk had destroyed the Navajo economy and morale, but the people were happy to return to their homeland. Yanabah Winker told about her family's experience during the roundup and later settlement in the Pueblo Colorado Valley.

> Where he was born, I don't know. There is a place called K'ai' Si'anii (Tanner Springs) during the time of wars with other tribes, they were attacked. . . . Probably when he was man enough and it was my grandmother and grandfather who lived in the forked hogans. My grandfather and my grandmother who had just had her baby two days ago, just left her baby beside here, giving up all hope and didn't care anymore, all the others leaving her behind. My uncles, I used to have two of them, I've seen them over at Shiprock, the younger one is the one that took care of me. Her biil dress, Ute saddlebags and deerskin leggings, another pair of shoes she already had on. She had all these things by her ready to go. When everyone was gone, she finally got up and went outside. Standing outside, she saw two people coming towards her. One had his face hit with a gun and blood covered all over him. It was my grandfather's brother that told of these things. The two visited other hogans, while my grandmother being very afraid hid. Later she found they were only trying to help and picked up the baby

she left behind and gave it back. My grandmother had a string of red beads hanging around her neck, she broke it, letting it fall to the ground, she dug a hole where she buried it. This happened to her when she was very young, it was when she had her third child. The dress she had on was taken off her and they just cut arm and head holes in the gunny sacks, and that was what was put on her. She was tied to a horse, along with her baby and started off.[34]

After the ordeal, Winker's family resettled in the Lók'aahnteel area.

[They came back] according to the location of their homes at that time or the area of land they owned. At that time, everything was plentiful on the reservation and they were very good leaders, but things are different now, maybe because we are living the white man's ways. . . . Coming back they came on their own with a lot of hardship also, took many days and [many people] were not brought back.[35]

During the late 1860s these families rebuilt homes and farms with little competition from other settlers. For ten years, they were dependent on U.S. government annuity rations of Euro-American-style clothing, food, sheep, and commercial wool yarns for their weaving. Rations were often in short supply, either because of corrupt agents who took goods for their own gain or because need was miscalculated.

By 1871 Charles Crary had established a store at Ganado that was purchased in 1875 by William Leonard, who had formerly been a clerk at Fort Defiance. In 1878 Leonard sold the store to J. L. Hubbell. Hubbell had come to the Lók'aahnteel area also from Fort Defiance, where he had clerked in a store. In the 1880s Hubbell took on a partner, Clinton N. Cotton, with whom he maintained a business relationship throughout his lifetime. At times Cotton was half-owner of the trading post, and during part of the 1880s and 1890s he apparently held sole ownership. During the 1880s Cotton lived and traded at Lók'aahnteel while Hubbell was sheriff of Apache County.

Cotton initiated efforts to market Navajo products nationwide. He shipped pinon nuts to New York City and promoted Navajo blankets for use in mining camps. He was apparently the first to suggest marketing

Navajo blankets as rugs to adorn the floors of eastern homes.[36] Through-
out Cotton and Hubbell's business relationship, Cotton aggressively
marketed Navajo products. By 1886 Cotton and Hubbell were buying
wool in quantity and selling it in eastern markets. The wool market,
though profitable, was sufficiently unstable that Cotton and Hubbell
sought a second use for Navajo wool—finished blankets.[37]

Cotton was known to the Navajos as Béésh Biwoo', "Metal Teeth,"
because of his gold dental work. Though he traded at the Ganado post
for several years, he was not popular with the Navajos. "And they said,
'Yeah, he didn't respect us.' I guess I could use the word respect. 'And
we didn't do much with him. We went other places.'"[38] Cotton's lack of
"respect" was likely attributed in part to his strict adherence to the trading
regulations. The government wanted Navajos converted to Christianity
and in churches on Sundays. Cotton did not do business on Sundays,
whereas other traders are reported to have opened their stores any time
customers arrived. Cotton did business only in cash, which was neither
convenient for nor desired by late-nineteenth-century Navajo customers.
By 1896 Cotton owned and operated a wholesale business in Gallup,
for which he was probably better suited. He operated according to strict
capitalist business standards of the day and had little time or patience
for some of the trading activities that did not result in direct monetary
gain. Finally, in his correspondence, Cotton repeatedly expressed his
desire to do business with people of white Anglo-Saxon descent to the
exclusion of all others.

By the 1890s, both Cotton and Hubbell were attempting to influence
the technical and aesthetic quality of Navajo blankets. In 1896 Cotton
issued the first mail-order catalogue to sell Navajo products, while in
1897 Hubbell began commissioning the blanket paintings through
which he attempted to exercise his own aesthetic preferences.

Both material and ideological realities of the early reservation trad-
ing post shaped the customs and protocols of trading transactions.
These are reflected in early photographs and in the spatial layouts of
some trading posts today. Glimpses of the early trading post are evi-
dent in museum reconstructions like Hubbell Trading Post at Ganado.[39]

In the late nineteenth and early twentieth centuries trading posts
often comprised several buildings. In Hubbell's time, people often stayed
at the trading post for several days, especially if they had traveled long

distances, before transactions were completed, so they would stay in the "guest hogan." Early trading posts also functioned as community centers where people could catch up on the latest news and visit with relatives and friends. A few traders like Hubbell capitalized on this social aspect of trade by sponsoring community festivities like chicken pulls and ceremonial gatherings, drawing large groups of customers to the post for days at a time. In the post's role as a community meeting place, the guest hogan was a multipurpose extra space. Community leaders sometimes used it as a private place to "talk to" those community members struggling with social problems such as alcoholism or infidelity. It was also a place where Navajos gathered for gambling and general socializing. The guest hogan served these purposes until the 1930s, when the chapter house became the community political center. Dorothy Hubbell ordered the guest hogan demolished in the 1950s because she did not approve of the gambling that took place there.

The buildings in which trade took place generally featured an open central area called "the bullpen" in which customers could mill about, stand, lean, and socialize for long periods of time. The bullpen was bordered on three sides by counters that were both higher and wider than those we envision in a typical general store. The high counters were designed to protect traders, who sometimes kept weapons underneath. Most exchange items were also kept behind the counters. This shaped the process of interaction between trader and customer. The high counters with raised floors behind them elevated the height of the trader and also likely served as visual symbols of trader superiority in the trader–Navajo power relationship.

In addition to reinforcing the traders' dominant position in the cultural and political economy, the physical space of trading posts accommodated and also helped shape particular trade protocols on the part of Navajo customers. These protocols, like the posts themselves, apparently varied less than the transactions that take place in today's trading posts. Laura Gilpin's description of Navajos trading is still consistent with many Navajo elders' visits to Hubbell Trading Post.

> Navaho people come into the post, quietly greet those they know by a gentle touching of hands, then sit on the benches for a long time considering what to buy. One will finally go up to the counter,

and, pointing to an article, put down the money for that one item, or if the Navaho is pawning jewelry, the trader lists each purchase. Following another long interlude of consideration, this process will be repeated. Sometimes individuals will stay at the post all day before the final lot of merchandise has been acquired.[40]

Occasionally, elders sit in their pick-up trucks and other vehicles parked some discreet distance from the trading post door. Some Navajos sit on outdoor benches as they watch to see which relatives or acquaintances might come to the post. I have often watched as Navajos greeted those who sat on benches and then walked to an elder's pick-up to greet them and engage in extensive conversation. I also developed and renewed many friendships by participating in these informal gatherings. We shared news of the day, talked of relatives and community events, discussed the rugs or other items they may have come to trade, and generally caught up on things that had happened since our last encounter. These informal and sometimes leisurely visits are reminiscent of the times when the trading post was an important community center.

Navajo Reservation Trading Posts in the Late Twentieth Century

No single description characterizes the various businesses that today are identified as contemporary trading posts. Like any other commercial enterprises, Navajo Nation trading posts are subject to the pressures of modernity and resulting political and economic change. This diversity is a largely post-1970s phenomenon. The trading posts operating one hundred years ago varied somewhat with the style and preferences of the trader or trading family, but most shared common physical and functional features, such as the bullpen and the use of credit and gifts. Today's trading posts are a mixture of gas station/convenience stores, local businesses engaged in combinations of barter, credit, pawn, and cash sales, and museum-like attempts to preserve and represent a Southwestern frontier past and sell products to Euro-Americans. Some traders even tried to bring in more customers by carving out a distinct identity for their post.

Coyote Canyon Trading Post

Twenty-five miles northwest of Gallup, New Mexico, sits the Coyote Canyon Trading Post. Until recently, the post was owned and operated by Mustang Corporation as a gasoline station and convenience store. It also served as a post office for the community. It probably was not frequented by many tourists. Occasional non-local visitors were those on their way to the monthly Crownpoint Rug Weavers Auction or the Chaco Canyon National Historical Park. The Coyote Canyon post largely served the local community's needs for gasoline, daily grocery items, automobile supplies, and mail pick-up.

Coyote Canyon post comprises several stone structures, the original of which was built sometime prior to 1902. It was probably expanded between 1902 and the 1940s, and then expanded again in the 1940s. Until it closed around 2001, the trading post interior was a well-lit space filled with racks of chips, crackers and cookies, potted meats, and other snack foods. As in many convenience stores, a counter with the cash register was close to the door and packed with impulse or frequent-purchase items such as popcorn, pickles, beef jerky, and newspapers. The walls were lined with refrigerated cases of soft drinks, milk, juice, and ice cream. (Alcoholic beverages cannot be sold on the Navajo reservation.) In an alcove was a wall of old postal boxes and a window for sending and receiving mail.

The Mustang Corporation dealt only in cash sales and did not purchase items from community members or other walk-in vendors. They did not engage in barter, credit, loans, or pawn. In 1996, the post's middle-aged Navajo employees did not know the history of the store. "It has just been here since we were small children growing up," they said, but the local community's elder women know stories about the post from "a long time ago."

Coyote Canyon Trading Post was founded by George Washington Sampson, called Libái, or "Grey Man" by the Navajos. Sampson owned several trading posts during the period between 1883, when he started his first post in Sanders, Arizona, and 1911, when he owned posts in Gallup and Chilchinbito, Arizona. He also owned posts at Rock Springs and Tohatchi, New Mexico, and Lukachukai, Arizona. Sampson apparently sold the Coyote Canyon business to trader Dan DuBois in 1902. Hubbell

FIGURE 1. Coyote Canyon Trading Post in 1998. It was refitted as a convenience store sometime before the 1990s, but has been closed for several years as of 2007. Photograph by Teresa J. Wilkins.

and DuBois crossed paths on several occasions. Once, Hubbell found DuBois freezing outdoors, apparently in a drunken stupor, and brought him inside, probably saving his life. Later, he found DuBois at the post, obviously suffering financial difficulty, and gave him money.[41]

Neither DuBois, Sampson, or their trading businesses and styles are well documented. However, a 1911 letter from Sampson to the Assistant Commissioner of Indian Affairs, F. H. Abbott, reveals some information about Sampson's trading history and the paternalistic position he assumed with his Navajo customers. The letter, written when Sampson owned businesses at Gallup and Chilchinbito, responded to Abbott's inquiry for information the government planned to use to determine which industries were the most profitable for Navajos. It illustrates Sampson's desire to solidify the trading post's monopolistic hold on Navajo customers and his agreement with other trading posts and trader roles in the civilizing mission of assimilation. I quote the letter in its entirety.

> During my twenty-five years experience, trading with the Navajo Indians I have often noticed that their flocks of sheep have not increased as they should have—and I believe this is due to the fact that they have been allowed to sell their sheep for cash, worthless turquoise and beads. Having thoroughly investigated this particular subject I firmly believe—the Navajo should not be allowed to trade his stock for anything but the necessities of life—which he can obtain from licensed traders. In this location—Bitter Weed Water, (Chil-chin-bito) Arizona, north of the Black Mountain—located 45 miles northwest of Chin Lee, Ariz.—60 miles north of Ganado, 58 miles southwest of Round Rock—The Indians have often come to me and I have heard them talk the matter over among themselves—about, why they cannot get wagons and harness and schools. The Indians in this locality are very ambitious and as a rule very well fixed—and they seem to feel slighted on account of not being able to get these things—when they are willing to do the required amount of work for them—when at the same time Indians all around them have these things—they think they are not being treated right—and can't see why the government gives some of the Navajos schools and wagons—and don't give them any.

The Indians here are well-behaved and ready for advancement—when the time comes, I think your idea of demanding estimates and information from the traders is a wise move—and personally I will be glad to give you any other estimates and information that you should desire. In regards to the principle [*sic*] industry of the Navajo Indian I am under the impression that they derive more benefit from sheep and cattle raising than any other industry. Next to their stock, I believe their blankets are the most beneficial. The Navajo blanket is made by the Navajo squaws. The wool used in the manufacture of a Navajo blanket is washed, carded and spun by hand and dyed by artificial dyes only. The natural colors being white, brown and black. The class of wool used in the Navajo blanket—and the only kind that the squaws can use successfully in the manufacture of a blanket—is the native wool—taken from the native sheep—bred by the Navajos. In regards to native silver work—It is made by the Navajo man—the silver used is Mexican pesos (Mexican dollars). The baskets made by the Indian women could hardly be called an industry—as they are not used as an article of trade to any extent—only among themselves. The baskets are used in their marriage ceremonies and also by the medicine men—but not sold to the white people to any extent until after they have been used. They are made of willow. The amount paid the Indians for the period between July 1, 1910 and June 30, 1911 are as follows

A—Blankets	$4000
B—Native Silver Work	550
C—Baskets	150
	$4700

The number of sheep bought and taken in exchange for the necessities of life—such as coffee, flour and sugar and clothing—are 650 head—prices ranging from $1.50 to $2.00 per head.

August 21, 1911, G. W. Sampson[42]

Unfortunately, the significance or quality of Navajo art and craft products at Coyote Canyon Trading Post during this early period is unknown. It is likely that Sampson or DuBois supplied Navajo wool to

Gallup wholesale houses like C. N. Cotton's Mercantile and perhaps blankets to either Cotton or Hubbell.

Two Grey Hills Trading Post

Two Grey Hills Trading Post is nestled near two brownish buttes for which it might have been named. Founded in 1897, the post is located on a dirt road seven miles west of the Newcomb, New Mexico, Chapter House on U.S. Highway 491. Just five-and-a-half miles further west on the dirt road is the Toadlena Trading Post, which contains the recently established Two Grey Hills Museum. Upon arriving at Two Grey Hills Trading Post, you face the original building constructed by brothers Henry and Frank Noel and their partner Joe Wilkin. Since then, additions have been made to the original two-room log structure, and doors and windows have been sealed and moved. The current trader and owner, Les Wilson, can explain the order of the various additions.

The front room of the post is filled with groceries and other goods for local consumption. Intermingled with groceries, videos, enameled cookware, and other items are weaving tools, wool, shears, and wool carders. Here one also finds local arts and craft items, such as dolls, folk carvings, and beadwork.

Two Grey Hills Trading Post has been owned and operated since 1983 by Wilson and his family. The Wilsons maintain a "rug room" in the back of the store in which they keep their inventory of Two Grey Hills rugs, fine jewelry, paintings, and pottery. Here they also display historic photographs of the post. The Wilsons encourage modern weavers in the area to produce the fine quality rugs and tapestries for which the area became known. They encourage credit accounts, thereby allowing a weaver and her family to purchase groceries and other items on credit against rugs in progress. They also buy beginners' rugs, hoping to encourage them to continue weaving. The Wilsons buy other locally produced art, carry credit accounts, and make loans to steady customers. In this sense they carry on, in contemporary form, a tradition begun with the founding of the post in 1897.

All founders of the Two Grey Hills Trading Post had been in the trading business for a number of years. Just before he joined with the Noel brothers to establish the post at Two Grey Hills, Wilkin sold a trading

Figure 2. Two Grey Hills Trading Post—the Navajo reservation's oldest continually operated, privately owned trading post. Photograph by Teresa J. Wilkins, 1998.

post he helped found west of Narbona Pass. Purchaser J. B. Moore renamed it the Crystal Trading Post. Wilkin and the Noels started the Two Grey Hills post in a tent near the ruins of an 'Anaasází settlement from which the Navajos derived the place-name, *Bis Dah Łitso*, meaning "Yellow Clay at an Elevation." The traders freighted goods by wagon into and out of Gallup. In 1898 Wilkin sold his share of the post to the brothers, who in turn sold the post to Win Wetherill in 1902. By 1909 the post was owned by Joe Reitz and Ed Davies, with Davies acquiring sole ownership by 1912. Meanwhile, George Bloomfield had established Toadlena Trading Post just five-and-a-half miles to the west.

Though Davies and Bloomfield were competitors, they were also friends, and both worked with area weavers to improve the quality of their rugs and develop markets. Apparently, and not surprisingly, area weavers were receptive to the traders' encouragement, but they maintained control of their aesthetics. It is said, for instance, that area weavers did not like the color red, so the red calico fabric Bloomfield had stocked at his post never did sell. But with Bloomfield and Davies's help, weavers acquired and used cleaner wool, spun finer yarns, and developed distinctive designs. Interestingly, they also took snapshots of the rugs they felt best exemplified their new aesthetic direction to show to other weavers. According to their own tastes, weavers eschewed reds and developed fine rugs using the natural creamy white, brown, and gray color variations of local sheep along with synthetic-dyed black wool. Indeed, in their reply to the 1911 inquiry by Assistant Commissioner of Indian Affairs F. H. Abbott, Reitz and Davies described area weavers' work as follows:

> In Reply to your inquiry of the work done by Navajo Indians at the Two Grey Hills, would say that we have purchased the following.

(A) Blankets	$6,855.85
(B) Silverware	125.00
Total	$6,980.85

> No other native work is purchased by us. The $125.00 for silverware is the amount paid for work only as we supply the Mexican pesos and pay for making it up. The blankets are the work of the women and are all native wool carded and spun by the women. There is no native dye used now in this part of the country. The

silverwork is done by the men. Hoping this information will be of
service to you. Begging your pardon for the delay we remain

Respectfully
Reitz and Davies
(Sept. 11,1911)
(Report to Asst. C. I. A. Abbott, September 11, 1911)[43]

The Two Grey Hills Trading Post is now the oldest continually operating
trading post in private ownership. The post was sold in the 1930s to
Victor Walker, in the 1940s to Willard and Marie Leighton, in the 1970s
to Derald Stock, and in 1983 to Les Wilson. Each owner and operator
had continued to support fine weaving in the area and help meet the
community's needs. Each one also engaged in a variety of exchange
practices, including cash sales, some barter, loans, and credit.

Hubbell Trading Post National Historic Site

As you drive into the gated entry of Hubbell Trading Post National
Historic Site, you can see the remains of an 'Anaasází site that archaeolo-
gists have named "Wide Reed Ruin," adapting the Navajo name of
Lók'aahnteel, "Place of the Wide Reeds." Continuing down the drive you
cross a wooden bridge over a tributary of the Pueblo Colorado Wash,
past a National Park Service Visitors' Center, and turn into the trading
post parking lot. In the winter, the few parking spaces in front of the
trading post are often occupied by the pickup trucks of local customers.
During the rest of the year, pickup trucks compete for space with auto-
mobiles, sport utility vehicles, and recreational vehicles of all sizes.

During the tourist season, the entry to the post is often crowded.
Tourists wander about. Local children eat snacks bought at the trading
post, and local people come to purchase groceries or sell rugs, pottery,
paintings, kachina dolls, and other items they have produced. Whole-
salers of these and other products also frequent the place.

The trading post doorknob has the uncertain loose feel of a knob
that has been in use for quite a long time. One grasps it firmly and
turns until the latch clicks and the door opens with a loud squeak. This
moment is often the first time that newcomers to the post can directly
sense the otherness and long history of the place. The dark interior is lit

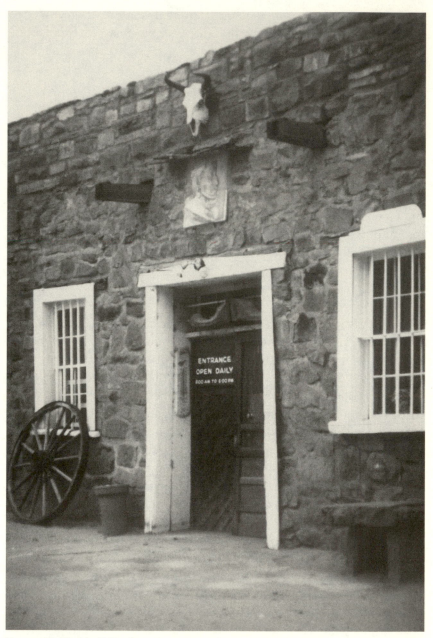

Figure 3. Hubbell Trading Post, Ganado, Arizona. Hubbell installed the portrait of local Naat'áanii Totsohnii Hastiin over the door to honor him and to encourage his followers to become loyal customers.

only by bare lightbulbs suspended from the ceiling and by daylight filtering through small windows in the back of the room. The loud squeak of footsteps on the original wooden planked floors is startling. This is where many first-time Euro-American visitors, myself included, stop in their tracks. Rather than the typical store's open room filled with shelves or racks, visitors find themselves dwarfed by the counters surrounding the bullpen. The few hasty visitors who rush headlong through the entry stop short in the center of the bullpen and stand looking confused. When I did this myself, I wondered, "What do I do? Where do I go? What is this place? What do I do now that I am here?" At the same time, I was thrilled to experience a place I had only read about before.

In 1997, the Virginia office of the National Park Service began working on a plan that would ease the transition into the interior of traditionally constructed trading posts, preventing visitors from the disorientation described above. Part of the plan included making certain that visitors first encountered a person in "gray and green"—NPS uniform colors. I found it interesting that the NPS wanted to create an homogeneity of experience and familiarity across parks while at the same time their marketing strategy emphasized the visual "otherness" of Indian country and the frontier quality of the trading post.

Hubbell Trading Post's cool, dark interior contrasts starkly with the flourescent lights of the Coyote Canyon convenience store. The NPS has gone to great lengths to restore the physical sensibility of the frontier trading post, and the post is neither the shopping mall of contemporary American society nor something out of a frozen past. Merchandise is a hybrid mixture of old and new items. A freezer case houses Ben and Jerry's ice cream alongside cuts of raw mutton. Navajo woven sash belts, bolts of calico fabric, and horse trappings are displayed alongside trendy southwestern-style denim jackets, tee shirts, and souvenir mugs.

Until recently, the Western National Parks Association (WNPA), which manages the store, had employed trader Bill Malone as the manager. Malone is an experienced reservation trader who knows the intricacies of conducting business in the local community. He often conducts transactions in Navajo language, he knows the trading protocols Navajos expect, and he knows respectful ways of trading with Navajo elders. Malone is also an internationally recognized expert in southwestern Native American arts. But in 2004, WNPA and NPS replaced Malone

with a store manager whose background lies in retail sales of Native American arts rather than more traditional trade.

The WNPA also employs an assistant manager, bookkeeper, and numerous sales clerks, usually young Navajo women. All personnel are trained to answer questions for tourists, but few are able to assist elderly Navajo-speaking customers with their transactions. The NPS is charged with operating the trading post in the traditional frontier manner, a situation that sometimes conflicts with contemporary business practices and goals. For example, until 1996, the post gave credit and occasional loans to community members. They regularly donated merchandise or money to community events such as school fundraisers, parties, and funerals. In 1996, a new policy halted loans and limited credit accounts to artists who regularly sell rugs or jewelry. For long-time customers, a ceiling of fifty dollars was placed on credit accounts. Malone then apparently made loans and donations from his personal funds due to a responsibility he felt as a long-standing trader in the Ganado community. But these practices changed when he was replaced. The Navajo language also began to disappear at that time. Many local trading post patrons complain that the employees are not able to converse with them in Navajo. The need to turn a profit is apparently shifting the goal of the trading post from meeting community needs and selling the finest examples of art toward becoming another tourist souvenir shop.

In addition to operating the trading post, the NPS offers tours of the Hubbell home and grounds and maintains the collections and archival records that the Hubbell family sold to the NPS.

These three trading posts represent a range of possibilities in the evolution of the businesses since their inception in the 1870s. Each is still a functioning business concerned with different purposes—local store, tourist attraction, and purveyor of the fine arts of Navajo people. Each is significant to the local community in its own way.

Significance of Trading Posts for Navajos

When I drove into the parking lot of Coyote Canyon Trading Post on a summer morning in 1998, an elderly Navajo woman sat in a car parked in the shade of a tree. Inside the store I talked with the clerk for some time, and then I looked around the ruins of the historic building exterior.

Over an hour later, the woman was still sitting in her car, watching the comings and goings of community members. People sometimes stopped to chat with her and then went on their way. This trading post was built as a store, and by the early twentieth century had become the community's gathering place. As of 2007, it is abandoned.

Whether the trading post is a convenience store, a store where credit is obtained, or a museum, today's trading posts can be important local sources of much-needed items. Trading posts are often the place where locals fill up their cars with gas for the long trip to "town," or where they purchase limited amounts of grocery items for near-immediate consumption. The post is also where locals pick up mail and, as the above examples illustrate, see community members and exchange gossip and news. In fact, the material significance of a community trading post was highlighted in 1997 when, after a robbery and murder on the premises, Thriftway Corporation (which later sold the post to Mustang) closed the Coyote Canyon Trading Post with no plans to reopen. Community members were outraged and launched a protest that threatened to jeopardize Thriftway Corporation's Navajo Nation leases. Thriftway bowed to local pressure and reopened the store. This situation contrasts ironically with similar stories from the frontier trading post period. It is said that Hubbell abandoned a trading operation near the Ganado dam when a Navajo witch was murdered in the doorway of the building. Afterwards, no Navajos would come to the building.

The trading post also figures prominently in Navajo history through stories and current practices. Some trading posts are remembered by Navajo people as existing just to help the people reestablish their livelihoods after the return from the Long Walk. Many times community elders told me, "Naakaii Sání [Hubbell, "Old Mexican"] was here just to help the Navajos." And some trading posts have figured so prominently in the livelihoods of families that elders are reluctant to shop elsewhere. Grace Henderson Nez was an elderly weaver whose mother, grandmother, daughter, and granddaughters exchanged rugs at Hubbell Trading Post. Grace remembered J. L. Hubbell giving her fruit and tin money when at the age of five she accompanied her parents to the trading post. She fondly remembered the ways that Hubbell and his sons, Lorenzo, Jr., and Roman, helped her family over the years. During her lifetime Grace Henderson Nez sold rugs to all the traders at the Ganado Post, and she

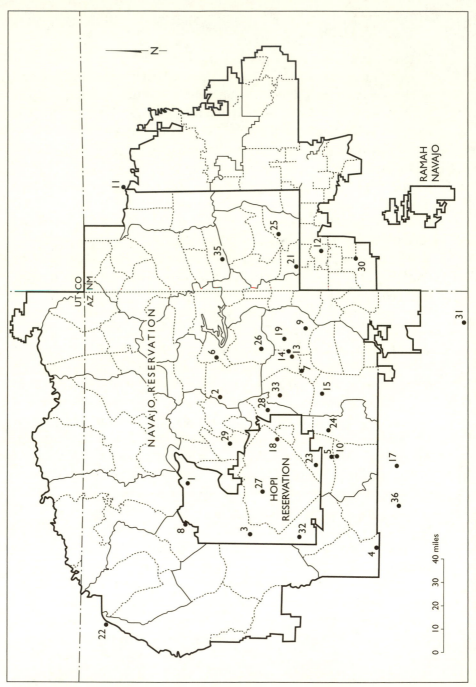

Communities with Hubbell Trading Posts. Post names and dates compiled by
Clint Colby and Eugene Bahe. Chapter locations compiled by Teresa Wilkins.

44

45

demonstrated weaving at the site after it was purchased by the NPS. She told me, "My children tell me I should buy my groceries in Gallup because they cost less there. I have always purchased my groceries at Hubbell Trading Post and I will keep doing that."

During NPS discussions about the significance of Hubbell Trading Post National Historic Site within the National Park system, one Navajo employee said, "It's significant because it's here. It's important to preserve because it is here!" A community elder, when told that I was interested in knowing whether Hubbell Trading Post was important to the Navajo community today, replied, "Hubbell Trading Post is really essential. It's all there and you don't have to ask any questions. It was built by the Navajos. It has all the old ways right there. It's essential to keep it." This statement underscores the images of Hubbell Trading Post as a place inextricably linked to the history of the Navajos. The association is so strong that many members of the community do not feel they need to ask questions about the history. It is embodied in the place that is the trading post and the Navajo people's memories of Naakaii Sání and his family. "This was set aside because it's here!" Hubbell Trading Post embodies the old ways. It is "unique in the face of everything changing. You have that feeling of knowing where you're coming from, your past. . . . "

Although the trading post embodies a local past for Navajos, it embodies another past in the imaginations of Euro-American visitors. In the foreword to McNitt's *The Indian Traders,* historian Peter Iverson discussed a collective memory for trading posts in the Euro-American imagination.[44] The significance of Navajo Nation trading posts is glimpsed through examination of published accounts of trading posts, magazine articles, and trading post guidebooks.

During the early twentieth century several accounts of reservation trading posts were published.[45] These were followed by several late-twentieth-century accounts as the early trading posts came of age and traders like Hubbell passed away.[46] After the turn of the twenty-first century, trading posts are receiving attention in a small proliferation of magazine articles and guidebooks.[47] A common thread, expressed in different forms in these literary representations of the trading post, foregrounds primitivism against a background of impure and impending modernity.

As early as 1902, Earle Forrest, a traveler through the Four Corners area, lamented the passing of the Old West and thrilled to find a remnant of the past in a trading post. "We had arrived at Meadows Trading Post. Standing with a group of Indians in front were three white men, a woman, and several children, all watching us curiously. I was excited by the scene, feeling that I had found an authentic remnant of the Old West. I had, indeed."[48] Forrest was thrilled to be in this land where he perceived that time had no value and life was free and easy. About his stay at Meadows, Forrest continued,

> The next day I settled down to life at a primitive trading post in the heart of old Navaholand [sic], where life had not changed much in the past forty years and the Old West still survived. The Indians lived just as they had for generations. This was still their country, for the white man could find no use for desert land so far from civilization and the railroad. There was nothing he wanted there, so he allowed the Navahos to live in peace. They were content and seldom wandered away.[49]

Forrest was enticed by the otherness and "outsidedness" of this place as compared to early twentieth century American "civilization." The longing for places and persons apart from industrialized society is evident in Forrest's words and as we shall see, carries through in the literature on trading posts today. I must say that this is only somewhat different from my own first encounter with a trading post.

The economic metaphors in Forrest's account are full of irony. Time had no value, but what was the significance of time to a Euro-American anxious to capture and freeze American Indians in a moment? Life was free but for American Indians, it was at the cost of subordination to a dominant Euro-American society. Forrest acknowledged that this was still the Indians' country only because white society had seen no use for it. And Navajos appeared to have the freedom to live according to their traditions only as long as they stayed in this place. A further irony: Forrest wrote these words about the sanctity of the place at a time when Native children were being relocated to boarding schools far from their homes with the express purpose of teaching them to discard their traditions, languages, and families. At the same time Forrest applauded Native

existence he lamented its passing. This was both the prevailing popular sentiment and scientific theory of the time.

Trading posts have been characterized as lonely, distant, and isolated by many writers over the past one hundred years. Of course, a trading life would be lonely to one who did not consider the Navajos to be people. One trader's wife, Mary Jeannette Kennedy, conveyed the loneliness in an account of her life. She spoke only of her few and infrequent relationships with other white people. In contrast, Hubbell's life is never characterized as lonely or isolated. Rather, he built lifelong national and local networks of friends and business relationships with people from a wide range of ethnic groups and socioeconomic and cultural backgrounds.

Remoteness, isolation, and disappearance in the face of modernity are themes that still pervade today's representations of trading posts. In two guidebooks and two magazine articles I examined (one interestingly titled "The Vanishing Trading Post"), surviving trading posts are represented as anachronisms, or as a rare and disappearing breed. The same images are ascribed to the posts' patrons earlier in this century. To read the description of the Borrego Pass Trading Post is to step back in time.

> It remains a fixture in its small community, and it does a surprisingly brisk business in auto parts, used furniture, clothes, housewares, toys, even wedding and prom dresses—the kinds of goods most other trading posts unloaded years ago. . . . For those who remember how rich life was at the posts, and for those few who continue the trading way of life, the thought that it might all pass someday soon is saddening.[50]

As with the people and objects before them, trading posts are now fetishized as some of the last authentic contacts with the Old West. They are marketed to curious tourists who might venture in search of the Old West. The writers ask that we overlook the racks of rental videos and other trappings of contemporary life in favor of the old benches and crumbling walls.

But, according to the guidebooks, what kind of place is a trading post in the late twentieth century? "Trading post—the word conjures up images of well-stocked walls, beautiful rugs, redrock canyons and

remote locations far from city life . . . [that] will give you an unparalleled experience of a vanishing way of life."[51]

Indeed, the guidebooks insist on some version of authenticity before listing a business as a trading post. Coyote Canyon Trading Post, for example, is not included in current trading post guidebooks though its location is accessible to tourists. A criterion for authenticity seems to be that the business owner is descended from a trading family or, at least, a family that reproduces the Navajo–Anglo characterization of trading relationships. Guidebooks feature Gallup establishments such as Richardson's Trading Company and Ellis Tanner Trading Post, yet they omit the long-established Gilbert Ortega's Trading Company and others now owned and operated by families from the Middle East.

In contrast with the Navajos, who are content for trading posts to develop in whatever direction their communities need, Euro-Americans seem to insist that trading posts remain part of that timeless land of which Forrest wrote. For many Euro-Americans, if the posts do not resist modernity, they lose their characterization, history, and significance.

CHAPTER THREE

THE CREATION OF A USABLE PAST

Between the 1880s and 1920s, profound changes occurred throughout the United States. By the 1880s a network of railroads crossed the country, enabling many Americans to travel. Industrialization and the development of such inventions as the telephone dramatically changed Americans' lives. Americans, of course, both accommodated and resisted change. For the Southwest and Native arts, resistance took significant form as the anti-modernist Arts and Crafts movement. Several reservation traders like Cotton, Hubbell, and Moore, who were looking for markets for Native arts, plus the Hyde Exploring Expedition, a New York–based company that funded trader Richard Wetherill and his brothers to excavate archaeological sites, were aware of the movement's sentiments, and some even sympathized. These sympathizers, bolstered by such writers as Charles Lummis and George Wharton James, tried to capitalize on the movement by developing markets among educated Victorian Euro-Americans for Navajo rugs and other Native products.

Mail-order catalogs were the means by which traders created and developed markets for handmade Native products. Many traders had their own catalogs, including Cotton, Hubbell, and Moore. Another popular journal called *The Papoose* was published from 1902 to 1903 by the New York-based Hyde Exploring Expedition. Each enterprise created particular images of the American Southwest, Native people, and their products. These loaded images appealed to Euro-American ideas about the authenticity of production, referencing labor, materials, time, nature, and the sacred. One contrast to this method of marketing was the

Pendleton trade blanket catalog. Pendleton used a marketing strategy that emphasized end-use rather than production. They authenticated their commercially manufactured, Euro-American-designed textiles as originating from a rapidly disappearing "primitive" Native world, emphasizing that the products were highly desirable and utilitarian for the "civilized" home. A look at other catalogs reveals that by the 1920s, these trader marketing strategies solidified around themes of non-Christian sacredness. Thus began a contest of quality and knowledge still apparent in today's rug market.

Victorian Crisis and the Stable Self

Between 1880 and 1920 educated Euro-Americans struggled to adapt to enormous changes in society that redefined their self-conceptions with terms that became increasingly individualistic. Such changes were fundamentally related to ongoing socio-cultural and economic transformations.[1] The resulting anxiety was not simply a reflection of a conflict between capital and labor. Rather, many Americans perceived socio-economic changes as threats to their individual autonomy, their values, and their families. The centers of economic power were shifting from small entrepreneurial organizations to large corporate and bureaucratic institutions. Corporate capitalism's pursuit of greater profits demanded further labor specialization; consequently, a particular individual's economic success was no longer primarily determined by his own labor pursued as a family business, craft, or trade. Success, and even the opportunity to work, increasingly depended upon the actions and decisions of others. Victorian Americans assumed the stability of a self as a vision or entity that was in many ways constructed in opposition to someone different. Many other societies, Navajo included, view the self not only as a process, but as an unstable process dependent upon maintaining ever-changing relations with others.[2]

A number of educated upper- and middle-class Americans viewed this loss of autonomy as the result of their "over-civilized" modern existence and placed the blame on their industrial capitalist society.[3] But the anti-modernist sentiments of the 1880s to 1920s were not a general reaction. They reflected the class and power positions of an educated, wealthy to moderately comfortable, northern bourgeoisie. The movement

was composed primarily of professionals, such as lawyers, politicians, journalists, ministers, and academics—intellectual leaders who helped shape and maintain dominant American values. It was much later that their ideas were marketed to a broad audience and manifested themselves in particular class formations.

Many Victorian Americans perceived vast and increasing injustices in distributions of wealth and power, and they attributed stratification to American society's overall moral and spiritual decay. They sought altruistic ways to resist "progress" and the stiflingly comfortable Victorian lifestyle they felt was achieved at the expense of so-called real experience. These anti-modernists believed that moral and spiritual revival lay within the pursuit of individual therapeutic experience. Some promoted a return to what they thought of as a lost martial vigor. Some, concerned about lost spirituality, either returned to existing religious organizations or sought answers in occult mysticism. Others developed an interest in psychology. This renewal of interest in varied and alternative types of spirituality brings to mind the rise in popularity of New Age thought and spiritualism near the end of the twentieth century—a trend of alternative healing and a quest for spirituality largely on the part of educated, affluent Euro-Americans.

The anti-modernist movement affected traders and Navajo weavers as well, mostly by the aestheticization of the life of the "primitive craftsman." Americans perceived the craftsman's existence as tragic, difficult, natural, and therefore "real" in ways the lives of comfortable Victorian Americans were not. In a sense, the difficult life was understood as one in which individuals had greater control over their circumstances. Though a few anti-modernists dropped out of industry to pursue the life of the craftsperson, most chose other avenues, including the consumption of the so-called primitive craftsperson's products. By consuming and aestheticizing "primitive" objects, they attempted to create for themselves a real, natural experience.[4] One irony, of course, is that "doing-by-consuming" reinforced the transition to a consumer society, not only by accommodating these consumers to the precise corporate capitalist conditions they resisted (as T. J. Jackson Lears argued), but also by distinguishing their elite status in an increasingly stratified society.

Creating Authentic Value

Meanwhile, a distinct but related crisis had occurred in the southwestern United States. The U.S. government's 1860s internment of Navajo people at Hweeldí had caused economic devastation. Navajo people suffered from the loss of their land base and herds of sheep and became dependent on government-issued food and commercial goods. They were also forced to forge important trade relationships outside of their indigenous and Spanish circles. These factors combined to seriously undermine Navajo demand for their own products; at the same time, reliance on commercial materials such as cotton string warp and non-colorfast aniline dyes compromised the formerly very fine quality of these products.[5]

Within these local and national spheres of circulation, several Navajo reservation trading enterprises began marketing Navajo products through mail-order catalogs and journals that promoted the idea of an Indian Room in every tastefully decorated Victorian home. American Indian products were promoted as material registers of tourist travel, esoteric knowledge, and exotic experience. Thanks to a new mass cultural form—the mail-order catalog—those who did not travel could purchase exotic experience from the safety of their comfortable homes. Between 1896 and 1911, Navajo reservation traders C. N. Cotton, J. L. Hubbell, and J. B. Moore produced elaborate catalogs marketing the products of Navajo and Hopi people. Mail-order catalogs featuring American Indian and other ethnic products flourished between 1896 and 1920. I will concentrate on only a few that featured goods from the American Southwest.

Each catalog represented trader motivations as altruistic concern for "their" Navajo clientele. This was a classic anti-modernist sentiment, ironically and conveniently channeled into successful capitalist enterprise. The notion that art and craft production was culturally appropriate labor that "will afford means of livelihood for the Indians in the transition period from savagery to civilization" conveniently supported traders' pursuits of profit.[6] Each trader took the position that what was good for business was good for Navajos as well. Each expressed this view in his own words.

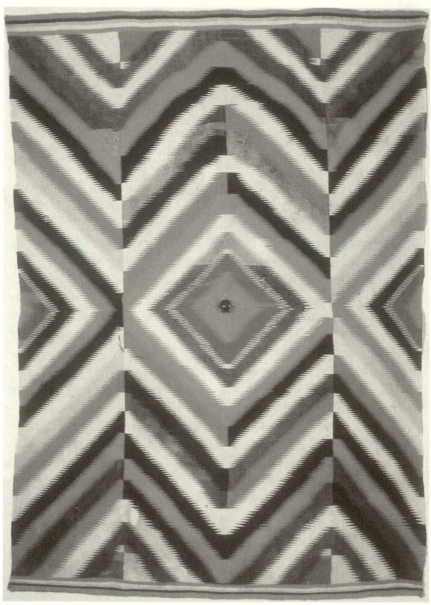

FIGURE 4. A Germantown Eyedazzler rug exemplifying materials and styles woven from the 1870s until around 1900. Courtesy of the University of Colorado Museum of Natural History, UCM #39337.

Cotton:

> It has been over a quarter of a century since the writer first com-
> menced to trade with the Navajo Indians. . . . At that time the
> Navajos were very poor and only had sheep, pelts, goat skins and
> wool to sell. . . . I decided the only way these people could prosper,
> and the traders as well, was to encourage the making of blankets
> in a commercial way, which I proceeded to do, and by hard and
> consistent effort, I was enabled to sell all I could procure.[7]

Hubbell:

> The first duty of an Indian trader, in my belief, is to look after the
> material welfare of his neighbors; to advise them to produce that
> which their natural inclinations and talent best adapts them; to
> treat them honestly and insist upon getting the same treatment
> from them . . . to find a market for their production of same, and
> advise them which commands the best price. This does not mean
> that the trader should forget that he is to see that he makes a fair
> profit for himself, for whatever would injure him would naturally
> injure those with whom he comes in contact.[8]

Moore:

> Beginning some fifteen years back as an Indian trader in a rather
> small way, I have labored unceasingly with and among these
> Navajo weavers. . . . Not the least satisfaction in what has been
> accomplished, is the greatly increased prosperity and better con-
> ditions of life that has come to the people among whom I live and
> work, as their earning power has grown.[9]

And the Hyde Exploring Expedition, through its publication *The Papoose*,
was more emphatic about its combination of altruism and marketing:

> *The Papoose* makes its advent without fear and offers no apology
> for its existence. There was no longer felt want to be filled, but lots
> of room for anything so worthy an object as the revival and per-
> petuation of arts and crafts rapidly dying for lack of appreciation.
> Aside from the artistic comes the practical side of its mission. The
> Indian of today needs all the champions that can enter the field.[10]

As we shall see, most catalogs did not merely feature objects, brief descriptions, and price lists. Often they included photographs of American Indian producers, primarily women, and lengthy narratives that established the authority of the trader and the authenticity of the products. Through the catalogs, each trader marketed the idea of an artistic sense that would transform weavers' products from "hideous" items for Native use to tasteful curiosities for the Victorian home. Some traders promoted the idea of an Indian Room as a home decorating theme. They also promoted their experience and knowledge as evidence that a primitive item was actually a valuable art or craft object. Thus the consumer who is not able to travel among the red men can still seemingly experience their culture through purchasing products. This self-proclaimed altruism seemingly helped advance previously "savage" people through culturally appropriate labor—an important aim of the anti-modernists. Traders also called attention to categories such as materials, originality, age, scarcity, and a primitive sacredness of the items to authenticate their products (see figures 6, 7, 8).

Each trader tended to emphasize one particular aspect in their marketing strategy. Cotton emphasized the authenticity of "natural" materials, while Hubbell tried to revive garment designs from an earlier time. Moore evidently recognized the significance to anti-modern consumers of connecting to Native spirituality. And the Hyde Exploring Expedition commissioned articles by anthropologists, such as George Pepper of the American Museum of Natural History, whose scientific authority validated their products and collecting as a hobby.

C. N. Cotton and the "Authentic" Materials

In 1896, C. N. Cotton issued a mail-order catalog advertising the Gallup, New Mexico, wholesale house he had established in 1895 while transitioning out of his daily operations at Hubbell Trading Post. Cotton represented his new business as located "in the heart of the Navajo Reservation" and cited "over a quarter of a century" of trading experience that enabled him to buy direct and offer the lowest possible prices.[11] Of the traders whose catalogs I examine in this chapter, Cotton was by far the most interested in business and profit. Cotton's letters stored in the Hubbell Trading Post archive reflect his preoccupation with business

concerns, whereas Hubbell's correspondence exhibits broader concerns with Navajo life.[12] Though he spent eleven years from 1884 to 1895 as the principal and sometimes sole owner of the Hubbell Trading Post at Ganado and certainly must have conducted business with a large Navajo clientele, Cotton's only interest was in sales of goods for profit. In contrast to accounts of Hubbell's business practices, which teem with anecdotes of his social interactions with the Navajos in the Ganado area, the few stories of Cotton's experience revolve around his concern about theft and being armed with necessary weapons. In an 1889 report, Indian Agent William Vandever described Cotton's trading practice of dealing only in cash, offering no credit, and accepting no pawn.

> Nothing but cash is paid Indians for what they have to sell, and Indians pay cash for what they purchase. No credit is given. No silver bridles, belt buckles, or buttons or any other articles are taken on pawn. Price lists in English are properly posted but none in Navajo. Liquor of no kind is kept or sold. No breech loading arms, fixed ammunition or metallic cartridges are dealt in. No annuity goods are ever bought or sold. Mr. Cotton or his clerk are [sic] in no way interested in any herds of sheep, goats, cattle or horses grazing on the reservation. This store is never open on Sundays. Gambling by dice, cards or in any other manner not allowed.[13]

Though these practices were praised by the agent for their potential assimilating and "civilizing" effects on the Navajos, they also show Cotton's lack of knowledge or interest in working within the indigenous value system or economy.

Unlike Cotton's post, many trading posts were open for business, or would open their doors to customers, any day of the week and during the evenings. Hubbell was known for welcoming customers in the evenings, feeding them canned tomatoes with sugar and bread, feeding and watering their horses, directing them to guest hogans, and suggesting that they rest before conducting their transactions the next day. Hubbell in particular recognized that games and social activities drew a large Navajo clientele to his post, resulting in increased business and good will.

Cotton's priorities and interests probably led him to move to the off-reservation town of Gallup and focus on wholesale transactions with other traders and off-reservation businesses. From Gallup, Cotton could

deal primarily with other traders and suppliers, which he did begin-
ning in 1895. Further reflecting his preferences, Cotton's catalog illustrates
fewer of the new design forms that permeated both Hubbell's and
Moore's activities. This may indicate his lack of interest in or success at
working directly with the weavers themselves.

While Cotton's preferences indicated his support for assimilation of
Navajos to Euro-American ways, he nevertheless realized the potential
for profiting from American perceptions of "primitive" Navajo lifeways.
Although each trader employed several strategies in appealing to Victo-
rian American longings for authentic, natural, or primitive products,
Cotton marketed the "natural" qualities of the persons, tools, processes,
and materials involved in Navajo blanket production. His catalog, written
by anti-modernist author George Wharton James, clearly illustrates the
modernist distinction between natural producers and cultured consumers
by supplying information that would enable "discerning housewives"
to make better educated purchasing decisions.

> The Navajo [weaver] is a natural artist, and, in addition to putting
> into her blankets religious and tribal symbols emblematic of faith,
> custom, or tradition, frequently weaves into the fabric the story of
> her own life replete with all its joys and sorrows, trusting to some
> mystic power to translate its message to its future possessor. And
> the finished result is a gem of barbaric weaving that to many
> would appear almost hideous were it not for the perfect blending
> of colors.[14]

Cotton marketed the idealized Navajo weaver as a savage person of
"unrestrained freedom" whose designs teemed with the influences of
the natural environment of which she was such an integral part.

> To the checked emblem of the rainbow she adds sweeping rays
> of color typifying sunbeams; below the many-angled cloud group
> she inserts random pencil lines of rain; or she softens the rigid
> meander signifying lightning with graceful interlacing and
> shaded tints.[15]

Cotton's catalog represented Navajo weavers as persons taught by nature
rather than persons possessing an inherent artistic nature. And, clearly,

this representation was consistent with anti-modernist consumers' aestheticization of the tragic, difficult, natural, and real life that they sought through consumption. Though there is no evidence suggesting that Cotton understood the relational qualities that likely existed between weavers and their products, he clearly strategized to sell a particular idea of natural producers across boundaries to cultured consumers.

Cotton reinforced the idea of a natural Navajo artist by emphasizing the simplicity of the weavers' tools and materials. He used industrial terminology to distinguish between the supposed simplicity of natural labor and technological sophistication.

> No loom could be more simple than hers, —two upright poles, across the top of which a third pole is fastened, with a fourth one as a cross-beam at the bottom. . . . With her different 'shuttles', of yarn she squats on the ground . . . the shuttle is a simple piece of stick. . . . And thus every thread is 'battened down' with such vim and energy that one does not wonder to find the blanket when finished capable of turning the heaviest rains.[16]

From Cotton's industrialized perspective, a weft yarn is moved across the width of warp not with a true shuttle but with a "simple piece of stick." Weft yarns are battened down with the natural strength of human labor rather than machine. Cotton used these qualities to represent Navajo blankets as truly natural products: produced using simple tools, ancient processes, and natural materials still "woven in all their primitive and barbaric splendor and woven in the same way they were countless years ago."[17] He emphasized the handmade quality of Navajo blankets as products of human labor "untouched by a machine." He classified blankets on an evolutionary continuum from "crude" to "more finished" to "others done with such art that they are worthy of comparison with the finest offerings of the Orient." Cotton helped set standards of quality that have evolved to a point where many of today's weavers recognize that a rug needs to look "machine-made."

According to Cotton, nature also provided the weaver with superior color choices of black, white, gray, and brown "shorn directly from the backs of sheep with wool of these colors."[18] This phrase is ironic given that Cotton often marketed the bright and varied color combinations

found in contemporary textiles woven of aniline-dyed commercial yarns. Cotton also emphasized the ancient nature and evolution of Navajo weavers' skills from "the simple arts of making primitive yucca and grass sleeping mats."[19] Cotton represented weavers' work spinning and weaving wool as a natural evolutionary process. The following passage accompanied a photograph of two Navajo women standing outside a mud and brush hogan with adjacent brush shelter, offering the consumer visual evidence of weavings' natural origins and weavers' connection to the land: "The Navajo is a great lover of seclusion . . . simple and primitive, it [the hogan] offers no attraction at first sight but novelty."[20]

As mentioned, Cotton had used the same marketing strategy to enhance the value of blankets woven of Germantown commercial wool yarn. The preference for natural materials evident in the 1896 catalog was apparently a new marketing strategy for the dealer. During the 1880s, when he alternately managed and owned the Hubbell Trading Post at Ganado, Cotton thought commercial materials, particularly aniline dyes, were a way to speed up weavers' production. He "succeeded in having one of the great dye manufacturers put up, ready for use, a quantity of aniline dyes" and, at least according to James, taught the weavers how to use the new dyes.[21] By the time he published his 1896 catalog, Cotton was disparaging commercial materials such as cotton string warp. He promoted Germantown commercial yarn's resemblance to the fineness of weave and waterproofing ability of the old and rare handspun churro and raveled wool Navajo blankets (see figure 4).

Though James stated that Cotton worked closely with weavers to encourage the use of the new dyes and the development of designs, Cotton's alleged close association with Navajo weavers is not reflected in either his correspondence or in his 1896 catalog. It is more likely that James used this strategy to establish Cotton's authenticity as a trader and that it was Hubbell who, behind the scenes, actually worked most closely with the weavers in design development. Hubbell opposed the use of aniline dyes and commercial materials, perhaps convincing Cotton of the superiority of natural materials by the time the 1896 catalog was produced. Hubbell's marketing strategy was to promote textiles that most closely resembled those old and rare pieces woven in the mid-nineteenth century.

J. L. Hubbell and the Authenticity of the Past

Hubbell established the authenticity of Navajo blankets by emphasizing their age, scarcity, and original use as garments. He issued his first and only catalog and price list in 1902, six years after Cotton's first catalog and one year before Moore's first catalog. H. G. Maratta, a graphic artist from Chicago, produced the small brochure in 1902, and it was printed before Hubbell actually saw the final proof.[22] Like Cotton and Moore, Hubbell asserted his authority to mediate transformations of primitive artifacts to works of art. He positioned himself in opposition to unscrupulous dealers who took advantage of eastern customers' lack of knowledge about southwestern Native products. Hubbell stressed the extensive knowledge required for collecting quality products and cited his "long residence and my extended references in this country as guaranty of my sincerity and honesty."[23] To further demonstrate his contact with a world he represents as distant and little known, Hubbell's catalog cover featured a photograph of a Navajo woman weaving at a very wide (approximately six to seven feet) outdoor loom and surrounded by three young children.

Inside the small catalog *Navajo Blankets and Indian Curios* customers found a wider selection of items produced by American Indians than in the catalogs of either Cotton or Moore. Photographs and text both demonstrate Hubbell's preference for old and rare objects. "The old blankets are passing away in the nature of things."[24] Though he had marketed Navajo garments for Euro-Americans' use as rugs, portieres, and throws for nearly twenty years, his catalog did not emphasize these functions. With the exception of portieres, all illustrated items were either made for use by Navajo, Hopi, or Pima people or they were, interestingly, reproductions. This is particularly evident in the case of Navajo textiles. Both Cotton and, to a greater extent, Moore promoted changes in the blankets themselves, such as heavier weights, that would make them suitable for use as rugs and to meet other Euro-American decorating needs. Hubbell's approach suggests that the original unaltered garment form often functioned in these other ways. He did, however, encourage weavers to produce their traditional garment styles in large sizes in order to make them useful as floor coverings.

Hubbell's catalog illustrations featured "old style" Navajo blankets accompanied by text that emphasized age and scarcity. He stressed that all consumers could own these rare designs through the magic of reproduction. Hubbell classified blankets as old style, *hanoolchaadi* [*sic*], or chief's blanket, Native wool and common coarse Native wool blankets, portieres, genuine old bayeta Native wool dresses, and old style women's blankets. Old style weaves were available in a variety of patterns, including the red grounds and terraced designs typical of Classic Period Navajo blankets and the old style blue and black stripes known as "Moki" patterns. These patterns ranged in size from a relatively small 2¾-by-3¾-foot priced at $9.00 to $12.50, to a quite large 9-by-12-foot that sold for $150.00. Within size categories, prices varied according to the fineness of weave, a standard of quality that, as we shall see, continues to be important.

Hubbell described the blankets he called *Hanoolchaadi* as being the very oldest pattern known. The name he adopted is a variation of the Navajo term *hanoolchaad*, which is more accurately translated as "carded wool." These old-style blankets were also available in a range of sizes. A 4-by-5-foot black-and-white banded pattern (now classified as men's blankets) was priced at $17.50 to $25.00, and 5½-by-6-foot blankets sold for $25.00 to $35.00. Gray-and-black-striped hanoolchaadi (now classified as women's blanket patterns) were offered in sizes ranging from 4-by-5 feet ($17.50 to $25.00) to 9-by-12 feet ($125.00).[25] Hubbell also offered the *biil*, or genuine old bayeta Native wool dresses, which were fine compact weaves composed of elaborate patterns, advertised as very rare and old. These were offered in a more limited range of sizes, suggesting that they may have been woven primarily for use as garments and not adapted for Euro-American consumers. Prices ranged from $25.00 to $50.00 for genuine old bayeta blankets, while prices for other biil ranged from $17.50 to $35.00 each.

Hubbell also offered three additional categories of Navajo textiles: Native wool blankets, small looms with partially finished blankets, and portieres. Native wool Navajo blankets were priced by the pound rather than the piece, with prices ranging from $0.75 to $2.50 per pound. Decorative small looms were available for $0.75 each, allowing customers a souvenir of the technology that Cotton represented as ancient, simple, and natural. But such obviously inauthentic items as portieres, which were clearly made for Euro-American homes, could not be sold on the

basis of age or Native use. Therefore Hubbell emphasized the scarcity of the items, which resulted from difficulties inherent in production. They were

> made only by the best weavers, of whom there are but few living with skill to make two blankets nearly alike. In bright and old style colors and patterns, size about 5 x 12. Price varies according to fineness of weave . . . per pair . . . $200.00 to $300.00[26]

The argument that few weavers could or would produce two blankets alike is probably somewhat true. However, it is also interesting in view of the fact that the biil produced by most weavers during Hubbell's time were two-piece dresses consisting of two "blankets" or panels woven alike and sewn together.

Having established the value of the older products, Hubbell marketed newer textiles as reproductions of the old blankets for those who could not afford to acquire the originals. Exact reproductions of the old blankets, should such a copy have been possible to obtain with any regularity, were apparently not viewed by Hubbell as inappropriate or inauthentic.

> The next thing to possessing a genuine old blanket is owning one made exactly on the pattern of such blankets. The old things are passing away, in the nature of things. I can supply genuine reproductions of the old weaves. What I tell you regarding these goods will be the truth, and you will in all cases find the prices based properly on the value of the goods themselves, with no misrepresentations, no shams, and no counterfeits.[27]

While Hubbell marketed age and scarcity and Cotton marketed primitive labor and natural products, their competitor, J. B. Moore at Crystal Trading Post in New Mexico, had other ideas.

John B. Moore Commodified the Sacred

J. B. Moore issued his first catalog in 1903 after having owned at least a half interest in the Crystal Trading Post since 1896. As Moore began collaborating with Navajo weavers right away, there may be little coincidence between the timing of Cotton's first catalog, Hubbell's development

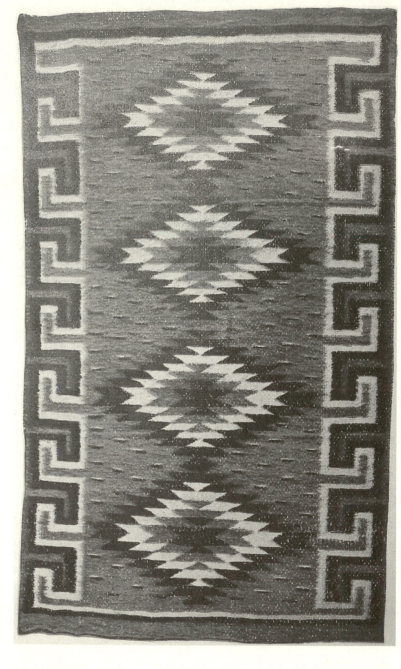

FIGURE 5. A J. B. Moore rug featured in the 1906 *Pioneer* magazine. It is a good example of the late-nineteenth- and early-twentieth-century rugs woven of handspun wool that had been dyed with aniline dyes. Photograph by Milan Sklenar, 2004.

of the blanket paintings at Ganado, and Moore's recognition of oppor-
tunity in trading in Navajo-made crafts at Crystal.[28] While Moore did
not directly acknowledge competitors in his catalogs, he nevertheless
attempted to base his authority and credibility as a trader and expert
on his living on the reservation.

> While this booklet makes no claim of being a pioneer in its field, I
> think it may justly claim to be the first of its kind published and
> distributed from the very center of the Navajo Indian Reservation,
> by an Indian Trader living among and dealing directly with the
> Indians who make the goods which it illustrates and describes.[29]

Moore also offered visual proof of his presence in Navajo country.
His catalog featured photographs of the land around the Crystal Trading
Post, interior and exterior views of the trading post, outdoor looms,
hogans, and Navajo people. Moore was well aware of anti-modernist
sentiments. He advertised in a publication of the Roycrofters, devoted
to those involved with the American Arts and Crafts movement.[30]

To appeal to Victorian Americans' desire for primitive functional objects,
Moore employed several strategies. He emphasized the natural origins
of the materials and the use of primitive technologies; when these cate-
gories were questionable, he emphasized the sacred nature of primitive
products and stressed that sacredness resulted in a scarcity of the products
for the Euro-American consumer market. He later adopted a value-
producing strategy consistent with anti-modernist philosophy and con-
cerns about culturally appropriate labor. Unlike Cotton, who operated
his business in capitalist fashion with little interaction with weavers, or
Hubbell, who adjusted his ways of doing business to fit many Navajo
values, Moore imposed changes in production on many of the weavers
whose work he purchased. He broke the process into stages in which
he apportioned materials to certain women for spinning and others for
weaving.[31] In this sense Moore began ushering weavers into if not a
moneyed economy, at least a more capitalist mode of production.

By the time Moore published his first catalog in 1903, Navajo weavers
had been using commercially manufactured, synthetic-dyed German-
town wool yarns in combination with handspun, natural-colored yarns
for nearly four decades.[32] In addition, traders encouraged the use of

particular designs and colors. Moore even went so far as to impose standards that included using synthetic dyes and design motifs from Oriental carpets. Of course, these commercial wools, synthetic dyes, and "outside" designs would not have been accepted by collectors as either natural or authentic. Nevertheless, Moore stressed the "natural" quality of all materials and emphasized "primitive" technology, labor intensive process, and simplicity of design. Like Cotton and Hubbell, Moore also emphasized the authenticity of natural materials and designs. However, unlike Cotton and Hubbell, Moore actively encouraged the use of aniline dyes and Middle Eastern designs not previously used in Navajo weaving.[33] Though Moore promoted synthetic dyed yarns primarily produced by his wife, Marion (who was not Navajo), he criticized commercial wool yarn as "not a true Navajo article."[34]

When the commercial source of materials was evident, Moore sometimes situated authenticity in the realm of the spiritual and cited scarcity as a reason the objects might be highly collectable. This is particularly evident in the case of sash belts woven of Germantown commercial wool and described in his 1903 catalog as "wound round and round the waist. . . . Much ceremonial significance attaches to them, and they are not readily secured. Are really pretty, and very appropriate for the Indian den or corner."[35] By the time Moore issued his catalogue there were approximately four variations on the chief patterns, as later described by Joe Ben Wheat. Moore described the "old" chief patterns as being "originally a strictly ceremonial one, and even yet, is woven with reluctance by most weavers."[36] Chief blankets had a long history of exchange between Navajos and other Native people, and Hubbell had attempted to "revive" the patterns because he believed they were popular among Native users and Euro-American collectors.[37]

Between the publication of his 1903 and 1911 catalogs, Moore produced seven color plates of rugs, one of which he called a sand-painting style that, he said, exemplified the imagery created in sand during some Navajo ceremonies. In fact, this plate does not illustrate a Navajo sand-painting—it prominently features the swastika motif not found in earlier Navajo weaving but in Oriental carpets, a design that some Navajos still remember Hubbell encouraging weavers to use. Like Hubbell, Moore stated that he marketed reproductions of old patterns, though the evidence does not quite support this assertion. And in fact, the 1911

catalog features designs that clearly resemble Oriental rugs of the period. Moore's catalogs reflect very little of Classic Period Navajo textiles.

Moore stands apart from other traders in his reorganization of the production process and subsequent marketing of what he called his highest grade of products. He assumed sole credit for the development of a quality Navajo product.

> Beginning some fifteen years back as an Indian trader in a rather small way, I have labored unceasingly with and among these Navajo weavers, inducing them to weave better, finer, cleaner, and handsomer rugs on one hand; and just as persistently on the other, to convince the buying public of the real worth and better value of this better product. . . . In light of past experience, I doubt if I would enter again on the proposition if set back to the time of the beginning. . . . It has not been easy. In the beginning I had stubborn and conservative workers in these Navajo women, and a discredited product to contend with on one hand; and on the other, a prejudice and lack of knowledge that has proved harder to break down and overcome than I had anticipated.[38]

According to Moore, the weavers were stubborn and the potential customers were not enlightened. But his efforts resulted in an improved product and a steady market.

If we look further into Moore's activities, we can see why he did not advertise to a public concerned with authenticity the precise ways he accomplished this improved product. Moore attempted to create a new type of artist for whom labor was separated from the rest of daily activities. Under Moore's system, he parceled out different stages in the production process to different individuals, and he alone maintained control of materials and design development. However, his efforts were less a system of mass production and more a change in a way of life.

In a 1911 report to Indian Agent F. H. Abbott on the production and sale of textiles and silverwork, Moore again asserted that Navajo textiles were of poor market quality and offered a lengthy description of his work with weavers. Moore sent wool away to be cleaned and scoured after having been shorn. He then appointed Navajo women whom he recognized as expert spinners to spin the clean wool into yarn. His wife, Marian Moore, then dyed the wool yarns with aniline dyes.[39] "It

is then dyed under proper conditions where good soft water can be had and with the best dyes obtainable."[40] Only then was the yarn given to one of a group of about sixteen weavers who worked for him.

Because of this compartmentalization, the rugs he marketed as the highest grade were, in fact, produced by a number of different individuals, including his wife. It is difficult to know how weavers and the local community felt about this fragmentation of the weaving process. Of course, weavers were engaged in the serious business of earning a living, so there were obvious advantages to accommodating the trader's requests. However, given the relational qualities of weavers, the process, and their products, fragmentation of the process must have been a major change. The process of production was removed from the context of home and family and compartmentalized in a way that required many people to work with non-relatives' products, which had been quite uncommon before. That the changes had profound cultural implications is suggested by issues about copying another's work, which I will discuss in the next chapter. We can only wonder about the local understandings of and relationships to those rugs that were truly hybrid products of many unrelated peoples' labors.

In addition to creating a new type of weaving process, Moore attempted to create a new type of weaver. He has been credited as the first to publicly name individual weavers and publish their photographs in his catalogs, promoting them as individual artists.[41] Existing literature refers to this practice as a sign of Moore's respect for the weavers, and indeed that may in part be the case. It is likely that Moore thought the names and photographs of individual weavers would authenticate his proximity to the Navajos, as did the photographs of the Crystal Trading Post landscape and hogans. Once again, we can only speculate on how this practice was received in the Crystal community. There might have been tensions and conflict for those individuals singled out for success. Some Navajo people today object to the practice of using both names and photographs. We might suggest that these concerns were at least equally powerful earlier in the twentieth century and in a community less accustomed to photography and interactions with Euro-Americans.

As an important aside, traders have been credited with developing rug styles that later became associated with regional trading posts.[42] It is generally assumed that styles developed in the area surrounding the

post and that Navajos did not travel extensively to trade until they began acquiring motorized vehicles. These accounts overlook the family development of rug styles, and they underestimate the extent to which early twentieth century Navajo weavers might have traveled to exchange their rugs. Traders did not necessarily monopolize individual weavers, though they often attempted to do so through credit, tin money, and other strategies. Weavers sold their work, often over long distances, to several different traders at least as early as 1908 and likely before. Little documentation of this practice exists but a particularly interesting example is a letter from Moore's wife, who wrote to Hubbell on August 13, 1908.

> He [J. B. Moore] also says that if you should at any time wish to talk over the matter of selling blankets in a retail way with us that we will be very glad to see you at any time when the Psychological [sic] hour arrives, or perhaps if all goes well, and you are agreeable, he would go over to Ganado and see you. We are now buying blankets right and left from our next door neighbors as well as yours, and -um-er-well- you see we do not think we are doing the wisest thing possible for ourselves and we have the gall to consider ourselves next best to you in the blanket business.[43]

This is very interesting in view of the fact that Hubbell's and Moore's early influences on design and style are widely discussed as two mutually exclusive turns in the aesthetic development of Navajo weaving. There was probably far more commonality among trader preferences than previously assumed, and more acknowledgement must be given to the individual weavers for exercising their aesthetic preferences as well. In fact, Navajo weaver D. Y. Begay explained the historic interaction this way: "Weavers studied the designs that were foreign to their eyes and then elaborated on them, a process that inspired creative exploration and self-expression."[44] I will elaborate on this process of aesthetic interaction in the next chapter.

The Hyde Exploring Expedition: Southwest Trade, Northeast Aesthetic, and Anthropology

Museums, anthropology, and the market for artifacts from people commonly thought of as "indigenous" or "non-Western" have long been

intertwined. A particularly salient early example of this relationship is
The Papoose. The journal was produced during the culmination of a
ten-year relationship between Hyde Exploring Expedition founders
Talbot Hyde and Fred Hyde, Jr., and trader Richard Wetherill. The
Hyde brothers of New York—wealthy young heirs to the Babbitt Soap
Company fortune—first met Wetherill during an 1893 tour of the Anasazi
ruins in the Mesa Verde, Colorado, region. Later that year they renewed
their acquaintance at the Chicago World's Fair and in addition, the
Hyde brothers then began financing Wetherill's excavations of south-
western archaeological sites, including Chaco Canyon.[45] The Hyde brothers
wanted scientific validation of their explorations, so they hired George
Pepper, then a Harvard anthropology student who later worked for the
American Museum of Natural History, to supervise the excavations.
They also arranged for artifacts from the excavations to be housed by
the American Museum of Natural History. Between 1898 and 1903, the
Hyde brothers also financed several trading posts, most of them estab-
lished in the San Juan area of New Mexico. Richard Wetherill operated
the post at Chaco Canyon, and others were established in Thoreau,
"Tiz-na-tzin," Ojo Alamo, Largo, Raton Springs, Farmington, and a post
on the Escavada Wash. Trade must have been aggressive. These posts
served as vehicles through which large quantities of American Indian
products were transferred to the Hydes in New York. They were then
sold through a store opened in 1899 on West 23rd Street in Manhattan.
In 1898, Wetherill wrote to Talbot Hyde that "all the blankets in the
region come to us,"[46] and in 1899 there were local rumors that Wetherill
paid high prices for all the Navajo blankets he could purchase. By 1899,
Wetherill was concerned about authenticity and adopted standards
promoted by Cotton, Hubbell, and, probably, Pepper. He rejected
blankets using commercial materials like aniline dyes, cotton string
warp, and Germantown commercial wool yarn.[47] No doubt, the Hyde
brothers needed a vehicle like a mail order catalog through which to
market these goods and promote them nationally. And, because of their
interest in scientific validation, a journal like *The Papoose* was an ideal
format from which to promote collecting of artifacts as a popular mass-
cultural activity.

Like the marketing efforts by other traders discussed in this chapter,
The Papoose offered "all matters of interest to Indian educators and

collectors of Indian works of art."[48] The journal's position statement, authored by editor Thomas F. Barnes in the inaugural January 1902 issue, reveals the complex relationship between the commercialization of American Indian products, anthropological evolutionary theory, government policy toward American Indians, and liberal anti-modernist sentiments.

> *The Papoose* makes its advent without fear and offers no apology for its existence. There was no longer felt want [*sic*] to be filled, but lots of room for anything so worthy an object as the revival and perpetuation of arts and crafts rapidly dying for lack of appreciation. Aside from the artistic comes the practical side of its mission. The Indian of today needs all the champions that can enter the field. . . . Let it not be taken that *The Papoose* is to be the redressor of all the wrongs that have been done the Indian in the past, but rather to assist in warding off future injustice. . . . Small wonder a race of people so oppressed and robbed should cease to think of art and allow their wonderful handiwork to die out. Uncivilized is the word we almost universally hear applied to the Indian. Good men and women, misguided, perhaps, but good in a moral sense, go among the Indians and cultivate souls but forget corn. Now corn and the soul go hand in hand, always allowing corn the first place. *The Papoose* desires to see, first: Justice done to the Indian in regard to reservations. Second: Encouragement in the branches of the nearly forgotten arts of his tribe. Third: Education of the children at home on the reservations, within reaching distance of the parents. Fourth: A course of training for both young and old in practical living, farming, fruit and stock raising . . . the responsibility is ours to make some strong effort to undo the wrong our people have done. . . . We spend large sums annually for oriental rugs and hangings, not knowing, or perhaps not caring to know, of the wonderful product of the industrious Navajo at our very doors. . . . As a race we are looking constantly for new sensation. Turn toward the Indian, study his history, look into his condition and in the betterment of that condition find sensation upon sensation. . . . *The Papoose* hopes to grow and become lusty and strong in what it sincerely believes to be a field of useful labor.[49]

The statement illustrates a process whereby *The Papoose*'s authors transformed the image of both people and products from primitive savage to aestheticized object. In so doing, they reinforced the identity of Euro-American consumers as cultured and refined. There is nothing in this literature to suggest that Euro-Americans had an understanding of the relationship of Navajos and other American Indian people to their land. However, despite its altruistic leanings, *The Papoose*'s language reinforced the government's policy of removal of Native people from their lands. The idea of the dying savage was used to rationalize land control and object collection. In 1902, government policy concerning American Indians centered around their removal from indigenous lands and assimilation into Euro-American society. Bolstered by an evolutionary theory that posited a lower position for primitive savages, both the government and numerous altruists (such as missionaries, educators, and collectors) appointed themselves the mission of eradicating the savage Native. As we see with *The Papoose*, the dying savage was next transformed into an aestheticized object through the idea of culturally appropriate labor in the form of arts and crafts production. And, finally, aestheticizing the American Indian fulfilled the anti-modernists' longing for sensation, experience, and refinement.

At this point, I should emphasize that despite the critical perspective we now have on the anti-modernists' agendas, *The Papoose* writers (and, perhaps, readers) were more enlightened than most Americans, who thought American Indian people were a dead people. At least those involved with *The Papoose* knew American Indians were living persons in need of a new economic foundation because their traditional economies had been devastated by loss of their land bases. However, the methods that the writers advocated reinforced the idea that Native people, while not actually dead, lived in a time that was frozen, original, and different. For the Navajos, *The Papoose* advocated a kind of labor system consistent with capitalism yet tailored to the "primitive" lifestyle the anti-modernists revered.

> Steady employment should be given to them, yet not such as would make them feel that they must labor from sun-up to sun-down, without stopping; they should be given a certain amount to do, in a certain number of days or weeks, and let them take their own appointed time for the work; doing much at one time and less or nothing at all when they feel like it; in so doing they are living out the plan of their ancestry.[50]

Whereas the capitalist system regulated labor times to ensure Euro-American workers time for consumption,[51] *The Papoose* did not concern itself with this option for American Indians. Instead, the idea of Native labor was offered as an educational, entertaining, or aesthetic image. Ironically, it bolstered the identities of Euro-American consumers and reinforced their distance from primitive production at the very time when anti-modernists sought to reconnect with the primitive.

Like the catalogs offered by Cotton, Hubbell, and Moore, *The Papoose* promoted Navajo blankets as the pure products of primitive labor, untainted by Euro-American materials and technology. George Pepper was the most vehement of the group in denouncing impure materials in a 1903 article published by the journal. He described aniline dyes as "contaminating wool" and producing "hideous colors" from "fat envelopes."[52] He applied the metaphor of a disease to the inauthentic materials that swept across Navajo land,

> breeding contagion wherever they went, and, like leprous discolorations they have marred the face of one of nature's children. . . . Our eyes are looking into the eternal yesterday where the distant horizon once glowed with the colors that we love.[53]

There was a contradiction inherent in Pepper's reasoning. While he argued that so-called primitive lifeways were naturally selecting in favor of the civilized, he viewed the technologies produced by civilization as disease with the potential to destroy a pure and natural aesthetic.

The Victorian Home and American Indian Arts

By the end of the nineteenth century, Victorian Americans had come to imagine the home not only as a source of identity, but also as a family's haven from the heartless world of capitalism. A glance at such magazines as *Godey's Ladies Book* or lithographs by Courier and Ives confirms this image. Home was a sign of material comfort and opulence, a shelter in which women nurtured children and men sought respite from their busy world of work. In fact, it was during the Victorian era that the American concept of "work" became radically separated from "home," reinforcing an American perception of productive working males and nonproductive, but morally innocent, women and children.[54] As these concepts shifted and took on various shades of meaning, Victorian Americans

were encouraged to express their longings for natural experience in the home. While some Victorian Americans traveled, many were not able to leave their homes to find the intense experience they sought, and so they instead imagined a kind of spirituality that accompanied a difficult life as they constructed their "natural" lives through home decoration.

To promote this desire, *The Papoose* and other magazines prominently featured a Victorian home-decorating phenomenon called the "Indian Room." The Indian Room practice reveals a particular kind of desire by Euro-Americans for nature, exoticism, authority, and status in the newly developing industrial society. It offered consumption and collecting as a means for satisfying that desire.

It is difficult to trace the beginning of the Indian Room decorating phenomenon. So-called private collectors began traveling and assembling collections in the 1870s, so the decorating phenomenon probably developed as a result.[55] By 1903, *The Papoose* was offering Mr. Joseph Keppler's Indian Room as an ideal type to which middle class Americans might aspire.

> Joseph Keppler lives with an enchanting view of the noble Hudson River. If you are fortunate enough to be counted among his friends, you may visit his home. . . . Quaint old colonial furniture, solid and substantial monuments to the building of ancestors long since dead and gone, rare paintings and old china, works of art gathered in lands across the sea meet the eye on every side, but in a room, especially planned and constructed by Mr. Keppler, in a gable overlooking the sloping lawn, is placed the collection that is the subject of this article. In this room, surrounded by an almost priceless collection of Indian works of art, is where he studies and works and entertains his friends. Mr. Keppler began some years ago to collect materials for this room and although but little experienced in such matters, his artistic nature chose objects that appealed to that nature. Each article had to him some meaning . . . he dug deep into aboriginal lore and when books failed him he went among the red men and studied their myths and mysteries. . . . To him their rites and ceremonies are sacred. They breathe not of Paganism but of brotherly love and constancy.[56]

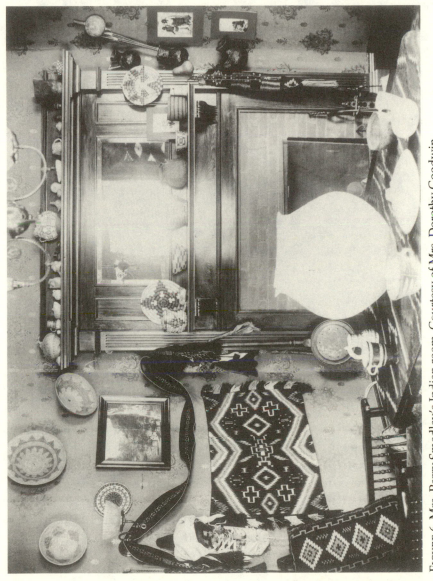

FIGURE 6. Mrs. Perry Smedley's Indian room. Courtesy of Mrs. Dorothy Goodwin.

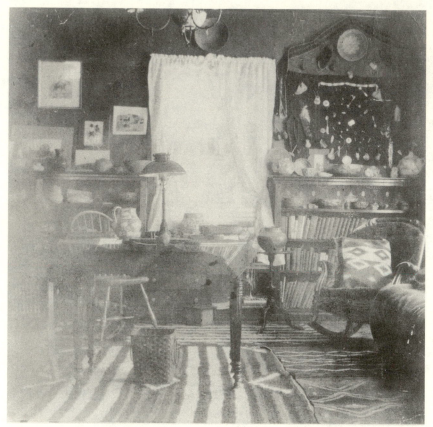

Figure 7. Mrs. Perry Smedley's Indian room. Courtesy of Mrs. Dorothy Goodwin.

The journal accorded Keppler's Indian Room all the authority of one who has "been there," recounting his advocacy work on behalf of the Seneca Nation of Iroquois and his membership in a Seneca clan. What he could not learn from books he learned by spending time with the Indians, relying on his essential artistic nature to amass and tastefully display an ideal collection. Keppler's artistic nature mediated the transformation from primitive use to modern aesthetic.

> Beautifully beaded moccasins, pipe bags, papoose carriers, leggins, sheaths for the hunting knife and hundreds of smaller articles are artistically grouped for the best effect. On the south wall hang over a hundred masks used in Iroquois ceremonials and dances,

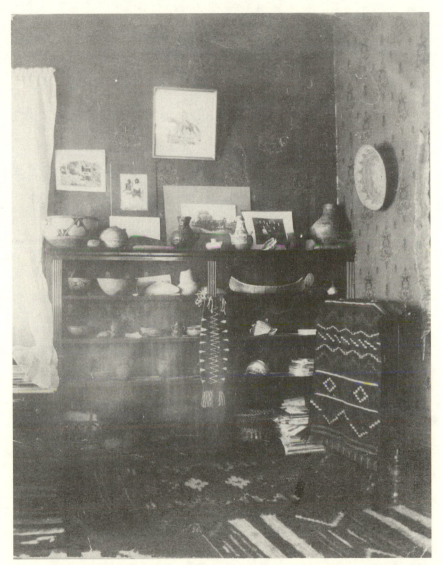

FIGURE 8. Mrs. Perry Smedley's Indian room. Courtesy of Mrs. Dorothy Goodwin.

all carved from solid wood and each of a different design and
meaning. Hideous? Yes, at first glance, but as your host explains
their meaning and use an interest is awakened that overshadows
all other feeling.[57]

Interestingly, *The Papoose* empowered Keppler with an essential artistic nature, while American Indian producers were represented as "a people taught by nature to use nature's own forms and materials."[58]

The article was accompanied by a half-page advertisement that read "An Indian Corner In Your Home Adds To The Artistic Effect." The Indian Room provides a rich picture of the American cultural concerns to which traders appealed and illustrates that trader activities and Victorian collection-display practices both developed and flourished in an inextricable dialogue with contemporary anthropological concepts of culture. Baskets, blankets, masks, medicine paraphernalia, and other artifacts were used to decorate Victorian homes.[59]

To the anti-modernists, Keppler's essential nature, scholarship, and authority were fundamental to the transformation of these objects. Though the image of Keppler's unbridled pursuit was anti-modern, it reinforced modernity through a collective vision that was elite, white, and male. Keppler's story is also a representation of the process of modernist construction of cultural difference. Keppler was the individual consumer of collective products; the cultured scholar who understood their natural ways of life; and his knowledge mediated the transformation of crude objects for use into tasteful displays. As we examine the ways middle class Euro-Americans acquired objects for their Indian Rooms, we shall see that the construction and maintenance of these categories was a messier process.

Acquiring An Indian Room

The Indian Room was marketed to Euro-Americans as a way of satisfying their desires for stasis and comfort in the midst of traumatic societal change. Journal articles presented "Indian Decorations in the Home" as a therapeutic practice. Whereas Pepper used a disease metaphor to describe inauthentic materials, *The Papoose* employed a similar metaphor, though in a different tone, to promote the overall act of consumption, collecting, and display. It was

> a microbe or some such thing that cannot be put off at will, but grows and gathers strength with each attack of the malady. Indian decoration has come to stay. Not the cozy corner of papier mache

heads and hideous burned leather hides making a nightmare of what should have been an artistic nook in the home, but a well selected collection. . . . Can you estimate the interest centered in such a corner to the seeker after information? . . .[60]

The anti-modernist "disease" that plagued *The Papoose* readership apparently progressed in ideal capitalist fashion, always accumulating, never diminishing. Journals represented consumption and aestheticization, informed by the scientifically validated pursuit of knowledge, as the only cure. While the Indian Room represented personal acts of resistance to corporate capitalism and socio-economic stratification, its practice—consumption and accumulation—ironically reinforced both class distinction and capitalist domination.

The enterprises that marketed American Indian products promoted an idea of the American Indian as natural producer of authentic products. But that image could also be used to promote a product that was factory-produced.

Pendleton Woolen Mills, Industrial Production, and the Commodification of Use

Pendleton Woolen Mills manufactured wool blankets using the most up-to-date industrial machinery—the Jacquard loom—and featuring Native-inspired designs developed by Euro-American graduates of the Philadelphia Textile School. To establish an American Indian authenticity for these products, Pendleton represented them as "true Indian patterns" and emphasized their use by Native people in their more primitive, natural contexts.[61]

The Pendleton mill was one of many established in eastern Oregon in 1895 as a wool-scouring plant and initially transported fleece from the northwestern U.S. to eastern markets. In 1909, a Bishop family that also included textile school graduates purchased the mill. They reduced the wool scouring operation and expanded blanket production, marketing aggressively to Native and Euro-American customers nationwide. Pendleton's self-described venture was the manufacture and marketing of blankets to American Indians, and their 1915 catalog boasted that Pendleton robes were widely traded on Indian reservations. The first

named designer of the blankets was Joe Rounsley, a graduate of the Philadelphia Textile School.

Despite the rather ambiguous relationship of Pendleton designs to American Indian designs, the catalog represented its products as true or typical of different tribes. However, the illustrations featuring people using the blankets reveal Pendleton's own version of an authenticating project.

The catalog's frontispiece features an illustration of Cayuse Nation Chief Umapine in traditional dress—which does not include a Pendleton robe—sitting straight and tall. His gaze appears unfixed but distant. He is the picture of the noble savage, the American Indian of a dim past. While this illustration fixes the American Indian male as a figure frozen in the past, Native women are images of a natural and sexual identity that would never have been appropriately ascribed to Euro-American Victorian women. Consider three other illustrations from the catalog. The first features a Euro-American woman dressed in a high-collared white blouse and long dark skirt, seated on a Pendleton robe draped across a daybed, engrossed in reading a book, and surrounded by the fine trappings of a Victorian den. The picture is an American version of taste, refinement, and affluence. On the next page is an illustration of an unidentified American Indian woman in traditional dress, breast-feeding a baby, with a Pendleton robe draped around her. The third is an illustration of an American Indian woman. Captioned "Sacajawea 'The Bird Woman,'" it shows a young woman wearing gold neck chains, a gold bracelet, headband with feather and, apparently, no garments other than a Pendleton robe loosely draped over one shoulder and wrapped around her body. These contrasting images of females using Pendleton robes reinforce the modernist distinctions between primitive and civilized: it juxtaposes the natural sexuality of the Native with the knowledge-pursuing Euro-American. Pendleton further created an authentic, primitive, original context for its robes, which can then be transformed into aesthetic objects. This further accommodated anti-modernist consumers to the aesthetic and collectible value of the items produced by the corporate organizations they resisted.

The Roots of Value Production

As we have now seen, during the early twentieth century, traders and scholars imposed strict standards of quality in their process of authenticating

the products of Navajo weavers' looms. They disparaged weavers' use of commercially available aniline dyes, commercial wool yarn, and cotton string warp. In addition, some traders like Hubbell and Moore exercised their own ideas about what constituted an authentic Navajo aesthetic and worked to impose aesthetic standardization. They demanded such high quality that, in the words of one weaver, "it has to look machine-made."[62] Yet these same traders and scholars emphasized the singularity of each blanket, its primitive origins, and its hand-made charm.

The efforts some traders made to impose their standards of quality were apparently well received by Euro-American consumers. As we shall see, Navajo weavers responded to traders' efforts in highly creative and also contested ways. Weavers understood traders' suggestions from within the perspective of their own needs and cultural values. They accommodated some suggestions, rejected others, and insisted in many cases on the primacy of their own creative expression—all the while knowing that the balance of power rested with the traders. Even so, traders were sometimes frustrated that their requests were not simply accommodated. Thus the process and end product of Navajo weavers' work was and is continually negotiated. Interactions between weavers and traders resulted in ever-changing senses of style, standards, and self-identities. Styles that likely had their origins in families of weavers who learned and borrowed from one another were given names such as Ganado, Crystal, Chinle, Wide Ruins, and Two Grey Hills. These patterns were identified to the national market as originating with the trader and trading post in those communities. Weaver and trader relationships resulted in standards of market quality that reinforced technical skills such as near-perfect straight sides and ends, uniformly twisted spun wool, and greater standardization and uniformity of color. Interestingly, these intercultural trade relationships resulted in both weavers and traders beginning to understand hybrid economies. Weavers came to see how a cooperative economy could accommodate a capitalist economy, and traders learned how a capitalist economy could in turn accommodate a cooperative economy. Thus, cultural identity shifts occurred among all involved.

"We Wove the Design We Wanted"

Visitors entering the "rug room" at the Hubbell Trading Post are immediately confronted with the diverse mixture of colors, textures, and patterns that characterize contemporary Navajo textiles. Bold designs in deep reds, blues, and grays are intermingled with intricate patternings rendered in soft vegetal hues of yellow, gold, rose, green, and lavender. On a wall above stacks of rugs hang rows of small oil and watercolor paintings depicting old Navajo textiles of another sort (see color plate 7).

Between 1897 and 1907 Hubbell commissioned the paintings, then asked weavers to copy the designs. He then sold the resulting products as authentic Navajo textiles. Three points must be considered to fully appreciate the ramifications of Hubbell's actions. First, both the paintings and the resulting textiles were hybrid products that reflected the preferences of the trader, the painters, and Navajo weavers. Second, Hubbell and Navajo weavers had vastly different cultural understandings of the idea of authenticity and both employed those ideas as a type of power and self-identity in their negotiations. Third, the relationship between copying and a Navajo concept of the ways persons and selves are constituted in relation to weaving also comes to bear when a weaver is asked to copy patterns.

The small paintings Hubbell commissioned between 1897 and 1907 encode the multiple meanings and agendas that drove a period of intercultural exchange among Navajo weavers, reservation traders, and Euro-American artists and consumers. A number of authors have discussed the production of these paintings as an attempt by Hubbell to

revive the old patterns through encouraging weavers to copy the designs.[1] However, these authors neither analyzed the trader's actions nor adequately situated his practices within national or local contexts. It is essential to examine the actions and interactions of Hubbell, artists E. A. Burbank and Bertha Little, and Navajo weavers who may have copied or adapted the renderings into their own products during the period in which Hubbell had them produced, as well as those weavers who do so today.

Hubbell was engaged in an exploration and construction of cultural difference. Though analysts have discussed the ways these paintings were produced, little attention has been paid to why and how Hubbell imagined he could shape the direction of Navajo weaving, why he thought copying existing textiles was a means to this end, and whether it was even possible to attain the desired pure image through copying. "Copying" designs, as it happens, is a very complex endeavor. Copying another weaver's work is, and was then, often a risky activity in which cultural understandings of creation, personhood, and individual autonomy are carefully negotiated. In addition, the ways that weavers negotiated the copying process have not been addressed in any literature.

Hubbell was motivated by his desire for a successful trading enterprise and his awareness of the American anti-modernist trend in consumption. Most of the paintings he commissioned reproduced those mid-nineteenth-century Navajo textiles that he deemed the best, most authentic, original, cultural products. The resulting paintings are a body of hybrid work that exemplify not only elements of a mid-nineteenth-century Navajo aesthetic but also the Euro-American traders' and artists' ideas about an original authentic Navajo aesthetic. Hubbell employed these images to encourage products that would fulfill the longings of an American consumer market for natural or primitive products and compete in the market for rugs from the Middle East.

Beginning in 1897, the small paintings became a part of a burgeoning body of material that included trader catalogues, books, and articles. These sources composed a discourse of difference as Navajo women's products—alternately genuine, artistic, original, authentic—were admired both in spite of and because of their so-called primitive origins.

Hubbell's collection contains paintings rendered and signed by Elbridge Ayer Burbank, Bertha Little, H. G. Maratta, and Herbert B.

Judy. Correspondence between Hubbell and Little suggests that a Miss Pierson (first name unknown), a Tucson-based friend of Little's, might also have copied blanket patterns, accounting for one or more of the unsigned paintings. Hubbell's sons Lorenzo, Jr., and Roman used the paintings as early as 1912.[2] And, in the 1930s, Roman and Lorenzo, Jr., who were apparently looking to expand the range of the paintings to include designs of Navajo *Yei'ii* figures and traditional Hopi blankets, also commissioned additional paintings from Raymond Pearson and Hopi artist Waldo Mootzka.

The total number of paintings originally produced is not known, but in 1909 Hubbell advised a customer interested in decorating her Indian Room that he had "about one hundred patterns in oil of the different [blankets] made by the indians, [sic] genuine indian designs copied by E. A. Burbank and other artists, simply to perpetuate the same."[3] A 1911 inventory showed 101 paintings at the Ganado post.[4]

In past studies the paintings were classified according to the functions of the original textiles after which they were modeled, such as mantas, chief blankets, moki-patterned serapes, and saddle blankets. Authors like Bauer, Boles, and Rodee added the market category of later "bordered" rugs to emphasize the shift in end use, but more importantly to explain the efflorescence of styles with enclosed borders—styles rarely seen in earlier Navajo textiles. Existing literature features fewer paintings and different foci for their analyses than those I have employed. Boles, for example, focused largely on color combinations, a limitation in the sense that while Hubbell is credited with emphasizing red as a primary color, red in fact has been a dominant color in Navajo textiles since Navajos acquired red trade cloth in early Spanish trade. Boles also examined only seventy-four paintings. Bauer, however, wrote that seventy-seven paintings were housed at Hubbell Trading Post in the 1980s. She also located nine photographs taken by George Pepper in 1994 of paintings whose whereabouts are as yet unknown. Rodee categorized the paintings according to the original textile function. While this classification reveals Hubbell's preference for older garment styles, the focus on the function of the original object does not sufficiently illuminate Hubbell's selection criteria and ultimate influence on Navajo textiles. Copies of actual garments are accounted for, but the emergence of hybrid and new design forms and functions remains unexplained.

I was able to locate eighty-three paintings as well as the nine photographs by George Pepper (see appendix). The paintings most clearly reveal Hubbell's agenda and influence when they are examined in relation to the design elements, layouts, and color combinations typical of the Classic Style Navajo textiles described by Wheat and woven during the mid-nineteenth century. This was the standard against which Hubbell himself evaluated weavers' products. The Classic Period or Style was delineated by Wheat (see color plate 4).

> The period from circa 1800 to the early 1860s is usually known as the Classic Period. . . . The majority of classic sarapes had a ground of crimson. . . . Designs were worked in indigo blue and white. . . . Rarely were other colors used.
>
> The designs consisted of stripes, stepped or terraced triangles, hollow or solid terraced diamonds, or zigzags arranged in rows or zones, so as to compose an overall pattern. Frequently, the field was divided into three or five zones, but the patterns of one zone often merged with, or reflected that of, the next. The end zones often had quarter-diamonds at the corners and one or more half-diamonds in between.[5]

In my study, I classified the paintings according to one of three criteria.

1) Copied Patterns: Those paintings apparently copied from existing Navajo textiles woven during the Classic Period with little or no modification by the artist.

2) Hybrid Patterns: Those paintings that feature design elements suggestive of origins in Classic Navajo textiles but modified, presumably by the artist since these layouts had not been found in earlier textiles.

3) New Patterns: Those paintings in which new forms predominate.

To analyze the uses of the paintings by trader, artists, and weavers, it is first necessary to discuss why Hubbell imagined the need for mediation in the quality of late-nineteenth-century weavers' products.

As we have seen, Hubbell's motivations for marketing Navajo textiles were complex. Hubbell's business experiences of the 1880s demonstrated that wool prices were not stable and could not be easily predicted. Thus, buying and selling wool was not a reliable source of profit. Aside from raw fleece, woven blankets were some of the only products his Navajo customers offered in exchange for their groceries and other goods.

By the 1890s the once-strong indigenous market for Navajo blankets was declining, but the mid-nineteenth-century blankets were being collected by affluent Euro-Americans. Hubbell recognized that a Euro-American market for Navajo textiles would provide a stable, predictable profit source against which to balance the fluctuating wool prices. In addition, the profit realized from the sale of finished products was far greater than the best profit from sale of the raw fleece.[6] Hubbell and his sometime partner Cotton attempted as early as 1887 to market Navajo blankets as rugs to eastern customers.[7]

Starting in the 1880s, Hubbell and other traders tried improving several aspects of the woven textiles. They believed standardization of materials and designs was necessary if they were to successfully compete in a market enthusiastic for Oriental rugs. By the 1880s handspun wool yarns were thicker and greasier than those produced during the 1860s, reflecting the loss and/or degradation of the straight, greaseless churro fleece (see color plate 1). Blankets produced with the greasier merino fleece that was available were thicker, heavier, and unevenly colored due to inconsistent absorption of dyes. During the 1880s, many of the finest blankets were produced from four-ply commercial yarns manufactured in Germantown, Pennsylvania. The yarns were already spun when they reached weavers, and most literature cites this labor-saving convenience as a primary reason weavers used these yarns. Navajo weavers usually tightened the spin of the yarn with their own spindles in an effort to more closely approximate the standard of the fine yarns they previously obtained from churro fleece.[8] However, the Germantown yarns presented traders with authenticity problems because they were commercially manufactured and not Native-spun and naturally colored or naturally dyed (see figure 4).

The color palette available to weavers had dramatically increased since the 1860s. Germantown yarns were available in a wide range of colors, and where blanket designs were once produced in combinations of two, three, or four colors, by the 1870s it was not uncommon to find the so-called "eyedazzling" Germantown blanket designs woven of as many as eight colors. In addition, from about 1885, a wide range of colors became available in the form of packaged aniline dyes.[9] Initially, Hubbell credited the availability of aniline dyes with giving the Navajo weaver "an opportunity, without much expense, to display her taste in

the manufacture of bright-colored blankets without having to purchase the brilliant colors at such a price that only a few could afford to buy and use them."[10] In addition to creating bright, busy color combinations that some traders and consumers later found garish, the aniline dyes were very unstable, and the colors often faded and bled.

In the 1870s, 1880s, and 1890s, Navajo weavers incorporated design elements and layouts that reflected the influences of weavers in Saltillo, Mexico, and the Rio Grande valley. This experimentation came at the expense of the design elements and layouts of the mid-nineteenth-century Navajo blankets and dresses. From the traders' view, Navajo textiles of the 1880s and 1890s were, in the words of anthropology critic James Clifford, "pure products [gone] crazy."[11]

Both the quality and authenticity of materials were important to the traders' process of creating a market among Euro-Americans for ethnic products. And from the vantage point of a century later, we clearly recognize that the loss of churro sheep resulting from the Long Walk and internment at Bosque Redondo, coupled with an increasing availability of commercially manufactured blankets and materials, was a major factor in the change of the quality of late-nineteenth-century weavers' products. But in the late nineteenth and early twentieth centuries, the common opinion was that the traders, though using the best of intentions, were to blame for a decline in quality of the pure products.

> Later the traders who bought the rugs insisted upon the use of purple and yellow which brought about a clash of colors. Then the commercial spirit of the Navajos worked to the disadvantage of their artistry and soon the rugs and blankets lost much of their original beauty of design. I have often seen the traders instructing squaws [sic] how to make blankets, telling them to work more in colors, to use pinks and purples and to leave less "bare space." The beauty of a genuine Navajo blanket is its simplicity of design and harmony of color. Like most children, the Indians are close copyists and their eagerness to give the traders what they want accounts for the loss of artistry in weaving as well as color blending.[12]

Traders supposedly caused the decline through several practices: they encouraged the production of greater quantities in less time; they encouraged the use of inferior materials such as aniline dyes and cotton

warp; and they bought and sold blankets by the pound. James por-
trayed this practice as a "frightful precipice" which might have been
the death of weaving.[13] However interesting a proposition, particularly
from a Marxist perspective, James's account is nevertheless faulty. James
credits Cotton and Hubbell with introducing commercial cotton string
for warp rather than the more flexible handspun wool and with pro-
moting commercial wool yarns to be used as the weft. Wheat's archival
research demonstrates that these materials were given to weavers by
the government at Bosque Redondo and that it continued supplying
them throughout the annuity period of the 1870s.[14] Hubbell took some
responsibility for the decline in quality, but he attributed it to his and
other traders' practice of purchasing blankets by the pound without
regard for texture, design, or artistry.

However, the general discussion over the years concerning quality
decline was contradictory. It credited traders with rescuing the art from
the edge of the precipice. Traders supposedly stopped buying inferior
blankets and attempted to assert their own standards of quality. James
argued that the weavers' "practical business sense" quickly forced an
improvement in quality.[15] Hubbell, while assuming some blame for the
decline, also paternalistically credited himself with creating the condi-
tions for weavers to "return to a display of his [sic] natural taste."[16]
Hubbell represented himself as a knowledgeable trader taking care of
the "primitives," who would, like most children, perform to the best of
their natural abilities if he conducted his project in a responsible way.
As with The Papoose's Indian Room promotion, Euro-Americans were
again ascribed an essential aesthetic sense while Navajos were portrayed
as being taught by nature.

By his own account, Hubbell had been trying to improve the quality
of Navajo textiles since 1884.

> I steadily refused to encourage anything but the very best of weaving
> and the effective [sic] was that for years I have had a good market
> for the blankets woven by my neighboring Indians. At last the
> fact dawned upon almost all the Indian traders that besides being
> a fad of mine it was a paying proposition, and I am glad to say
> that there are quite a number of them who are today working to
> improve the business, as well as to prevail upon the Navajo squaw
> to display her best ability as a weaver and as an artist.[17]

These comments reveal the modernist ideas that drove Hubbell's project. The discourse both obscured the government's role in the decline and reinforced the idea of authenticity being firmly situated in more "primitive" materials and practices. James at least granted weavers some agency, or relative power in their decision-making, but he also portrayed them as indifferent about their work and anxious to produce the least possible for the greatest economic advantage. While there certainly must have been a degree of indifference within the no doubt strange conditions of commoditization of their work, the decline in quality of materials available, not weavers' standards, must still be recognized as the major culprit in the decline of overall quality.

The Origins of the Paintings

The idea of making small blanket paintings probably occurred during an 1897 visit to Ganado by artist Elbridge Ayer Burbank.[18] Burbank was the nephew of Field Museum founder Edward E. Ayer of Chicago, and at his uncle's request he was traveling the Southwest documenting representatives of American Indian "types" via red conte crayon drawings.[19] Both trader and artist shared a preference for the old blanket styles and a concern that they were disappearing. Both probably lamented the quality of contemporary textiles when judged against the standard of the older products and brainstormed about ways the products could be "improved." Burbank expressed the opinion that there was an association between copying and a primitive aesthetic. Hubbell apparently agreed:

> I have been at the greatest pains to perpetuate the old patterns, colors, and weaves, now so rapidly passing out of existence even in the memory of the best weavers. I have even at times unraveled some of the old genuine Navajo blankets to show these modern weavers how the pattern was made. I can guarantee the reproduction of these antique patterns. The next thing to possessing a genuine old blanket is owning one made exactly on the pattern of such blankets. The old blankets are passing away, in the nature of things. I can supply genuine reproductions of the Navajo weaves.[20]

Hubbell may have encouraged weavers to copy from old blankets in his possession. But why depict the blankets in small paintings? Burbank

was eager to earn money from his painting, so he may have eagerly volunteered to render some blanket designs in oil. Also, Hubbell was in the business of selling blankets, not necessarily collecting them, so the renderings would enable him to amass as many different styles as he desired without keeping samples in stock. His selection process then enabled Hubbell to exert a tremendous amount of control over what he believed was the best of a Navajo aesthetic. In addition, my ethnographic research suggests that, despite comments in Hubbell's brochure, weavers might have resisted copying directly from the old blankets. That resistance might not have been as great when using images of the blankets. I will return to this suggestion when I discuss weavers' perspectives on copying the blanket renderings.

In any case, Hubbell's goal was to build a collection of images depicting the best of weaving and use it to preserve or revive the same. But, from Hubbell's point of view, what was the best of the art? The small blanket renderings offer a fuller understanding of some of his criteria. Hubbell was well aware of anti-modernist longings in Euro-American society that, for many upper and middle class Americans, were chan-neled into the consumption of natural, primitive products. Because Hubbell acquired older blankets for collectors at every opportunity, he was aware of their scarcity and collectibility. Given the anti-modernist desires for primitive, natural products and the desires of elite collectors for Classic Navajo textiles, it is plausible that Hubbell would choose to revive those Classic designs that he recognized as most rare and that he believed were purely Navajo in origin.

In taking a closer look at several of the blanket paintings, I will first examine a painting likely to have been copied from an existing textile with little or no modification by the artist E. A. Burbank (see color plate 2). We may reasonably assume it is a near copy of a then-existing Navajo serape, as the layout, design elements, and proportions are identical to those of 1860s or 1870s Navajo Classic Style textiles. Serapes and chief pattern blankets from that era featured horizontal banded layouts with backgrounds of simple stripes, "Moki" patterned blue and brown stripes, or the wider brown, blue, and white stripes characteristic of chief patterns. Design elements included simple crosses, Spider Woman crosses, terraced zigzags, and terraced diamonds. Women's garments of that period, mantas and biil (two-piece dresses), are generally pictured with

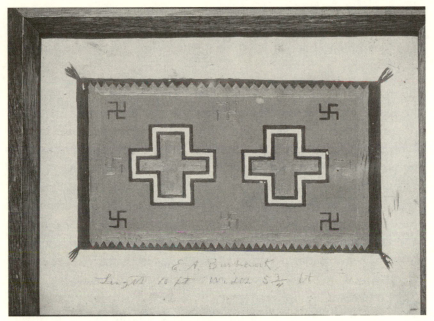

FIGURE 9. E. A. Burbank created this Hybrid style blanket painting as one of the examples J. L. Hubbell commissioned. Photograph by Joe Ben Wheat. Courtesy of the Hubbell Trading Post National Historic Site, HTR 2777.

black or dark blue centers flanked by wide red borders containing rows of diamond or cross elements or zigzag motifs. The painting we are examining and a photograph by George Pepper of a very similar painting apparently are among the more often and most closely copied Hubbell selections. Very close copies of these images were produced in a variety of materials ranging from Germantown commercial wool yarn to raveled wool, handspun wool, and even two versions woven of silk floss.[21] Several of these rugs still exist in museum collections across the country. Apparently some of them were special commissions actually woven at the Hubbell Trading Post. Two silk rugs (see color plate 3) were woven by a Ganado woman who was called ′Asdzą́ą́ Tsé dits′áhí or Gaabidáan bitsi; her English name was Mary Alice Hubbard. According to her son Peter, Mary Alice Hubbard often wove for Hubbell.

That's all she did. She'd weave, carding, spin the wool and make rugs just to get groceries, you know. Groceries was all she wove

for, just to live on, groceries was all . . . she worked right here [in the trading post] [weaving] something more like that up there [gestures to blanket paintings]. My mother made pretty rugs at that time.[22]

The rugs she wove, as described by Hubbard, resembled Classic Style garments patterned of horizontal banded layouts in red, blue, black, and white. The paintings her son pointed out feature the same layouts of terraced zigzags, terraced diamonds, and horizontal stripes in black and white on a red ground.

Though the red ground was a prominent feature of Navajo Classic Style serapes, many blankets featured terraced motifs on a ground of blue-and-brown stripes that the early traders called "Moki" patterned. In addition to the blue-and-brown background stripes, they feature terraced meanders, comb patterns, terraced diamonds, and Spider Woman crosses typical of Navajo basket designs and Classic Style blankets.

The remaining blanket renderings in the copied patterns are also likely to be copies of Navajo garments. Among the renderings are Navajo women's two-piece dresses, mantas, several chief blanket patterns, serapes, and utility blankets. They illustrate Hubbell's preference for the Classic motifs, depicting a woman's manta and a man's chief pattern blanket with terraced figures, crosses, and diamonds on a horizontal banded layout.

Clearly, Hubbell was committed to his revival of the old patterns. However, many of the "pure" forms apparently were not popular with Euro-American customers. The Fred Harvey Company, a major retailer and customer of Hubbell's insisted they could not sell rugs patterned after mantas or biil at any price.[23] Perhaps this lack of enthusiasm for the garment designs led Hubbell and the artists to experiment with motifs.

The hybrid patterns featured in paintings I examined in the 1990s contain design motifs that suggest the Classic Style garments but have been modified, presumably by the Euro-American artists who executed them. Instead of displaying the usual horizontal banded layouts with small elements such as crosses and diamonds, this second group of paintings illustrates textiles in a vertical layout (see color plate 5). Design elements are often exploded in size and feature two major focal

areas, similar to Middle Eastern layouts. Whereas an original Classic Style garment might have featured a red-ground terraced border with horizontal bands of six or eight small crosses, the paintings of this group tend to feature two large motifs (such as crosses nearly filling the design field), perhaps flanked by smaller motifs, within a vertical design layout. In a further departure from the Classic Style, these paintings often feature designs enclosed by single, double, or even triple borders. Figure 9 illustrates Burbank's rendering of two large crosses surrounded by eight swastikas on a red ground, all enclosed by a serrate zigzag double border of blue and black. The swastika was a motif adapted from Middle Eastern carpets and popularized in Navajo rugs by Moore around 1903 and 1904. Clearly, Hubbell also favored the swastika since several paintings feature the motif. In addition, the weavers remember his preference for the swastika motif.

Artist Bertha Little painted several of the hybrid patterns, suggesting that she had a preference for the old motifs in new layouts or that she came into the project later. Each painting has its roots in Classic Style designs. Motifs such as simple crosses and Spider Woman crosses, terraced diamonds, meanders, and horizontal stripes appear in vertical layouts suggestive of either Saltillo, Mexico, layouts or Middle Eastern carpet designs. In a particularly interesting modification, the blue-and-brown Moki stripes of the Classic Style garments give way to alternating red-and-black background stripes (see color plate 5).

While Hubbell and the painters increasingly modified Classic Style patterns, they also produced new forms. In a drastic departure from Classic Style designs, Burbank produced a design clearly rooted in Middle Eastern carpet patterns. Two large concentric diamond motifs are flanked at each end by a latch-hook figure with adjacent zigzag motifs and enclosed by a black zigzag border. In this pattern, though, Burbank retained the Classic Style red ground. As both Hubbell and Burbank were very concerned with the authenticity of so-called "primitive" products, this design was an interesting detour. Intermingling Navajo and Eastern aesthetics reveals that Euro-Americans viewed the category of "others" as incredibly homogenous.

Another Burbank painting featured black-and-gray stacked triangles reminiscent of Transitional Period (1880–1900) Navajo blankets on a

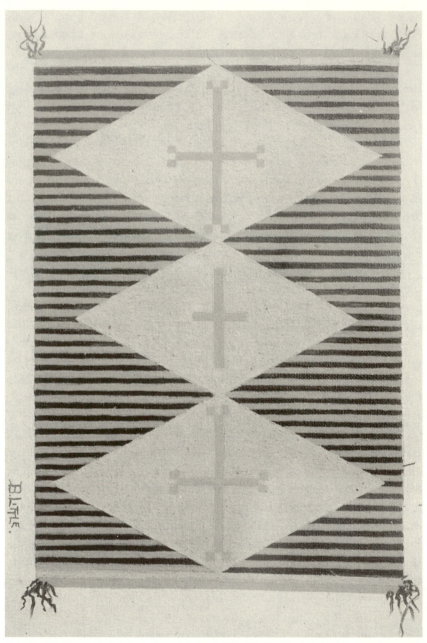

Figure 10. Bertha Little created this Hybrid style blanket painting as one of the examples J. L. Hubbell commissioned. Photograph by Joe Ben Wheat. Courtesy of the Hubbell Trading Post National Historic Site, HTR 2779.

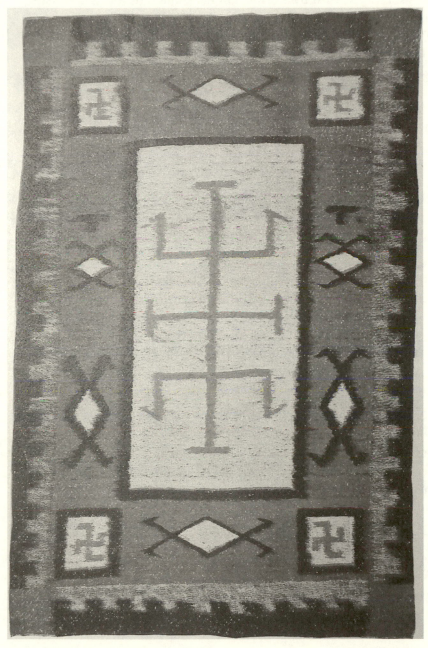

FIGURE 11. A J. B. Moore rug from the 1906 *Pioneer* magazine, an example of the new aesthetic forms that Moore encouraged and promoted.

white ground enclosed by a black border. Though he did not explain his reasoning, Hubbell marketed these black, white, and gray designs particularly for kitchens and bathrooms.

Therefore, a process that began as a way of preserving or marketing reproductions of original, "primitive" weavings quickly evolved into the production of new weaving designs to be marketed as authentic products. Hubbell then began trying to convince Navajo weavers to copy his designs.[24]

Navajo Weavers—Creating and Copying

Hubbell's Euro-American painters often exercised their own (or Hubbell's) ideas in their renderings. The few existing published accounts of weavers' use of these paintings would erroneously have us believe they did not exercise the same power in their aesthetic.

> At Ganado, Arizona, Mr. Hubbell, an Indian trader, collected patterns of the finest Navajo rugs and blankets. He had them painted in oil and watercolors and urged the women to make blankets in patterns indicated by the paintings. I have watched them studying the patterns and colors and there, with their hands, measuring off the size they would be. After which a squaw [sic] would produce a blanket exactly like the picture in color and design.[25]

The scenario that Burbank described was probably not typical. Even in examples that appear to be close copies, weavers made small changes in the overall scheme. And, more often than not, their rugs show a relationship to the paintings without being close copies at all (see color plate 6). Oral accounts, ethnographic information, and rugs produced during this period show that these design directions were not one-way transactions from Hubbell to the weavers. It is essential to consider Navajo weavers' impressions of, and participation in, the copying process. I will attempt to elucidate weavers' viewpoints by drawing upon data collected during ethnographic field study and oral history interviews, and by examining rugs produced during this time period that show a relationship to the paintings. My findings challenge the assumption that weavers readily and simply copied the blanket renderings.

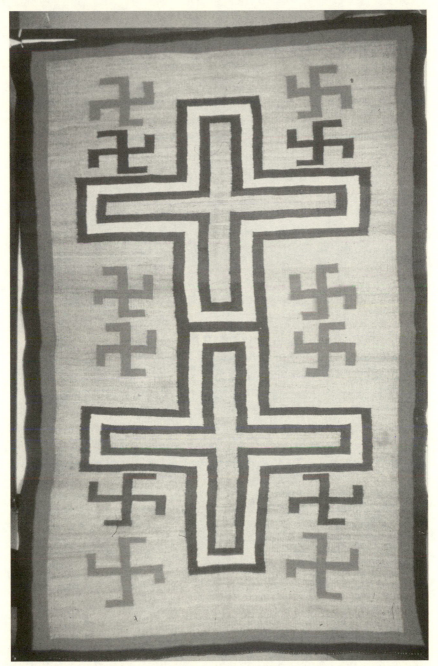

FIGURE 12. A 1920s Ganado style rug. Photograph by Joe Ben Wheat. Courtesy of the University of Colorado Museum, UCM 23508.

Like the catalogues some traders published, Hubbell and Burbank's anti-modernist copying experiments were situated in response to Euro-American capitalism, industrialization, rapid change, and a propensity to reproduce multiple copies of an object for mass marketing and consumption. While capitalism and industrialization fostered the development of a self-interested individual, Navajo self-interest was intricately situated in relation to family, land, and personal relationships. The cultural distinctions between trader and weaver created a field where ideas about autonomy and self-interest and their effects on design development were potentially fraught with conflict, and complex meanings and values were negotiated.

Although recent theoretical approaches to the study of personhood,[26] and the Navajo person in particular,[27] illuminate the relationships among Navajo humans and other forms of life, these relationships have also been well documented in oral traditions since the late nineteenth century.[28] Stories of First Man's actions constitute cosmological authentication of the relationships among all Navajo life.

The concepts of accommodation and resistance form the backbone of the general Navajo response to the outside world, including Euro-American traders.[29] Textiles from the period in question do suggest that in many cases weavers accommodated Hubbell's preferences. Like the silk blanket pictured in color plate 3, many rugs produced during this time closely resemble the small rug paintings, and Hubbell's correspondence indicates that the red, white, black, and gray colors prevalent in many of the rugs of the period were his own preference. However, some weavers apparently resisted these design influences:

> They pass out the papers [blanket paintings] and say you weave one like this. Your grandmother that passed away, she never did ever copy one. She didn't want the paper. She used to say "I'll weave my own pattern."[30]

Several weavers spoke of weaving for Hubbell, but others emphasized that they did not weave "for" Hubbell; rather, they traded rugs to him.

More often than not, though, weavers' responses fell somewhere between accepting the trader's suggestions and rejecting them entirely. Many rugs of the period, while not close copies, did feature design motifs and layouts similar to the paintings and not previously common to

Navajo textiles. For example, figure 12 features the two large crosses in a vertical orientation introduced by Hubbell (see also color plate 6). Unlike the paintings, though, the rugs feature grounds of natural brown-and-white wool with some red motifs.

Though weavers were concerned with the serious business of earning a livelihood by making a marketable product, they also asserted their own ideas about weaving. As they accommodated the traders—to an extent—their responses called for accommodation on the trader's part as well. However, the conceptual rhetoric of accommodation and resistance does not account for the full range of weavers' responses. While an accommodation and resistance framework explains some aspects of the negotiation between trader and weavers, the framework does not account for the inalienable qualities of weavers' products in the sense that weavers' products are alive and related to their producers, nor does it address the implications of inalienability for the copying process.

In a way, the weavers' actions mirror those of the trader and artists. Though Hubbell and Burbank were pivotal agents in the creation of a larger national discourse on creating difference between the so-called primitive and modern, the activities of the very Navajo weavers they objectified constituted a creative process of self-making. For many Navajo weavers their textiles are persons, embodying the "feelings" of their producers as well as those of users.[31] So when Hubbell suggested they copy the designs, weavers had to negotiate complex cultural understandings of personhood and agency. First, accommodating the trader's suggestions through copying both challenged weavers' autonomy over their own creative process and put them in potential conflict with the personhood of their looms. In addition, copying rugs subjected weavers to the perhaps physically and spiritually risky situation of appropriating parts of another weaver's self by appropriating her work. To illuminate this complex interaction, it is necessary to discuss the process by which weavers and looms create life and reproduce themselves through weaving. The subject is further illuminated by examining one early-twentieth-century weaver's understanding of the complexity of copying paintings for the trader. This then brings us the interaction of the Navajo creative process with trader agenda.

In the Navajo view of the world, everything has the capacity for life and is directed and controlled by the power of thought. Thought is an

action that gives life to ideas.[32] The central nature of this process for Navajo people is not limited to weaving but related to a sense of creative process that is central to Navajo philosophy. This process of autonomous creation is commonly described as *baa ntséskees*, "their thinking."

The process of creation intersects with a Navajo belief in individual autonomy. Authors often discuss a ubiquitous Navajo response to their probing questions—"It's up to you." Indeed, in my own field study, I quickly learned the futility of asking one individual's opinion about someone else's thoughts, opinions, or actions, including my own. When I sought advice about the appropriate way to act in a given situation, I was told, "It's up to you." Sometimes the reply was accompanied by a story about how someone had acted in a different situation—a way of giving advice that preserved my own right to make up my mind. Individual right over possessions and action is balanced by a need for consensus among individuals and an ideology of cooperation based on the interrelationship of life in the Navajo universe. Therefore, for Navajo people— unlike Euro-Americans Hubbell and Burbank—difference and complementarity are naturalized in various forms assumed during the process of life rather than in fixed categories.

The story of First Man delineates the creative process and contains two points central to an analysis of weavers' responses to the copying process. In the same way that First Man originally created possessions, livestock, ways of making a living, ideas, and plans through the action of his thinking, Navajo weavers bring life to their products.[33] This is why Navajo designs are usually left open in some way. "Your design is your thinking so you don't border that up. It's your home and all that you have. And so, if you close that up you close everything up, even your thinking and your work."[34]

Thinking is both a process or action, and a possession—knowledge— that can be bought and sold. Thinking is the powerful process through which all Navajo life is brought into being. While First Man's creative process is represented as autonomous, the creative process undertaken by weavers takes place in a web of relationships with other human and non-human lives. Weavers negotiate their individual autonomy against the impact on others. Thus, there is great potential for conflict and contradiction in the copying process.

All Navajo life—whether human, plant, animal, land, or object—is composed of five primary elements: moisture, air, substance, heat, and vibration.[35] Navajo persons are given life that is sustained by and per-petuated through their connections to the Mother Earth and the Father Sky. Navajo weavers' looms were given life, including all of these neces-sary elements, in a process of creation and exchange among Spider Woman and Navajo weavers.

> Spider Woman instructed the Navajo women how to weave on a loom which Spider Man told them how to make. The crosspoles were made of sky and earth cords, the warp sticks of sunrays, the healds of rock crystal and sheet lightning. The batten was a sun halo, white shell made the comb. There were four spindles: one a stick of zigzag lightning with a whorl of cannel coal [jet]; one a stick of flash lightning with a whorl of turquoise; a third had a stick of sheet lightning with a whorl of abalone; a rain streamer formed the stick of the fourth, and its whorl was white shell.[36]

Many weavers articulate this sense of life when discussing their work.[37] The loom, tools, and materials are powerful persons who, along with weavers' prayers, songs, and actions—their thinking—produce other persons in the form of rugs. Some weavers speak of weaving as a process of communication with the loom. Juanita Paul told me, "I can't force it. The loom has to communicate to me what it wants to do." Colla-borating with their loom persons, weavers instill in their rugs an inner being that is part of themselves and of their looms. As long as the rugs remain within the Navajo sacred geography, they embody this relationship to their producer. Though most weavers do not articulate this relation-ship to the sacred geography, some distinguish between rugs that are in the trading post for sale and rugs that are in the possession of far-away purchasers. Some weavers can "feel" their rugs in the trading post. Upon entering the trading post, these individuals often feel the locations of their rugs among the many there for sale. And many weavers are interested in knowing about the people who purchase their rugs and where the rugs are taken. Mary Lee Begay often talks about where her rugs are. "The trader wanted me to make all these old designs and now I'm used to it. I enjoy making the Old Style rugs. My weavings of old

patterns have gone all over the world—New York, Japan, Hawaii." For many of these weavers, the relationship emphasis shifts from the rug itself to incorporate the people who then possess the rug.

With these understandings of weaver, loom, and rug persons, consider one early-twentieth-century weaver's understanding of Hubbell's agenda.

A Weaver's Story of Hubbell's Request

Yanabah Winker lived in the Ganado area for much of her life. She moved there with her family when she was ten or eleven in 1897. It was, coincidentally, the year that Hubbell probably commissioned his first rug paintings. Winker's mother was a weaver, and it was from her that Winker learned to weave. Both traded their blankets to Hubbell until his death in 1930, and after that they traded to his sons. Winker's descriptions of the blankets and rugs she produced were consistent with the patterns reflected in the small paintings. She wove rugs of "mostly gray and black borders" and described others as having "white and blue stripes and in the middle that was like a cross in black." She recalled that Hubbell wanted that "cross"—the swastika—in the rug "no matter how big or how small the rug was." Apparently, Winker accommodated at least some of Hubbell's suggestions. But she acknowledged that she didn't exactly understand Hubbell's agenda.[38]

> Yes I know [about the blanket paintings], but you made your own design the way you thought about it, but Naakaii Sání told us to make it his way and I don't know why, but when we were making it, we used . . . the design we wanted.[39]

Clearly, in Winker's view the trader's suggestions did not compromise her right to make her own decisions about her work. She acknowledged Hubbell's preference for swastika motifs but didn't understand why he would attempt to tell women how to weave their textiles. In fact, Winker looked to the small paintings as representations of weavers' work, not the trader's preferences. She cited possible ancestral origins for some designs, saying, "We probably wove them like that and for that reason he had them there."[40] Winker's statements indicate that Navajo weavers produced their own textiles within the context of their cultural understandings of autonomy and creation, and she apparently did not find

the trader's suggestions coercive. In fact, she did not seem to understand why he even made them. Since Winker likely understood Hubbell's request as a preference for ancestral designs, she also likely assumed her own autonomy in design adaptation to avoid directly copying another weaver's work. However, copying does sometimes involve conflict for weavers.

Navajo Weavers in the Late Twentieth Century

When the National Park Service acquired Hubbell Trading Post as a historic site in 1967, they set about restoring the trading post, Hubbell's home, and grounds to approximate the pre-1930 conditions that existed when J. L. Hubbell operated the post. The Park Service also commissioned copies of the large rugs the Hubbells had used on the floors of their home so the originals could be preserved. Weavers Louise Begay, Mae Jim, Elizabeth Kirk, and Sadie Curtis, who were employed at the site as demonstration weavers, laboriously copied the large rugs. In addition to these well-known weavers, other weavers occasionally receive requests from potential buyers to copy existing rugs. All weavers I spoke with emphasized that copying was far more difficult than weaving one's own pattern. The difficulties can be categorized as either technical or spiritual, but I should emphasize that this distinction is my own and a perspective not necessarily shared by the weavers.

Copying an existing rug requires great technical skill in matching sizes, proportions, patterns, colors, and yarns. Often weavers are asked to copy old rugs in which dyes have faded, making the colors extremely difficult to match. In addition, the proportions and patterns are not the original thoughts of the copier, so more and different kinds of calculations are required. "It takes a lot of measurement." "Sometimes you come out short in your weaving." "Sometimes there's a mistake in there, the edge is not straight. And it's hard to make it right."[41]

There are other complications of copying rugs, complications that derive from the way rugs embody the personal qualities of other weavers. As previously noted, Navajo textiles embody the persons of their producers as long as they remain within the geography of the Navajo four sacred mountains. Some weavers discuss being able to feel the persons of other weavers in the old rugs they are asked to copy. There is a lot of

risk in encountering rug persons produced by an unrelated weaver or
from another time. For example, if the weaver of the rug to be copied is
no longer alive, the encounter can subject the copier to risk of sickness, and
disease might result from coming into contact with a deceased person.[42]
With this in mind, it appears highly unlikely that Hubbell would have
actually unraveled some of the old garments, as he stated in his 1902
catalogue, to show weavers how they were made. It is difficult to imagine
weavers patiently standing by as a rug person's life was destroyed in
their presence, unless, of course, they quickly sought spiritual help.

Moreover, the intent of the weaver is embodied in the person of the
rug, so there may be other risks as well. Helen Kirk explained:

> It used to be that women were stingy with their weaving. They
> were probably tight with it. That's how a long time ago was. People
> used to be stingy with it. When there was somebody coming they'll
> cover their rug. People would say "She'll copy from me." . . . It
> gets so hard and it gets so tricky. I usually come home with a
> headache.[43]

As we see, when a weaver copies an existing rug, she enters into a rela-
tionship not only with her own loom person but also with the person of
the weaver embodied in the rug to be copied. If the weaver of the original
rug is deceased, or was stingy or imparted other negative qualities into
her work, these qualities are embodied in the rug person. The copier
then comes into relationship with those qualities, resulting in the possible
illness or death of the copier. These relationships might also appear to
be processes of creating difference albeit within Navajo culture. Many
weavers readily share design ideas and inspirations within their fami-
lies, but such information is priviledged and so rarely shared with non-
relatives. But before moving to this conclusion, I turn to a comparative
discussion of copying the Hubbell paintings.

Among the weavers today who copy patterns or borrow designs
from the Hubbell paintings, there is a general understanding that they
were done "a long time ago" and represent actual blankets. There was
no understanding among the weavers with whom I spoke of either the
individuals who produced the renderings or of Hubbell's motivations
in commissioning and using them. The small paintings are, in fact, held
in high regard by many weavers (whether they copy them or not) as

"the weaving of the ancestors." Some weavers feel a responsibility to use the designs in their own work in order to continue the old styles. "That's the way weaving was done a long time ago and we should still weave that way."[44]

Today, weavers who demonstrate their skills at the Hubbell Trading Post and those who sell their work to the current trader enthusiastically copy entire patterns and/or incorporate selected motifs in their own designs. In a practice that no doubt would please Hubbell and his sons, tourists occasionally request rugs that are copied from particular paintings. In addition, many tourists inquire about the use of the swastika as a design motif, making the paintings the subject of a broader historical and international discussion. Previous traders at the Ganado post during its tenure as a historic site actively commissioned copies of the patterns from weavers who demonstrated their work at the site. Bill Malone, for instance, felt obliged to encourage the styles as those traditional to the post, though he actively encouraged artistry in all styles of Navajo weaving. He did not limit his acquisitions to the old styles.

Both Navajo rugs and the small paintings are objects produced by persons and thus, in the Navajo view, have the capacity of persons embodying the intentions of their makers. So, I wondered, why do many of the same weavers who recognize the dangers of copying existing rugs apparently enjoy copying the paintings? Obviously, the technical challenges of matching the colors, yarns, sizes, and even mistakes, of an existing rug are not an issue with the small paintings. While the paintings suggest proportions and colors, the transformation of these elements from small oil or watercolor renderings to large wool tapestries frees weavers to make their own decisions about many features. But that does not address the question of personhood. It is dangerous to evoke the person of another producer into one's own creation. Yet what makes encountering the persons of the paintings safe, and, indeed, pleasurable? The answer to this question is two-fold. First, the Hubbell blanket paintings were produced through the "thinking" of Naakaii Sání—Hubbell. Evoking another person into one's creation may not be dangerous in itself. Rather, it is the intent that the other person embodies that may cause harm. Again Helen Kirk explained, "The paintings have good feelings. I like to copy them. Yes, they are alive. The feelings that are there are good."[45] Copying depends on the intent—"the feelings"—

of the original producer embodied in the object to be copied. So, rather than separating and distinguishing "others," to copy is to join in relationship with those persons.

Many analysts remind us that the category of "primitive" is a modern construction. And numerous scholars have examined the intersections of the primitive with Euro-American issues of authenticity, nature, and time.[46] As we have seen, Hubbell actively engaged in constructing ideas about weavers' products as the old, primitive, natural products of cultural others. The images selected by Hubbell and Burbank as the most authentic are locally held in high regard as the weaving of the ancestors. Before we confuse this recognition with a simple acceptance of categories established by the trader and artist, we must remind ourselves of the Navajo category of authenticity—that is, anything produced by a Navajo person. In far more complex ways than originally intended, the paintings truly represent the weaving of the ancestors.

While an examination of the larger national discourse about Navajo weavers and their products provides us with a Euro-American perspective on Hubbell's activities, a closer look at the othering process as exemplified by the small paintings illuminates the local interactions and implications of his project. While Hubbell was constructing primitive style, Navajo weavers did not share the Euro-American primitive-modern construct and, as we shall see, they had different and complex reactions to changing social conditions and pressures, and they did not share Hubbell's concept of authenticity as their particular reaction to modernity. Neither resisting nor acquiescing, they appropriated Hubbell's project into their own creative process. All the while, they were also challenged to accommodate or resist new understandings of economy, the changing lifeways of boarding schools, government demands, commodification, and curiosity about sacred matters and personal interactions with those Euro-Americans who objectified and commodified their work.

Trade "A Long Time Ago"

The door opens, letting in a flood of light, and the old wooden floor creaks under the footsteps of a grandmother and her daughter and grandchildren. The grandmother clutches her purse and a long bundle wrapped in a cotton cloth. As her grandchildren survey the candy, chips, pickles, and beef jerky on the trading post counters, the grandmother and her daughter walk into the rug room. Quietly they stand, waiting for the trader to look up from his work. Then without offering a greeting or lifting his head, seeming to keep his attention focused on the paperwork at hand, the trader says, "What do you want for your rug, *shimá* ['my mother']?"

This was a common scene at Hubbell Trading Post. Almost daily, Navajo weavers of all ages, often accompanied by various family members, came into the post, hoping to sell their rugs for a satisfactory price. Though this scene occurred often, there was and is no one "typical" trading post encounter, as many factors influence the nature of each. Encounters vary with the relationship between trader and weaver, the fame of the weaver, the market quality of the work the weaver produces, the weaver's position in the community, and the trader's ability to purchase at any given time. The history of the relationship between trader and weaver and their families are also important to the nature of a transaction.

Various cultural factors have shaped trading relationships throughout history and continue to do so in the present. Although some modern weavers do not rely on traders or dealers to market their work, trade

relationships are still important for many weavers. They incorporate aspects of gift exchange, commodity sale, and barter that can otherwise be seen in everyday interactions between Navajos, but due to the fluid nature of the encounter, trading post exchanges never completely fit the typical characteristics of any one type of exchange. Both Navajo weavers and many traders approach their business transactions in a relational way, viewing particular protocols as essential aspects of a satisfactory exchange.

Gifts, Qualities, and Cash

Navajo and other southwestern textiles have been and continue to be exchanged in transactions that resemble gifting, bartering, and a monetary sale.[1] The assumption that all forms of exchange other than the monetary sale are pre-capitalist forms permeates much of the literature on Navajo economic practices.[2] Notable exceptions include Louise Lamphere's analysis of cooperation and individual autonomy, and the work of Chris Gregory and scholars working in other regions, who emphasize that non-capitalist economies are not simply "natural" economies producing for subsistence rather than exchange. They suggest that in such economies some objects have an inalienable quality that can be used to form indissoluble bonds between persons. Navajo weavers regard their rugs as persons, which suggests that such a relationship holds between weavers and their products.[3]

Gregory delineates gift and commodity as two major and opposed types of exchange. Gift exchange includes inalienable objects and is concerned with personal relations between people, whereas commodity exchange involves alienable things and establishes objective relations such as quantitative value between things. Nicholas Thomas emphasized that a gift is both a thing and an action of persons.[4] In the Navajo world, all things possess the potential for animation through thought. From this perspective, any exchange, whether gift or monetary sale, may involve inalienability and establish a relationship between persons. Exchanges between weavers and traders thus fall somewhere along a continuum between the categories of gift and commodity.

Recently, anthropologists have looked at the practice of "barter" as a mode of exchange in its own right,[5] and this discussion is particularly relevant to the types of exchanges that occurred throughout history in the Southwest, both during the early and influential years of the trading

posts and in many trader–weaver exchanges today. The continuing variability in the exchange of Navajo textiles shows that such forms as gift and barter do not necessarily disappear when moneyed transactions become common.[6] Rather, new hybrid forms emerge. According to Humphrey and Hugh-Jones, anthropologists seeking quantitative social values as a basis for non-monetary exchange have also overlooked relational social characteristics of barter transactions.

Barter generally involves the exchange of objects that are different in kind. Prior to Spanish contact in the Southwest, Navajos bartered blankets, baskets, buckskins, and other items for turquoise, pottery, and food from the Pueblos and Utes.[7] Early Spanish accounts discuss similar trading activities with both American Indians and the Spanish.[8] Exchange of unlike goods continued during the nineteenth century, and flourished in the 1880s with the rise of permanent trading posts, railroads, and the early tourist industry.[9] Between 1880 and the 1950s, at Hubbell and other trading posts, textiles were exchanged for food, tools, wagons, commercial clothing, money, tin money (trading post currency), or combinations of these. While trading in the 1990s Hubbell post did not involve tin money, textiles were still exchanged for combinations of money and objects.[10]

Humphrey and Hugh-Jones characterize bartering activities as complete transactions that do not bind partners with further exchange obligations. But assigning obligations to transactions somewhere between gift and commodity exchanges can be a complex matter.[11] While trades of goods for textiles that occurred between Hubbell and weavers may not appear to have involved obligations, the political, economic, and social aspects of Hubbell's relationships with weavers did involve elements of obligation and dependence.[12] A weaver might have exchanged her products against payment for goods already received by her or members of her family. Or she might have been bound to complete a transaction with a given trader in order to acquire materials for the next rug. Finally, the tin money that a trader used to pay weavers bound them to the post, as other traders would not honor it at face value.[13]

Value in barter exchange is negotiated, not governed by a universal criterion of value such as money. Value can be established in terms of substitutability, by comparing qualities rather than asserting a quantitative equivalence. Trade in Navajo textiles involves the comparison of such qualities as fineness of weave, straightness of sides, color harmony, and

design symmetry. However, not everyone in such a trade will value the same qualities. When traders weigh an understanding of the market quality of a rug, they generally convert (and always have) the value of goods exchanged according to a monetary standard. But many weavers who participate in moneyed and barter transactions calculate value in relation to their own possibilities, needs, and relationships with other people, not in reference to an abstract monetary price. One weaver who usually sold her rugs to a prominent Colorado gallery discussed her relationship with the Hubbell Trading Post this way: "Yes at Hubbell Trading Post I get food for sings and peyote meetings. When I say we will have one that's where I get the baskets and the blankets. . . . That is how I weave for him."[14] Mrs. Jim preferred to obtain materials for ceremonies from a place close to home within the Navajo geography of four sacred mountains. Thus, for some transactors the quantitative measure of equivalence may be an outcome of a transaction rather than its basis. And for others, both qualitative and quantitative measures influence exchanges.

Barter exchanges also depend upon information networks. Such exchanges play a fundamental role in social relations not by binding people to one another through obligations, debts, credits, or wages, but through the exchange of knowledge about things.[15] The construction of networks and exchange of knowledge about Navajo textiles and weaving has occurred through complex relationships since the development of the Euro-American and international market for Navajo products. Many discontinuities in the distribution of knowledge about Navajo weaving exist among weavers themselves, between weavers and traders or dealers, and between trader/dealers and consumers—not to mention scholars. Discontinuities in knowledge are often manipulated to one's advantage. Arising from these discontinuities and manipulations come questions about authenticity, a primary concern for collectors. For example, both Moore's 1911 catalog and a loose-leaf plate issued between 1903 and 1911 feature versions of a rug design now recognized by the name "Storm Pattern"[16] (see figure 13). Moore said the pattern had its origins in Navajo religion and claimed it was in short supply because most weavers were too "superstitious" to produce the design. But, Wheat suggested that the design is more consistent with the layouts of other Middle Eastern patterns that Moore had apparently encouraged.[17] Because

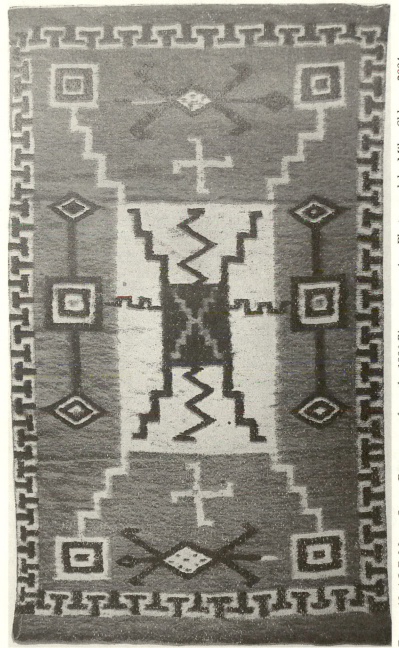

FIGURE 13. A J. B. Moore Storm Pattern rug from the 1906 *Pioneer* magazine. Photograph by Milan Sklenar, 2004.

of the variability in colors and motifs in known examples Wheat argued that the pattern was not likely sacred at that time. From Wheat's materialist scientific perspective, at that time the known sacred Navajo designs did not vary. By citing mythological origins and short supply, Moore had created a particular desire for this rug design, enabling him to command higher prices for it. Interestingly, some weavers today describe the Storm Pattern as a sacred design. The pattern's layout symbolizes the Navajo sacred geography with motifs that represent the four sacred mountains, lightning, and the hogan as the center of Navajo life.

Weavers share in another kind of knowledge relationship. Many believe that one must "pay" another for sharing their knowledge about weaving. Sometimes, such teaching takes place only after an aspiring weaver has demonstrated a desire and commitment to learn. Several weavers have told stories of "stealing" the materials and knowledge of weaving from their mothers and weaving in secret until their weaving was later discovered. In addition, some weavers carefully guard their dye sources and techniques lest others copy them.[18] Sacred knowledge associated with the process of weaving is also carefully guarded.

Traders and dealers possess a different type of knowledge—that of influence and marketing. They often gave weavers technical or design "advice" in a manner that allowed them to either refuse a rug or pay a lower price. Traders also represented Navajo people and their products to consumers.

Bartering practices can incorporate different aspects of a transaction, particularly in instances of transcultural exchange. And, because barter engages an individual in their identity as a specific person and in relationship to another person, each barter transaction is different. In the case of Hubbell's exchanges with weavers, these relationships were not only intercultural interactions influenced by his Spanish traditions and by weavers' Navajo traditions, but they were also gendered. Through repeated exchange negotiations between Hubbell and individual Navajo weavers, a trading pattern was established in which the identities of not only Hubbell and the weavers were constructed, but an identity was also constructed for the Ganado post and the rugs sold there. One material register of that identity is widely recognized today as the "Ganado" or "Ganado Red" rug style.[19]

It is not my intention in examining these characteristics of barter to reify yet another "type" of exchange transaction. As mentioned, trading post exchanges do not wholly fit within gift, barter, or commodity-exchange models. Rather, I employ these diverse ideas about exchange to emphasize the variability and ambiguity in the transactions through which Navajo textiles are produced and exchanged. Navajo weavers exchanging blankets and rugs in 1900 at Ganado were marginal participants in the larger moneyed economy. At that time, the Navajo economic system was a mixture of livestock-raising, agriculture, and the sale of handicrafts.[20] However, during the twentieth century, Navajo people were quickly ushered more fully into capitalist economic relations.

World War II had profound effects on the Navajo economy.[21] Sheep herds had been drastically reduced through a U.S. government stock-reduction program. Navajo men served in the U.S. military forces, and many men and women sought off-reservation employment as wage laborers. The time is generally viewed as a period in which the Navajos became full participants in a cash economy, signaling an end, some have argued, to the trading post era.[22] While full participation in a cash economy, no doubt, has tremendously changed the nature of relations of production for Navajo people, we cannot simply assume, as many studies do, that those relations are consistent with a Euro-American capitalist value system.[23] Contemporary Navajos demonstrate that money does not necessarily dissolve bonds between people. As we shall see with trader and weaver exchanges, money is, in fact, often used to maintain old relationships and create new kinds of bonds. Navajo people use money not in the sense of accumulation, but as a means for acquiring or accomplishing other ends. Some Navajo people look forward to earning the most money possible from weaving so that relatives and friends can have needed ceremonies. Others plan rug sizes and styles around their family's primary needs, such as school clothes, college tuition, or vehicle payments.[24] When I discussed rug prices with weavers, they never spoke only in terms of monetary amounts. They always discussed what they planned to do with money, indicating that money is but one necessary step in the movement of things.

As Farella has suggested, there are religious considerations involved in the acquisition and use of money as well.[25] Martha Tsosie illustrates

this point in her comments, saying, "I probably made thousands of dollars from weaving and they say you are supposed to be thankful for it . . . maybe in peyote . . . and then in the Navajo way they say that if you make more than you normally do you are supposed to get a medicine man who makes a prayer for you."[26] Though these insights into the functions of money do not explain meanings, they do illuminate a relational approach to its acquisition and use. This challenges Marx' assertion that money necessarily dissolves social relational bonds between persons.[27]

It is helpful at this point to step back and widen our view, as an exclusive focus on the physical objects of weaving overlooks a Navajo perspective that privileges the process of weaving over the final product.[28] An examination of the contexts surrounding textile production, exchange, and consumption reveals the degree to which a textile is or is not a commodity in the Marxian sense. It also reveals the relational nature of Navajo textile circulation. Contexts within which objects are produced or circulated may also reveal concepts of value, power, accommodation, and resistance.[29] For an examination of this context, we turn to the counter of the trading post.

Economics Behind the Counter

As mentioned earlier, contemporary trading posts vary in function and type. While older bartering relationships evolved into hybrid forms of capitalist and non-capitalist interactions, these contemporary forms of exchange also vary from strictly cash and credit to combinations of cash, credit, pawn, loans, trade, and even a type of "credit card" issued by some traders against an individual's anticipated tax return. With traders and Navajos engaging in many forms and strategies of exchange, most of these forms have coexisted to one degree or another with a bartering system since the late nineteenth century. Since World War II, cash and credit transactions have been the dominant modes of exchange. Situating contemporary exchange in a historical context illuminates the significance of cultural factors that are often important even in cash transactions today. Further, situating trade relations in a political and historical context explains changes not only in the material relations of trade but also in Navajo customers' attitudes about trading posts and their relationship to Navajo life today.

Color Plate 1. A flock of churro sheep belonging to traders Les and Irma Wilson. Photograph by Teresa J. Wilkins, 1998.

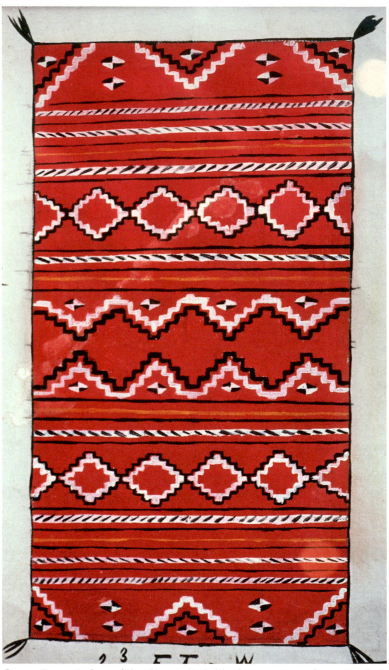

Color Plate 2. One of the Classic Style blanket paintings that artist E. A. Burbank created at J. L. Hubbell's request. Photograph by Joe Ben Wheat. Courtesy of the Hubbell Trading Post National Historic Site, HTR 3524.

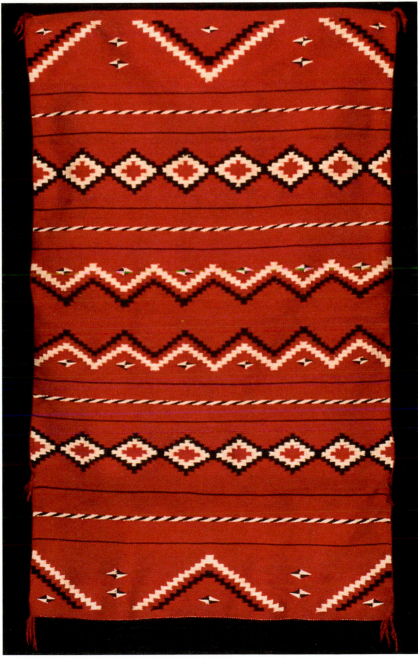

COLOR PLATE 3. A Navajo silk rug woven around 1897 by 'Asdzą́ą́ Tsé dits'áhí, Mary Alice Hubbard, of Ganado. It is a close copy of the painting in color plate 2. Photograph by Ken Abbott, 1989. Courtesy of the University of Colorado Museum, UCM 33317.

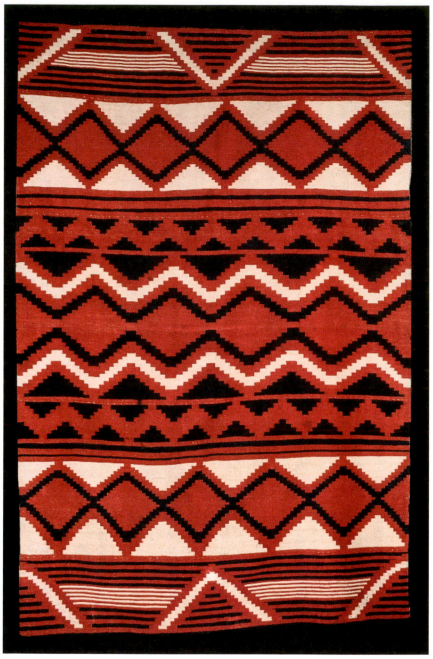

Color Plate 4. A Navajo blanket in the Classic Style. Photograph by Ken Abbott, 1989. Courtesy of the University of Colorado Museum, UCM 23487.

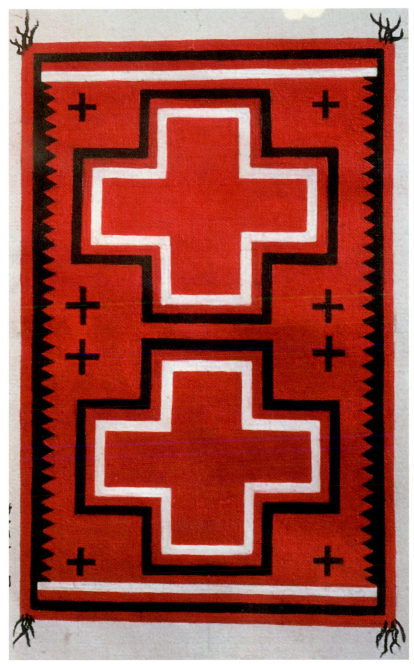

Color Plate 5. One of the blanket paintings that artist Bertha Little created at J. L. Hubbell's request. Photograph by Joe Ben Wheat. Courtesy of the Hubbell Trading Post National Historic Site, HTR 2792.

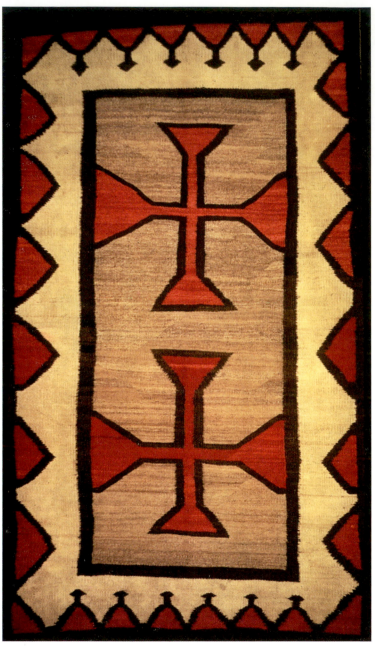

COLOR PLATE 6. A 1920s Ganado style rug. Photograph by Joe Ben Wheat. Courtesy of the University of Colorado Museum, UCM 23433.

Color Plate 7. The rug room at Hubbell Trading Post. The rug paintings hanging on the wall above the bookshelf are the collection that Hubbell commissioned around 1900. Photograph by Teresa J. Wilkins, 1995.

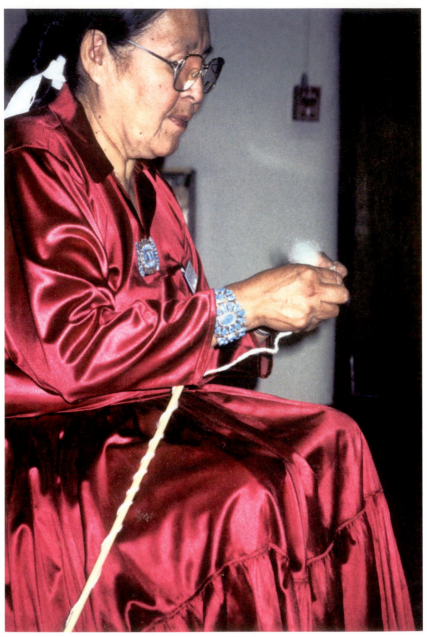

COLOR PLATE 8. Helen Kirk spinning, 1996. Photograph by Teresa J. Wilkins.

Types of Trading Post Transactions

Many sources describe trade transactions from the traders' viewpoint. Brugge and Roberts are more favorably inclined to trader practices than other authors, and both take into account some cultural aspects of trade, though Navajo views are not a central focus. M'Closkey and two government reports (issued in 1935 and 1973) harshly criticize the accumulations of wealth by traders at the expense of the Navajo people.[30] Adams incorporates both Navajo practices and trader exploitation in his account of trade during the 1950s at the Shonto Trading Post, located in the Western Navajo Agency of the reservation. These accounts, taken collectively, leave one with the sense that the relative degree of exploitation by traders is a matter of opinion and perspective. However, none of the accounts take into consideration the local cultural changes that affected trading protocols and exchange forms over a hundred-year period. The historical conditions surrounding trade changed dramatically from the post–Long Walk era in which Hubbell established his businesses "just to help the Navajos" to the present day in which the local effects of inflated prices and credit saturation are very apparent.

To fully understand the ways hybrid exchange forms developed and evolved, we must examine Navajo economic concepts of cooperation and economy. Exchanges were shaped by both traders' and weavers' understandings of economics and personhood.

An Ideology of "Helping"

One of the most discussed practices in Navajo life today is "helping." Help includes anything done or offered by one individual that may benefit another. Helping is included in several positive prescriptions for Navajos as delineated by Ladd in the 1950s as part of the Harvard Values Project.[31]

1. Take care of your possessions.
2. You ought to take good care of your children.
3. Children should take care of their parents.
4. In general, people ought to help the aged.
5. One ought to help a person who is in dire need.

6. There are other people it's particularly important to help: one's wife and her family.

7. In general, you ought to help anybody who needs it or requests it.

The ideology of helping is a complex web of relations between ideas of cooperative and uncooperative behavior, autonomy and authority. These are important aspects of a Navajo cultural system. Generalized reciprocity has been analyzed within Navajo society,[32] but the ideology of helping also applies across the cultural divide. Intercultural relations among Navajo weavers, Euro-American traders, and other rug buyers are dialectical relationships in which varied practical and moral economic values are contested and negotiated.

Helping is good, and among Navajos there is a moral obligation to help others when they need or request it. Very early in my field research I learned that helping someone often establishes a strong trusting relationship. In the spirit of generalized reciprocity, help is diffuse and not generally calculated against a specific return. This diffuse help that is a fundamental part of everyday life is more difficult to characterize than a form of exchange in which accounts must be settled. However, the diffuse nature of the exchange is an important part of the affectionate and cooperative relationships that sometimes existed between traders and weavers. Everyday forms of help may appear mundane but are fundamental. Helping is not specific to particular types of situations or relationships, but obligations tend to be stronger toward family, including clan, and people who have helped one in the past.

Lamphere argued, and I agree, that the values placed on cooperation are perpetuated (and sometimes negatively reinforced) by gossip, joking, and witchcraft accusations. Like the helping obligations it implies, cooperation is only generally defined. In conversation people often refer to others who gave them rides, contributed to a ceremony, or cooked for them. But just as often, discussions center around uncooperative behavior and actions—gossip about who helped whom or, more scandalously, who didn't help. Such people are often described as stingy, mean, jealous, or lazy. One collaborator described a situation at work in which another employee was particularly uncooperative and difficult. The collaborator remarked, "She doesn't have enough to do at home," suggesting that if

the individual in question had relatives and friends to take care of she would be more cooperative.

Anthroplogists generally associate these social mechanisms and pressures with value systems that privilege relatively egalitarian social relations. From a functionalist perspective, anthropologists often view witchcraft as a particularly powerful pressure to enforce social values. In many societies, the characteristics and practices of witchcraft express the opposite of an ideal social person. A successful Navajo person is sometimes the target of witchcraft. Markers of success include material wealth, such as a modern home, a new vehicle, and a steady job; valued situations, such as a large family or an attractive physical appearance; or symbols of social power, such as elected office or a high degree of formal education. To protect themselves, some people will hide their wealth or hand money over to relatives immediately on receipt. There are also many stories of witchcraft practiced around trading posts or practiced by some people who worked for trading posts in their earlier days.

Cultural understandings of cooperative behavior do not contradict the respect for individual autonomy. Because concepts of cooperation are generalized and more clearly defined by what they are not—uncooperative behaviors—they preserve many choices through which individuals exercise their autonomy. Moreover, requests for help are presented in an indirect, ambiguous way, leaving space for the individual to decide not to comply. An invitation to attend a ceremony or other event is sometimes presented as an announcement that the ceremony will take place at a certain place and time. Congruently, a request of monetary or gift assistance with a ceremony usually consists of a general statement that there is a need for a healing or transformative ceremony and that the family is busy making preparations. At that point, the person of whom the request has been made has several choices. They might, of course, offer assistance. Should they be unwilling or unable to help, they have several ways of declining. They might remain silent or suggest another person who is likely to help. They might also indirectly decline a request for assistance by making an excuse.

Direct requests for assistance and direct denials of aid are generally considered quite rude and tend to make everyone very uncomfortable. In fact, there is a great deal of discomfort in request-making when there

is a belief that the request might be denied. Correspondingly, there is great discomfort in further pleading for assistance when a request has been denied.

This discomfort becomes particularly significant in weaver–trader relationships. Weavers often refer to rug buyers, traders, and dealers as "friends" who "help out" by purchasing their products. There is an understanding shared by many weavers that buyers in general, and rug trader/dealers in particular, have consented to participate in the rug market by virtue of their positions. There is a strong sense among many weavers that traders are obligated to buy rugs. Consequently, there is sometimes a lack of understanding when the trader does not live up to the obligation that he agreed to by being in the business.

Forms of Trading Post Exchange

When Hubbell established his business at Ganado in 1876, the Navajo people were rebuilding their economy after the ordeal of the Long Walk. The only goods they could barter for groceries and clothing were wool, lambs, and woven blankets, all of which, interestingly, were the property of the Navajo women. The following story illustrates the difficulty many people faced during the period and the memories they share of their struggle. Gabidáan, a *hataałi*, "medicine man" and silversmith, as well as a traveling demonstrator who worked for Hubbell, told the story to Zonnie Lincoln of Ganado:

> Let me tell you something my children about a long time ago. A long time ago when starvation was around, and when we had enemies, before people went to Hweeldí. A lot of people died from starvation. They would pick up bones of horses that died, maybe about a year ago. You know how the bones get white and are still held intact by the tendons? They would hammer it, boil it and peel off the fat with bé'ézhóó/brush to give it some flavor and they would drink that. Today we have good food but it was awful! Yee! That's how people made their living. They ate just about anything[,] like skunk. And even a cat couldn't walk any-where. They even ate dogs. Gabidaan was telling this story. He said, "We were sitting around being hungry. The men were talking

among themselves when a cat came in at night." He said, "Boys, we are hungry. Ha, ha! And it looks like our food just walked in." So they all ran after the cat and caught it. I guess the cat was also hungry for food, too. "Hurry, hurry! Build a fire." They built the fire and grilled the cat. They covered the cat under the charcoal. It had all its intestines inside and they cooked it. After they took the cat out, Gabidaan said they were so hungry that he was the first to cut out the arm. He gulped some of it and the taste tingled to his nose. I guess the cat tasted really hot. It was worse than tsah/sagebrush. And he went out and vomited it out. The people were ready to feast, but they threw it outside. It was just outside the house that they were sitting. He told us cat meat was bitter.[33]

Those were obviously times of great hardship for the Navajos, and many moved their families to the Ganado area to be near the trading post. Many community elders today share the sense that Hubbell and the Navajos were "all in it together," building lives and families throughout those years. It is little wonder that many Navajos would have a profound respect for someone like Hubbell, who learned to trade according to their cultural protocols, gave gifts, bought blankets, and helped people when they were in need. Stories of the ways Hubbell "helped" the Navajos abound, and few elderly people directly criticize the trader.

For his own part, Hubbell made every effort to establish familial relationships with his customers. He developed a close friendship with the naat'ánnii, "headman" he called Ganado Mucho, who was known to Navajos as Tótsohnii Hastiin, "Man of the Big Water People." Hubbell also befriended his son Many Horses, not only to acquire and maintain a customer base but also to establish his position as a Spanish *"don."* In fact, it is said today that Hubbell and Many Horses were such close friends that Many Horses was buried in the Hubbell family cemetery just northwest of the trading post. Hubbell employed many strategies to both expand his financial base and maximize relationships with his Navajo customers. Bartering, in particular, offered Hubbell and other traders repeated opportunities to build relationships by appearing to participate in the practice of helping and by developing the now long-standing practice of giving "something else."

Barter has a long history in the southwestern United States. Spanish documents note Native exchanges of corn and turquoise for hides and

meat. Goods were exchanged for horses and sheep, bayeta fabrics, blankets, and other items. With the arrival of the Spanish, money was also introduced as a medium of exchange. Navajo people quickly learned the quantitative value of money as a means to an end, but qualities of goods and relationships remained paramount in exchanges. Writing about the late nineteenth and early twentieth centuries, Hill attempted to establish quantitative values in Navajo bartering transactions. However, despite extensive research, he was unable to apply consistent equivalencies in value to inter-tribal trading relations.[34] In contrast, reservation traders, even while engaged in bartering, conducted transactions according to a quantitative standard.

By the 1950s, barter accounted for only about 10 percent of transactions at Shonto Trading Post. It is important to note that Shonto is located in a remote western reservation community and may have continued traditional trading practices longer than busier posts located in the central and eastern parts of the reservation.[35] In any case, Indian agents always discouraged bartering because it was a practice of the communal economy. From the late nineteenth century, traders were required to conduct business in cash in an effort to assimilate Navajo people into private property ownership and the capitalist economy. Thus, currency and credit were integral parts of trader licensing requirements.

There was, however, a serious shortage of currency with which to conduct business. Several traders, including Hubbell, purchased thin metal coins bearing the names of their trading posts in denominations of five cents, ten cents, twenty-five cents, fifty cents, and one dollar. They then used these tokens as currency, issuing them to Navajos in payment for wool, rugs, or labor. These trade tokens ("tin money" in English, *bééshkagí* in Navajo), alleviated currency shortage but also obligated the holder of the token to exchange only at the post named on the coin.[36]

The exact date and place where tin money first came into use on the Navajo reservation is not known. Use of tin money on the reservation was prohibited in 1878, though Hubbell always considered himself exempt from the prohibition because he homesteaded the property on which his trading post stood. Hubbell used his own tin money at Ganado as late as 1904 to pay Navajo men who worked his fields and irrigation lines as well as Navajos who cooked, herded sheep, and performed other tasks around the property. He also paid demonstration

weavers and silversmiths between $0.50 to $1.00 per day in tin money or in goods.

In 1916, Commissioner of Indian Affairs Cato Sells tried to end the use of tin money. Hubbell argued for continuing the practice:

> If traders could not use tin money they would not be able to conduct business in cash. They would urge the Navajos to make all of their exchanges and take all their trade in merchandise, thereby undermining the government's policy to convert Native people to capitalism.

Tin money also simplified accounts for traders and prevented disputes over credit.

> Tin money enabled licensed reservation traders to compete with off-reservation traders because the tokens guaranteed that customers would return to their post. Hubbell argued that Navajos would purchase more from licensed traders.[37]

Hubbell's argument for tin money did not prevent him from reporting competitors who may have used tokens illegally. Hubbell's Ganado trading post was a homestead and not legally Navajo reservation land. Some other Hubbell posts were located on Navajo or Hopi reservation lands and thus subject to restriction from using tin money. In 1910 he wrote to Commissioner Peter Paquette that the trader at the Sunrise Springs Trading Post was illegally using tin money to tie his customers to the Sunrise store. Hubbell's problem, of course, was that the Sunrise Springs post was located several miles southwest of his Ganado and Cornfields posts, and Navajo customers were not trading with him if they used Sunrise Springs tin money.

In 1933, Commissioner John Collier mandated that payment to the Navajos should be either in United States currency or in credit at the choice of the customer. Collier may have succeeded to a degree, as McNitt states that tin money stopped being issued on the Navajo reservation around 1935.[38] My conversations with Navajos in the Ganado and Steamboat communities suggest that the Hubbells accepted (but probably did not issue) tin money at their Ganado post until the 1950s.

Other than its being, in effect, a counterfeit currency (an issue the commissioners apparently did not raise) what was the controversy

surrounding tin money? Most traders maintained that the tokens were redeemable at many trading posts and did not in fact bind a Navajo customer to one post for their purchases. In addition, the denominations corresponded to currency, so tin money appeared useful in converting the Navajo people to a cash economy. At first blush, tin money would appear to be a good solution to the currency shortage. However, the use of tin money was far more complex and ambiguous than currency. Both Navajos and Euro-American traders recognized different values in tin money. Tin money gave the traders the chance to assign relative monetary values to particular items, while Navajo customers appreciated several non-monetary qualities embodied in the tokens.

In 1934, Lorenzo Hubbell, Jr., gave his view of the value of tin money in reply to a Bureau of Indian Affairs questionnaire.

> Tin money should be used for such commodities as baskets, placques, rugs, pottery, etc. which do not have set market or cash value and are not readily saleable. Tin money should be used instead of the present system of issuing due bills for unused balances, incurred when the Indian sells his product. Tin money will tend to keep the Indian business on the reservation. This will also act as an added incentive to advertise products referred to above.[39]

The Hubbells, in fact, were reasonably consistent with the market values they established for baskets, plaques, rugs, and pottery and had been so for many years. Tin money apparently offered traders a further opportunity to manipulate the monetary value of objects to their advantage. Further, if Indian business was kept on the reservation, then business, of course, came to the traders, and Navajos were segregated from adjacent predominantly white communities such as Gallup.

Navajos no doubt recognized their own relative value in tin money. In 1922 Commissioner of Indian Affairs Peter Paquette wrote to Roman Hubbell that

> the Indians feel that they are not slaves and that they should be paid cash for their labor the same as anyone else, and they feel that they are not being justly treated in this matter. There are many times when they are unable to do so on account of being paid off in this tin money.[40]

Navajo customers were certainly aware of the limitations of tin money. Many traders said that tin money from one trading post was redeemable at most trading posts, but neither Hubbell correspondence nor Navajos' memories support this assertion. In 1905 trader Sam Day II reluctantly accepted some Hubbell Trading Post tin money from a Navajo family attending a dance in St. Michaels (approximately twenty-eight miles away) when they had nothing else to exchange for food. He insisted that Hubbell redeem the tin for cash.[41] And according to some Navajos' memories, tin money was not redeemable anywhere except at the post from which it was issued. One Ganado elder told me that Cotton accepted Hubbell Trading Post tin money at his store in Gallup but redeemed it at only half its face value. Given his and Hubbell's business relationship, Hubbell likely redeemed the tin from Cotton at full value.

Brugge points out that Navajos did sometimes ask to be paid in tin money and suggests that its restricted negotiability might have been convenient for managing family accounts. This may have been only one strategy through which Navajo people negotiated economic situations. It is likely, particularly given a statement by Lorenzo Hubbell, Jr., that products and/or labor were valued differently according to whether the payments were in cash, tin money, or trade, and that Navajo workers were aware of this. Cash transactions were conducted at face value, whereas tin money's value was flexible. In addition, merchandise bartered from the post was exchanged at retail price to the trader's advantage because his investment in the merchandise was at the wholesale level.

Finally, my interviews suggest that bééshkagí also held symbolic or qualitative value for the Navajo users. Marie T. Begay of Steamboat, Arizona, is one of several Navajo elders who fondly remembers relatives carrying, giving gifts of, and constructing objects with tin money. Begay saved the bag that her father used to carry his tin money and was eager to show it to me when we spoke about the subject (see figures 14 and 15). Margaret Hubbard of Ganado pointed out that there are limitations in the abstract value of currency. She missed the flexibility that tin money offered, both in pricing and other uses. Mrs. Hubbard wished it were still used today. "Today's money can only be used for one thing. You just spend it and it's gone. With tin money you could do all kinds of things. My father made a belt out of his tin money." Ambiguity

FIGURE 14. Marie T. Begay at her home after sharing stories of weaving and trading. Photograph by Teresa J. Wilkins, 1996.

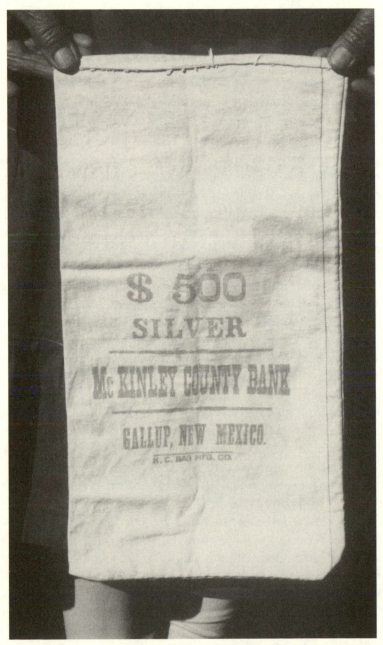

FIGURE 15. A tin money bag. Many elders carried their tin money in bags like this one, which was used by Marie T. Begay's father. Photograph by Teresa J. Wilkins, 1996.

surrounds the history and memory of tin money as it does so many aspects of trading history.

Credit

One of the most contested forms of exchange between traders and Navajo customers is the practice of giving credit against some future payment.[42] Following the Long Walk, the Navajos had only wool, lambs, and blankets to barter with; wool and lambs were seasonal, so blankets were one of the few commodities Navajos had that could be exchanged year round. Yet there was and is a somewhat seasonal cycle of blanket/ rug production as well. While commercial yarns made it possible for weavers to produce blankets year round, the spring and summer seasons were times in which other tasks, such as lambing, farming, and cere-monial responsibilities, often took precedence over weaving. Thus, more weaving was done during the winter season. This is often the case today. By the early twentieth century, trade goods included small numbers of other crafts such as baskets, pottery, and silverwork along with hides and pinon nuts. These items were, and continue to be, exchanged on a barter, cash, or combination basis and have never played a major role in the credit exchange system.

In the early years of trade, goods were exchanged between Navajos and traders through bartering. To buy and resell wool, traders began offering credit against a seasonal quantity of wool or "clip." Traders, in turn, paid wholesalers like Cotton in goods, and like their Navajo cus-tomers, required long-term credit without security from the wholesalers in order to do business through the year. Wholesalers frequently carried traders through bad years.

By the 1920s, the market for Navajo rugs had peaked and raw wool once again became the basic commodity for sale. But traders and weavers still struggled with the quality of wool from local sheep for Navajo weaving. As a result of the Long Walk and destruction of churro sheep flocks, the government issued mixed bred churro-merino sheep and later Rambouillet breeds to the Navajos to rebuild their herds. This change in breed resulted in a greasy, short crimp fleece that was not suitable for the hand washing, carding, and spinning techniques used by Navajo weavers.[43] As a result, many rugs woven from yarns of the

1880s and later were thicker, coarser, lumpier, and greasier. They were often unevenly dyed due to the heavy lanolin content of the fleece and the quality of early aniline dyes. As the percentage of churro fleece declined, Navajo wool was perhaps more profitably sold as raw fleece for factory processing than as finished rugs of inconsistent quality. Dependence on raw wool sales resulted in a heavier dependence by both trader and Navajo customer on long-term credit from the wholesale houses.

The credit situation was a risky endeavor for both wholesalers and traders because traders had no recourse if Navajo customers defaulted. Credit was unsecured and Navajos were not subject to lien or attachment by on-reservation businesses. Wholesalers frequently absorbed much of this risk. This interdependency explains Adams' statement, "When Navajos are making money the store is making money; similarly when Navajos are living on credit the store is living on credit."[44]

Ironically, the beginnings of seasonal wool purchasing and credit against a future wool clip and lamb sales were consistent with the more generalized practice of helping that was so important to Navajos. Traders would advance groceries and other necessities, thereby "helping" families who would in turn "help" the trader by weaving and exchanging blankets two to five times a year and wool clip twice a year. The wool clip either settled the family's debt or was credit against future purchases.

Credit accounting to customers often took the form of "trade slips" or "due bills," small pieces of paper with the customer name and the amount of credit due. These paper records were used from the 1870s to the present. Both Hubbell and his son Lorenzo Hubbell, Jr., justified the use of tin money by citing the difficulty of using due bills. For the Navajos, due bills were as restrictive as tin money. In 1973, a report by the Federal Trade Commission criticized due bills: where such bills were the only evidence of trading post debt to a customer, the report said, the trader could not be liable for the debt if it were lost.[45]

Not only was the occasional or seasonal trade compatible with the Navajo practice of helping, it also resulted in other trader practices compatible with the Navajo economic values. Hubbell and other traders often visited Navajo customers at their homes and delivered gifts of food and other supplies. These visits are remembered in various stories referring to the help and friendship offered by the traders. Margaret Hubbard of Ganado told one such story. "Naakaii Sání ["Old Mexican,"

or Hubbell] would give a sack of potatoes when he came to see my grandpa. They'd talk Navajo to one another and talk about things that were going to go on this summer or this winter. They're really nice."
Grace Henderson Nez of Ganado told a similar story.

> He [Hubbell] was very kind to us and he really spoke Navajo, too. He was an old man. He was good friends with my grand-mother. She wove for him for years. Yes, he helped. We had a lot of sheep, close to 1,000 of them. That's how my mother and grand-mother raised their sheep. He would buy the little lambs from us. He would come over. He would bring over food, canned foods, everything, bread, a variety of canned goods, mainly peaches and tomatoes and crackers. Mainly that. Also crackers like these. That's what they had then. Also pork. They weren't cut thin, they were cut very thick. They were all cut thick. That would be on the very top and he'd bring a box full. And it was well worth a lot of money. Back then, money wasn't as it is now. They were this big, like bééshkagí (tin money). They were very thin. That's when they call it bééshkagí. The money only went up to $1.00, 50 cents, 20 cents, 10 cents, 5 cents. That's what he would bring along on his trip. My grandmother used a flour bag, back then we didn't have any purses. My grandmother would carry around the flour bag and the coins would jingle. Then he would load the lambs and take them. That's how he helped us. He really helped us. Naakaii Sání was his name. He had a son who died [Roman Hubbell, Jéékaaø, Hard of Hearing]. He was deaf. He was kind like his father. She sold to him and he helped us for a long time. They knew my grandmother. He helped us greatly many times. As a man, he was really helpful. But they all passed away. I don't think any of his children are still alive.[46]

While Navajo customers often viewed these visits as helpful, they served different purposes for the traders. Given the difficulty of collecting in case of default, traders depended on knowledge of herd sizes and future wool clip in order to estimate what the sales might be for the coming season. They also monitored the progress of blankets on weavers' looms and offered suggestions of sizes and styles. They extended credit based on estimates of livestock, wool, and textiles they could expect the

family to bring in trade. Adams observed the same practice when he worked as a trader at Shonto, Arizona, in the 1950s. He argued that a skilled trader could estimate community earnings with such accuracy as to be able to tie up 75 percent of earnings in advance credit.[47] These estimates required the frequent monitoring of family economies by visiting family homes and discussing future plans. Though Navajo customers viewed traders' actions as helping, they were also aware of the credit strategy. Conflict over these practices occurred only when the customers took their goods to another trader instead of settling their debt.

Often, trader visits were used as indirect ways of collecting debt. Traders were indeed licensed to do business only on the trading post property, so collection at any other site was illegal. However, the indirect nature of the request to settle the debt was also in keeping with Navajo concepts of cooperation and autonomy. Navajo customers were generally aware of their debt and equally cognizant of the fact that when, where, and how to settle the debt—if they chose to settle at all—was up to the individual debtor. From the Navajo perspective, a trader who came to the homestead was announcing a need, and the Navajo debtor would agree to help the trader.

Traders would also cut off credit to customers who did not settle accounts. They often attempted to manage their customers' indebtedness by discouraging charges and suggesting limits on individual transactions. Threats to cut off accounts were frequent, but traders did not generally cut off long-term customers until they had truly reached their maximum level of indebtedness. By employing these strategies for credit management and debt collection, traders placed themselves in the paternalistic position of budget manager, often for much of the community.[48]

Interestingly, Navajo customers sometimes manipulated this paternalistic situation to their own advantage. Navajos who traveled to demonstrate arts and sand painting were often paid through the trading post. Some requested that Hubbell manage their accounts in particular ways that also limited their ability to comply with cooperative obligations. If their money was held at the trading post, they could not give it away to a family member who requested assistance. Others asked Hubbell to apportion out amounts of credit to family members to extend the resources. Joe Tippecanoe, for instance, requested that Hubbell credit a

salary payment to his mother's account but also asked him to ration her groceries over a period of time; otherwise, he said, he feared she would "just give them away."

Traders could also collect overdue accounts by cutting off credit to the debtors' relatives.[49] This strategy must have been useful for traders like Hubbell, who were well aware of Navajo kin networks and cooperative obligations. During my field experience, I observed a powerful family conflict that resulted when a trader based a rug's retail price on the need to credit an amount to the overdue account of the weaver's sister.

Finally, traders could threaten to stop some of the more social practices like writing and reading letters for customers, arranging employment for traveling demonstrators and railroad laborers, and interceding with the law or the government. Though Adams described these activities as outside the commercial trade, the Navajos regarded the practices as parts of the economic exchange. Such were and are highly consistent with the Navajo ideology of helping. Successful traders like Hubbell employed many of these strategies for managing accounts and maintaining relationships with Navajo customers. These practices no doubt evolved from the earliest trading days, during which Navajo people had little to trade and traders were anxious to exploit the profitability of the wool market. After 1940, wage labor increased and farming and livestock decreased from 58 percent of total income to 7 percent of total income. World War II brought still more labor opportunities, increased dependence on government assistance, and greater availability of transportation to the Navajo reservation. The economic foundation of trading posts shifted from raw wool, rug, and craft trade to include monthly Social Security, retirement and welfare checks, and wages.[50] This shift increased cash and small retail transactions, lessening dependence on long-term credit. It also undermined trading posts' competitive position in the Navajo economy. With the increased options of off-reservation stores and available cash, traders intensified their strategies for maintaining customer relationships while Navajo customers worked to broaden their cooperative networks.

Credit Saturation

By the 1970s, reservation traders had come under fire for the practice of "institutionalized credit saturation," which the FTC defined as "a practice

whereby the trader extends credit up to his customer's known periodic income."[51] This was accomplished by withholding welfare and other government checks—compelling the Navajo customer to endorse their check to the trader—refusing to negotiate checks for cash, diverting checks to the trading post, and using due bills and trade slips. The practice had been highly criticized during the 1960s and 1970s, first by Adams, then by the Southwest Indian Development, Inc. Like the use of tin money and the seasonal wool sales discussed earlier, credit saturation insured that Navajo customers never received any cash and were compelled to continue charging at the same trading post until the next check arrived and began the cycle again.

According to Adams, trading posts did not generally compete with one another, but all competed with off-reservation businesses. Actually, trading posts had competed and cooperated both with each other and with off-reservation businesses since the early days of trade. Not only did Hubbell complain about loss of his competitive edge when other posts used tin money, he also competed with Crystal trader J. B. Moore for the high quality rugs of both Ganado and Crystal area weavers.[52] The degree to which Navajo customers traveled for the best bartering transactions during the early trading years has been underestimated in the literature, which assumes there was little travel until the 1940s.[53] Competition with off-reservation businesses was intense, however. Kluckhohn and Leighton noted that markups on merchandise in reservation trading posts were twice that of off-reservation posts due to "high freight rates, low turnover, and generally inefficient business methods."[54] The costs were then passed on to the Navajo customers.

It is easy to understand how early traders like Hubbell accomplished credit saturation when customers had goods to barter only a few times a year. But how did credit saturation continue after the 1940s, when Navajos began receiving welfare and other government payments? Several factors, including traders' knowledge about Navajos' resources, came into play. Most trading posts were also post offices, so traders knew which individuals received checks and when they arrived. Some traders used several tactics to control Navajo customers' funds. They allowed customers to charge goods in advance up to the amounts of their expected checks. Some traders then physically held the checks while customers endorsed them over to the trader. The Southwest Indian

Development, Inc. (SWID) described some conflict when Navajo customers tried to take their checks from the traders' hands. If customers tried to rebel against the system, their credit was often cut off.

By the 1970s, credit against monthly checks accounted for approximately 90 percent of on-reservation trading post sales. Interestingly, none of the sources that criticized traders for credit saturation discussed credit against rugs in progress, which has always been standard practice for those posts dealing with weavers. Adams was not heavily involved in rug purchases during his work at Shonto. "Rugs, once the cornerstone of the Navaho [sic] trade, now move in the weakest and most uncertain of all Navaho commodity markets, and are generally considered an unavoidable nuisance by traders in the Shonto area."[55] However, several posts, such as Hubbell, Two Grey Hills, and Burnham's, were still quite actively exchanging rugs, developing international reputations, and promoting weavers as artists.

Adams' experience points to the diversity of trading post enterprises by the 1950s. Shonto Trading Post was located in the Western Navajo Agency, far from tourist traffic. Unlike Ganado and Crystal, where traders Hubbell and Moore aggressively bought and marketed Navajo rugs, worked with weavers on design development and built large enterprises through the rug trade, Shonto traders were never as invested in Navajo textiles as a business and did not have that trading history on which to build a larger market reputation.

Credit in the New Millenium

Credit in reservation trading posts after the turn of the twenty-first century varies with the type of business and the demands of the community it serves. Trading posts like the one at Coyote Canyon dealt only in retail sales and did not carry open accounts with customers. However, many businesses that deal largely in Navajo arts still offer credit against work in progress. Credit is primarily limited to Navajo weavers who are long-term customers and whose work will sell easily and quickly. Occasionally, credit or materials are extended to silversmiths but rarely to other artists and artisans. Sometimes, some credit is extended against incoming government assistance. There is still no official recourse for debt collection, and occasionally traders lose money when they have

advanced groceries, materials, or money to weavers who decide to sell their work elsewhere. Most credit today is with off-reservation businesses, some of whom practice something like credit saturation by issuing "credit cards" secured by the customers' money, such as an advance on an income tax refund, on which a sizeable transaction fee is charged. As of this writing, there are no laws governing amounts for these kinds of interest. A few rug dealers still advance large sums of money to the point where weavers who take the advances are still indebted to the dealer once they have given the rug. They then need to keep weaving rugs for the same dealer because they become caught in a cycle of debt.

Today's Navajo Nation traders who deal in rugs are quite concerned about their reputations and relationships with weavers. They are sometimes defensive in the wake of the FTC report and some authors' Marxist analyses of the trade. These emphasized the exploitative practices while overlooking the cooperative practices and other ways that traders manipulate their situations to help customers. They also overlook the varying roles contemporary trading posts have in communities.

Pawn

Throughout the Southwest, visitors can walk into many businesses advertising jewelry for sale and see a case labeled "Dead Pawn." A kind of mystique accompanies the name, which still has the reputation of being attached to rare, old heirloom pieces the average customer does not often find. The images of pawn elicit visions of a wealth of fine turquoise, coral, and silver jewelry in a trading post locked case or vault tantalizingly visible from across the counter. Today, the term refers simply to items left as collateral against advanced credit not repaid and does not automatically imply antiquity or guarantee a standard of quality, collectability, or scarcity. Pawning valuable items in exchange for goods or cash has been carried on since the early days of trade. Today, Navajos and non-Navajos living in the area still pawn jewelry and other items sought after by tourists, as well as locally marketable items. After an FTC report recommended stricter regulations on reservation pawning, the practice became almost exclusively a "border town" activity, important in places like Gallup, Farmington, and Flagstaff. In addition to trading businesses, now shops that exclusively deal in

pawn carry a broader inventory of items like chain saws, televisions, and stereo equipment.

Most literature on reservation trading post pawn states that traders kept no record of pawn other than scribbled tickets attached to the merchandise.[56] However, at Hubbell's Trading Post at Ganado, there are extensive listings of pawned items left by Navajo customers in the early twentieth century. Items pawned include silver belts, bow plates, bridles, bracelets, rings, and sets of sterling silver beads. Navajo customers also pawned mixed beads, strands of coral beads, baskets, pouches, turquoise, buckskin, and saddle blankets. For example, from April 8 to April 14, 1905, twenty-nine different individuals (some from the same family) pawned sixty-six items for loans totaling $75.90. Amounts loaned ranged from $0.50 to $6.00. Repayment amounts ranged from $0.55 for a loan of $0.50 to $6.65 for a loan of $6.00. Accounts were noted "paid" but no repayment date was indicated. This might have been a particularly busy time for pawn activity, as lambs had been born but were not yet old enough to sell, and sheep would not be shorn until later April and May when their wool would be sold.

Pawning had three unique functions within the Navajo reservation economy. It was due as much to Navajo customers' need for safe keeping as to the trader's need for security. In fact, Adams referred to pawn at Shonto as superfluous security. Pawn may also have been a way of keeping valuable items out of the "helping" exchange network while avoiding accusations of selfish or uncooperative behavior. Today, Navajos often pawn valuable items when ready cash is needed. However, some items, like jewelry inherited from a family member, are often left in pawn for extended periods of time when the customer knows the trader will not declare the accounts dead and sell the valuables. When others need help these valuable items are not available to give. Whether intentional or not, keeping items unavailable in an economy in which many things circulate through cooperative networks suggests a practice similar to that discussed by Annette Weiner as "the paradox of keeping while giving."[57] Finally, pawning represents a way of converting assets that are not subject to scrutiny by social service representatives administering public assistance. Jewelry was not considered an asset when qualifying for assistance, so if a trader cooperated by withholding names and cash values available through the pawn system, a customer may

have used it as a source of unreported income. Adams noted this practice at Shonto.

During the 1950s, tribal regulations required that traders hold pawn for six months at no interest. However, after six months items could be sold for whatever price the trader could obtain. Pawn at Shonto and other posts bore little resemblance to these legal restrictions. Small items such as bracelets and rings turned over more quickly, while silver belts and larger items were held as long as it took to carry the account, whether thirty days or two years. From some traders' perspectives, pawn was "dead" not at the end of six months, but when the expected term had expired or the owner had given direct or indirect indication that they did not intend to redeem the item. According to Dorothy Hubbell, the Hubbells never declared pawned items "dead."[58] Indeed, Hubbell Trading Post National Historic Site today controls a significant collection of Navajo silver jewelry that had been left in pawn as far back as the early trading years.

Most reservation trading posts discontinued pawning in the 1970s after publication of reports by SWID and the FTC, both of which harshly criticized the practice and recommended stricter conformity with the federal Truth in Lending Act. Both of these reports targeted abusive practices by some traders while ignoring reputable practices and any advantages to Navajo customers.

Before the FTC investigation, pawning regulations were not very cumbersome. A trader could offer whatever amount of money he chose using the pawned item as collateral. Some Navajo customers sought the largest amount they could borrow against an item while others asked only small percentages of an item's value in order to insure they could repay the debt or to meet an immediate and specific need. Pawned items were then held for sixty days. The time period could be continually extended for two months if the person who pawned the item paid 25 percent of the amount due before the expiration date. Then the trader was required to place the item on conspicuous display thirty days before the expiration of the redemption period as a reminder to the debtor. After thirty days, the trader was allowed to sell the item for any price he could expect to obtain and keep the money from the sale as payment for the debt. If, for example, a trader loaned $2.00 against a pawned silver necklace, he might be able to sell the necklace for $8.00. Thus, traders

had the potential to earn large profits on the sale of dead pawn if they chose to sell. As mentioned previously, the Hubbells and some other traders did not generally sell dead pawn, so the FTC report's criticisms were not well received by many reservation traders. The more stringent regulations subsequently implemented by the FTC required more paper-work and required profits from the sale be turned over to the customer. Thus, most reservation traders discontinued pawning. Today pawning flourishes in the border towns where it is not regulated. In the Native American art establishments, pawn is generally reputable and often bears the relational resemblance to former reservation pawn. However, other businesses that accept all kinds of merchandise in pawn thrive. Again, interest rates are not regulated and the businesses are not located in communities from which the goods originate. Thus, there is tremen-dous opportunity for exploiting legitimate requests and also for moving stolen merchandise.

None of the cited literature has adequately examined Navajo actions in these exchanges. Trade exchages took complex forms, not only in their economic aspects, but in their intercultural forms as well. That is the subject I will turn to next.

"PLEASE, MY SON, MY RUG IS WORTH THAT MUCH"

Most literature on trading posts discusses the trader's perspective.[1] While valuable, these sources give only glimpses of Navajo experiences and the role a Navajo practice of helping might have played in trading post exchange. That practice was fundamentally important in shaping satisfactory trading post relationships, many of which are still important today. Trade relationships must be understood as holistic, long-term social relationships, including not only interactions across the trading post counter but also trader-Navajo exchange outside the trading post context.

Many Navajo people were and are uncomfortable with denying requests for help and with requesting help when there is the possibility of denial.[2] Extending this understanding to intercultural trade further illuminates Navajo values and experiences. Navajo approaches to trade relationships are sometimes characterized by deliberation and wariness. Generalized wariness is consistent with the discomfort that accompanies a possible denial of help. This awareness is crucial to understanding Navajo behavior and priorities in trade situations. Customers most often made requests for help with each item purchased. The trader then had several opportunities to offer help during the course of the transaction. The process of the transaction was one in which both trader and customer worked through the appropriate protocols.

While Gilpin described nonverbal trading behaviors, only Frances Wetherill offered a narrative of the verbal interaction. Wetherill, who wrote under the pseudonym Hilda Faunce,[3] was married to trader Win Wetherill,

and in *Desert Wife*, she described interactions that likely took place in the 1920s or 1930s at the Black Mountain Trading Post in Arizona. Given their nature, these trader-customer interactions likely took place over the course of a day or more. I quote one passage at length, as it illustrates many Navajo trade protocols and the diverse cultural understandings of the trade relationship.

> I was beginning to know a little what to expect from the Indians, and, of necessity, I learned rapidly the Navajo words for articles in the store. Our customers enjoyed teaching me and would point to sugar, coffee, tobacco, pants, and repeat endlessly, *eshinlcaon, co-weh, natoh, clagi-e* [sic], until I could say them with some shadow of the correct accent. The terms for money were the hardest for me; but the Indians were one hundred percent, good as beggars, and it was the lingo with which they tried to wheedle us out of everything moveable on the place that I first learned. "My dear grandmother," one would begin. "Come into this corner with me. We will speak slowly and not get mad. The children at my house who call you mother are hungry. They cry and call for candy and bread. One has a stomach. He said his mother would send medicine and apples and candy to him by me. Your children need shoes. In six months I will cut my wool. Allow me, my mother, my sister, my pretty younger sister, to owe you twenty dollars until I shear my sheep. This will make all your children who live at my house warm. Other Navajos may lie to you and never pay their bills, but I am not like those crows and coyotes and gamblers. I never lie; I do not know anything about cards; I never go where cards are. I work at home—haul wood, shear sheep, and look after my cattle that these thieves or gamblers do not steal them or eat them. See. My coat is worn out and no good. Let me have a new coat. Let me owe you four dollars for a new coat. Is this one four dollars? It is very thin and ugly for four dollars. But I am poor, so I will take it. And some shoes? Three-fifty? Oh, my mother, let me have them for three dollars. See, they are poor ugly things. Three dollars is lots for them. And you must give me a pair of socks for friendship, because I am your very good friend. I tell all Navajos how nice you are, how you feed any one who asks it and give apples and

candy to all the children who come to your store. Put some sweets in a bag, and I will take it to your children and tell them their mother sent it. Is this good flour? It looks black; it may be wormy. Give me a knife and I will cut open the sack and look at it. My wife will be mad if I bring poor flour. You use it? Is this what you make bread of? Bring me a piece of bread. Maybe you lie. The bread is good. May I see the sack you used? I can tell by the picture on the flour sack if you are lying about the bread. How much do I owe you now? Twenty dollars, plus four, plus three-fifty? Twenty-seven fifty? I will trade two-fifty more and then I will remember, thirty dollars. I never could remember twenty-seven fifty. In fifteen days my wife will bring you a blanket. The blanket is big and will be worth ten dollars, maybe twelve. It would bring fifteen dollars at Chin Lee, but my wife will bring it here and take twelve dollars because you are her sister. And my wife wants any empty lard pails you have. Bring me the one I see on your shelf now. Have you a sack? What shall I carry all this stuff home in? Give me a sack, mother, a poor ugly gunny sack will do. None? Then I must use my robe and I will be cold riding. Give me some strong twine to tie this robe so I won't lose my sack of flour. More than that, make it strong enough for a hair string. See, my hair string is dirty. I need a new one. It's a long way to my house and my horse is tired. While he rests I have time to eat. Give me a can of pears and a box of crackers, because I live a long way off and come all this distance in the cold to trade with you because I know you are good and we are friends. That's right, that's good. This is for friendship. My mother doesn't want money for this, because she feeds her friends. Have you any coffee made? No? Then bring me a cup of water and pass me a spoon and a can opener. May I have the spoon? Your little boy that lives at our house lost the best spoon we had. I'll take this one. Thanks, my mother, good, good. Now I go."[4]

As the above passage illustrates, trading was approached with wariness and some distrust by both the Navajo customer and the Euro-American trader. While Wetherill spoke of Navajo customers attempting to bargain for everything moveable, her customer was concerned that she might sell him substandard merchandise or charge unduly high prices. However,

both the trader (illustrated by the cooperative actions of Hubbell dis-
cussed later) and the Navajo customer tried to establish trust across
cultural and colonial boundaries.

The passage further illustrates that Navajo customers went to great
lengths to teach traders their preferred protocols for successful trading
relationships. Customers taught language, naming items and explaining
ways to respond to their requests. Then, the customer created a kin
relationship with the trader, in this case a woman. What "mother"
could sit among all the material goods in the trading post and not use
them to feed her hungry "children"? The customer shifted the respon-
sibility for the children's welfare to the "mother" who had the means to
care for them.

Wetherill's customer then went on to assure her that he was a good
relative. He did not lie, cheat, or gamble, and he worked hard at making
a living for the family by caring for their livestock. According to the
customer's reasoning, the trader is cooperative if she in turn cares for
her good relative by selling him on credit the things he needs and that
she has readily available. He requests by making his need known and
leaving it up to her to let him take a coat. According to the spirit of
generalized reciprocity, goods should circulate. If left in one place, the
goods and the people associated with them cannot live. Life is motion
and process, and goods given as gifts or on credit will result in other
things coming back to the trader.

Wetherill's customer placed a great deal of emphasis on receiving a
gift of socks over and above the things he wanted to charge to his
account. He further emphasized that the trader should feed him and in
return he would tell all Navajos that she respected them and lived her
life according to this particular cultural ideal. In the customer's view,
because Wetherill had been such a good friend, the customer's wife
would reciprocate by bringing a blanket, so he simultaneously began
bargaining for the best price on this future exchange.

The narrative offers other examples of Navajo agency and positioning
in trade relationships. The Navajo customer was apparently prepared
to bargain on the basis of both quantitative and qualitative standards of
value. Wetherill's Navajo customers knew the value of money in trans-
actions, and the customer's statements confirmed this. The customer

communicated that he can and will take his business elsewhere if Wetherill didn't live up to her responsibility in the trade relationship.

My discussions with Navajo weavers and other trading post customers confirmed that the Navajo ideology of helping was and is of fundamental importance in developing what I define as trading protocols. Several of these were illustrated in Wetherill's narrative:

> Ideal trade relationships are those in which kin relationships are established and maintained.
>
> Ideal trade relationships include an exchange of knowledge as a form of help.
>
> Ideal trade relationships include non-material and relational forms of helping, such as telling others about a trade partner's cooperative actions.
>
> Ideal trade relationships include selling on credit, pawning, and offering loans when the trader has the ability to help those in need.
>
> Ideal trade relationships include gifts given in addition to the goods acquired through trade.
>
> Ideal trade relationships are those in which goods, other objects, and knowledge continue to circulate among people.

These concepts can also be seen in stories that Navajo people told to me about their past trade relationships.

Stories of Trade

Stories of trade are historical accounts of people and events. Oral stories, like written accounts, are products of the cultural and historical conditions and the subjects who produce them. However, unlike many written accounts, stories are relational, marking time according to relationships among people, places, and events rather than according to a calendar. In this sense, stories are also ideological devices that serve multiple purposes. They are tales of lessons learned in the past and useful in the present. They also contain multiple levels of knowledge.

I employ stories in this chapter for several similar reasons. First, to offer accounts of Navajo experiences of trade, particularly with Hubbell at Ganado. Second, they reveal much about the articulation between

Navajo and Euro-American economies during the early twentieth century. Third, and perhaps most important, such stories are often used to convey information about Navajo experiences, protocols, and critiques related to late-twentieth- and early-twenty-first-century trading relationships.

There is no question that Hubbell and other early traders were motivated by their desire for monetary gain, chiefly from the potentially lucrative wool trade. Hubbell practiced each of the discussed exchange forms—barter, tin money, credit, and pawn—while creating situations of credit saturation and relationships of dependency among Navajo customers. We can get a closer look at these kinds of transactions through a story told to me by weaver Grace Henderson Nez at her home in Snake Flats, Arizona. Nez took her first rug to Ganado and traded it to Naakaii Sání in 1918 when she was five years old. Her account of her first rug trade was full of laughter, so I assumed she enjoyed recounting the experiences from her childhood.

> That's when Hubbell Trading Post was there. There were no automobiles, just wagons. I took my little rug over to the trading post. I made it all *nóódǫ́ǫ́z*/striped with black speck design. When I took it over there, the trader teased me. The Mexicans were working there. My rug cost $5. It only cost $5. My socks had holes in them. They were about this high. I bought those. I was happy about it. I also bought some apples. That's all they had back then. They didn't have any other things. I bought myself a safety pin. That's all they used to have. I recall that was all I bought. That's how I started weaving. He [Hubbell] was laughing about me. He was laughing about me, but the way I was taught my rug wasn't crooked. It was perfect. He told me it was very nice. When I got home, I asked for another warped loom. I was told to wait until I spin my yarn or card my own wool. Yes. After many days passed, that's when I started on another one. I did many afterwards. They set up the loom for me, but this time a little bigger than before. I was told to weave the designs a little fancier. "Do it like this," they would tell me, because sometimes I would string the yarn a little too far. "Unlace the yarn!" is what they would tell me. So that's how I learned. So that's what happened. So like I said, that's how I learned. Yes. I don't recall how much I sold my [second] rug for. It cost a little more than my first one, maybe around $12.00, some where

around there. Back then they didn't have shoes, just the ones you button from here. That's all they had. "I want those shoes," I said. So that's what I bought, my shoes. They would tell me that I was taking too long to button up my shoes and they would tell me to hurry up and bring in some wood or something. You didn't tie shoes back then. They were like this. They were like this. They were very thin shoes.[5]

Nez's story resonates with many stories told by older weavers who traded at Hubbell Trading Post. Many women learned to weave *nóódǫ́ǫ́z*, or striped rugs, as young children. I was often told that a weaver was "not supposed to sell your first rug," but I seldom met weavers who had not taken or sent first rugs to the trading post. Some young weavers, accompanied by their mothers, took their first rugs to the post to trade. Other weavers' relatives took the rugs for them. Some weavers said that they did not go to the trading post as children because "someone had to take care of the sheep." A few told of hiding in the wagon to accompany their parents on the trip. Some remembered being afraid of the trader, or being taught by their mothers and fathers to be afraid of the trader "because they're told that he wants some girls." In any case, to Navajo children the trading post was truly an exotic place.

Weavers and non-weavers alike remembered Naakaii Sání's hospitality. He was known for feeding people and their horses upon their arrival at the trading post. These actions, no doubt products of both his Spanish heritage and his awareness of Navajo courtesy, are among the first things people tell today when talking about the trader. Grace Henderson Nez continued,

> He was a very kind man. He really spoke Navajo, too. He was very kind to us. He would always give us apples, because there were no sodas back then, only apples and oranges. And he would always open up a can of tomatoes and he'd put sugar in it for us, also some bread, and he'd tell us to eat first. When we'd visit him or bring a rug, and when they'd take me there it was like that, too. He was very kind to us.[6]

My field study showed that weavers who sold their first rugs between 1910 and the 1930s to traders in the Fort Defiance and Chinle agencies received between three and five dollars in merchandise. Traders established

the prices they paid, and apparently there was little room for negotia-
tion. Later in their weaving careers, some weavers acquired extensive
knowledge of pricing and began negotiating values in their exchanges.
"I decided to set my price after I became aware of pricing."[7] Like Nez,
many weavers remembered exactly the merchandise they took in trade
for first rugs, such as Nez's safety pin and a bar of soap for Evelyn Curley.
Weavers often received packages of dye in trade that they then used to
dye yarn for a second rug.

Child weavers like Nez who took their rugs to the trading post
remembered Naakaii Sání encouraging them and teasing them. He
would say that their rugs were beautiful, and he would give them fruit
or tin money as gifts outside the trade. His encouragement was remem-
bered and appreciated by weavers, and it is now remembered as a sign
of respect.

Laura Cleveland remembered selling her first rug. "The trader said
to me, 'You're such a little girl, you wove a beautiful rug. It's good that
a young girl like you weaves. You can start selling me your rugs.'
That's what he said and he was thankful. He said he wanted to keep
it."[8] In addition to encouraging the young weaver, the trader himself
emphasized the relationality of the trading enterprise by acknowledging
that her weaving was help to him and his business.

While many weavers paid close attention to the quality and pricing
of other's work, criticism of another's work or holding one's own work
above that of others was not considered cooperative behavior. Traders,
however, were respected for making and communicating these distinc-
tions. Part of trader encouragement included recognizing and distin-
guishing individual weavers according to the quality of their work,
which was part of their integrity as persons.

Laura Cleveland continued weaving and trading rugs.

> After I brought another one in, I don't think he said anything. He
> would just laugh about it because the sides of my rugs never
> went in. He liked my rugs. He would tell me, "Even older women
> bring in rugs with the sides going in but yours is not like that."[9]

Many weavers remember the traders' comments about quality and aes-
thetic preference. Early traders introduced standards of quality that are
still discussed today. They encouraged weavers to use evenly spun

yarns, to produce blankets and rugs with straight edges, to use evenly dyed colors in harmonious combinations, and to incorporate design motifs that historically appealed to Euro-American customers. This criticism or advice is most often remembered as helpful. Interestingly, in spite of stories of trader preferences and criticism, traders like Hubbell and Lorenzo, Jr., are remembered as buying each and every blanket or rug that was brought to them. Some Navajos remember them never turning a weaver away. Today, advice about quality and aesthetics is sometimes negatively understood as the traders' ways of lowering their offering prices.

Despite the idealized picture represented through these stories, many weavers also recognized tension between trader encouragement and their compensation. Though exchanges were in goods and tin money, traders evaluated each blanket or rug according to a moneyed standard. And, with some exceptions, such as large, commissioned rugs and the weavers' first rugs, the prices were determined by weight. Since weight was not a quality valued by weavers, they apparently experimented with ways to accommodate the traders' preferences for "heavy" rugs. Mary Lee Begay shared some things she heard about weavers' strategies.

> They would help one another with plant dyes and my mother would help with that. She would help build fires and make dyes. When they finished the rug, I think they sold their rugs by the pound. Anyway, they placed their finished rug in the ground. When they placed it in the ground, it will dampen and weigh more. . . . That's how they sold their rugs.[10]

The more exclusively social activities associated with exchange are also prominent in memory. Stories are told of traders who gave additional gifts to customers. Gifts of tobacco and food were common. Assistance took many other forms as well. For example, Naakaii Sání was remembered telling one family to help themselves to his firewood when he heard the man of the household was ill and not able to chop wood for the family. Other traders practiced these helping strategies as well. Jáá'íí, Wilmer Roberts, at Jeddito Trading Post apparently helped families in need, including Laura Cleveland's. "He would ask my mother how much groceries we have left at home and she would say we have little groceries left. And he would put food like flour before her and tell her she didn't have to pay for it."[11]

Trade Outside the Trading Post

Trade relations were not restricted to the post. As previously discussed, Hubbell and other traders who purchased raw wool often estimated the amount of wool they could expect to receive by visiting customers' homes and surveying their flocks. Hubbell often brought gifts, and these visits were seen as "helping" social visits by the families in question.

The trading economy also included a sexual component. A few early traders like Thomas Keam (and several traders today) married Navajo women and raised families in local communities.[12] Some Navajos in the Ganado community tell stories of Roman Hubbell's first marriage being a traditional Navajo wedding ceremony. He later married Euro-American Alma Dorr, and after her death, married Dorothy Hubbell, who survived him and sold the trading post to the NPS. In case of marriage, traders were and are often held to the standard of obligations of a son-in-law in Navajo matrilineal society. These obligations included working for their wife's family, specifically their mother-in-law. However, many traders, including Hubbell and one of his sons, Roman, fathered children in Navajo communities outside of marriage forms recognized in the Euro-American legal system or churches. I intentionally distinguish between recognition of marriage in Euro-American churches and courts and recognition of marriage in a traditional Navajo way. In the traditional Navajo world, sexual relations between a couple constitutes a marriage and children establish a family. Stories are told of marriages between both J. L. and Roman Hubbell and Navajo women in the trading post communities. The stories include accounts of both Hubbells referring to particular women as their wives and acknowledging paternity of these women's children. Other stories, however, indicate that the Hubbells did not always acknowledge or support their Navajo children.

These relationships were entwined with trading post economics in a complex web of gifts, obligations, and expectations. For Hubbell, with his Spanish upbringing, sexual conquest and the ability to take care of a large extended network of people were symbols of the kind of honor befitting a Spanish "don."[13] This ideology meshed with Navajo matrilineality and the helping economy in interesting ways, as a weaver who asked not to be identified explained.

This man really helped the Navajo people. They helped one another. He played an important role giving people credit. He helped my family a lot and we've increased so much. He gave us life, or life improved through helping our grandparents. That's how the story goes. People would come to the trading post, and he would give them groceries, but it turned out that some women bore children for him. They are now grown adults. And people say those are his children and nice looking. . . . That was what they did to get groceries. That's what the ladies did. In return he gave them children. This is not a good story to tell. So that's how he helped the Navajo people. He gave us beautiful children and we're thankful about that, too.[14]

In Navajo communities, this is a complicated and controversial story, particularly in the present-day when government-imposed ideas about blood quantum and blood purity are conflated with issues of national, ethnic, and cultural identity. There is a wide diversity of opinion about the actions of traders and their exploitation of Navajo women customers in desperate economic circumstances. Some of the traders' descendants acknowledge the trader relationships as part of their ancestry, while others consider it a more private matter. However, in Navajo society a child's primary source of identity is through the matrilineage. The statement offered above, and other stories, indicate that these children were sometimes looked upon as gifts to the matrilineage. An anonymous source explained, "We call them 'our stolen ones.'"[15]

The traders' Navajo wives and descendants sometimes had unique roles in the trading post relationship. Though neither of the Hubbells apparently took an active parenting role in raising their Navajo children, they did provide for some of them in a material sense through trading post transactions. A Navajo wife of Roman Hubbell (the same woman he is said to have married in a traditional wedding ceremony) brought a cow to the trading post to exchange for groceries and other supplies for her family. The transaction was apparently carefully negotiated item-by-item. When the transaction was complete, the trader apparently said, "Take this cow back. It belongs to my daughter," and returned the cow to his wife. Other descendents' memories, however, might be more painful. One descendent experienced jealousy and prejudice in the

community because of the support. Some community members allegedly likened the person's worth to a sack of flour because they were conceived through a trading liaison. Another remembered chopping wood to heat the schoolroom where Hubbell's Euro-American children were taught while not being provided with material support, acknowledgement, or education.

These stories add a dimension of reality to accounts that have tended to be trader-centered. Navajo customers' stories reveal that the social relations of trading were paramount. Navajos who traded with Hubbell possessed a clear sense of his affluence and were also aware of their roles in helping him toward his prosperity. However, Hubbell was also well aware of appropriate behavior of both the Spanish patron and the Navajo cooperative person. He manipulated both perspectives to his advantage in establishing and maintaining cooperative relationships with some Navajo families. They in turn appreciated his prosperity because he "was here just to help the Navajos."

The social relationships established and maintained through trade should force a rethinking of more strictly Marxist and quantitative analyses of the trading post era and Navajo economies.[16] While analyses of available trading post account ledgers like Hubbell's indicate that traders seriously exploited Navajo labor and products for their own gain, the ledgers are only one dimension of far broader and more complex economic exchanges. The Hubbell ledgers do not show gifts "over the counter" that completed a transaction. Nor do they usually indicate gifts of food, goods, or tin money taken to a customer's home, though I located one ledger entry recording $10.00 cash given at a customer's home. Most home gifts that Navajos remember were groceries, supplies, clothing, or tin money in far smaller denominations. Ten dollars would have been an extravagant gift under any circumstance and may have been a loan or credit toward some larger project rather than the customary gift given at a home visit. It is impossible to provide a clear picture of the "dollars and cents" of early transactions.

Trader-Weaver Exchange at the New Millennium

A great deal has changed at trading posts in recent years. Barter is still a mode of exchange, but it is limited for the most part to exchange

among artists and craftspeople who can still exchange rugs for jewelry and other goods. Bééshkagí, of course, went out of use in the 1950s at Hubbell Trading Post, and the lightweight coins are now collector's items.[17] Many trading post exchanges are cash transactions, but credit and combinations of "cash and trade" are still significant at some posts, like the Two Grey Hills Trading Post and R. B. Burnham's Trading Company at Sanders, Arizona. A certain degree of credit saturation can still take place, but Navajos have many additional options in convenience stores, supermarkets, and general merchandise stores on the reservation, as well as major supermarkets and chain stores such as Wal-Mart in the border towns. While one or more people in the family might maintain a credit account against a monthly check or rug in progress, these same weavers and other family members might also bring home wages and salaries. These income sources enable the family to shop in places other than the trading posts.

Credit saturation and the dependence on one trader or trading post also decreased with regulations the FTC put on pawn transactions in the 1970s. As pawning activities shifted to such border towns as Gallup, Farmington, and Flagstaff, the positions of trading posts and traders within their communities were altered profoundly. As one trader told folklorist Laura Marcus, "We used to be the hub. Now we're just one of the spokes."[18] However, some posts, like Two Grey Hills and Burnham's, for which sales of Navajo textiles are integral to their operations and reputations, span the divide between traditional trading posts and art galleries. The relationships among Navajo weavers, traders, and the customers who purchase Navajo textiles are still part of a complex economic system. The system is still seen by many weavers within the Navajo ideology of helping. Many weavers are profoundly aware of the relational nature of the system, with individuals playing different and interdependent roles. Some weavers are concerned about their dependency in the system and convey a sense of alienation when they discuss the future of their way of life. Martha Tsosie explained it thusly:

> My *nálí* (paternal grandmother) and my *shimá sání* (maternal grandmother) would always tell me that I am going to weave the rest of my life and also that I will be supporting my children with it, too, and there's nothing else that I can do to support them with.

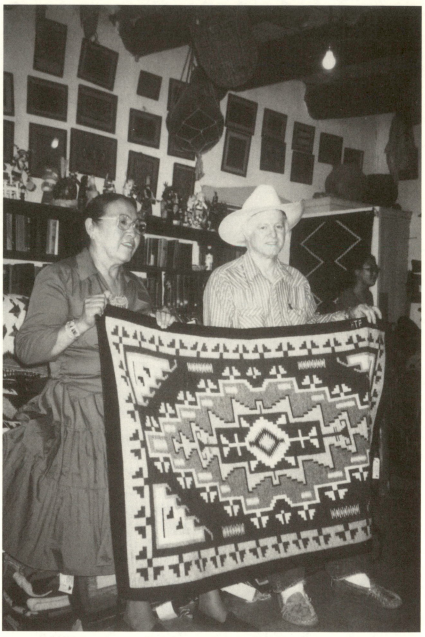

FIGURE 16. Helen Kirk and Billy Gene Malone in the Hubbell Trading Post rug room. Photograph by Teresa J. Wilkins,1996.

And the children today don't know how to weave. They are busy going to school, and that's how I see it today. I always wonder how it will be later on. Maybe in five years the traders at the trading posts won't still be buying our rugs. There will probably be no more buying rugs at the trading posts, and it seems like it's going to be like that soon. Or maybe they will only sell books of weaving and the buying of rugs won't be anymore. It just seems that way.[19]

Trading stories offer Navajo weavers opportunities to teach about proper cooperative behavior. In Navajo traditions, words and thoughts contain as much power and force as actions. Negative or critical statements not only bring to life unfortunate or dangerous circumstances from the past, they also create disharmony for those who speak and those who listen. Thus, a cooperative person thinks carefully about his or her choice of words and their consequences. This caution, in addition to the awareness of the textile market as a "helping" system, sometimes results in weavers using stories to indirectly criticize traders and trading relationships. Early in my field study, I wondered why weavers seemed reluctant to criticize traders and discuss their unsatisfactory experiences. I wondered whether this was, in part, due to general dependency on traders and the system, and, in part a guardedness about what to disclose to a researcher. I soon learned to listen more carefully, and became aware of a pattern in weavers' statements. When they praised the past trading relationships, they ended their stories with a brief comment on the present. Marie T. Begay's statement is one example:

He [Harold Spring at Sunrise Trading Post] really helped us with the lambs. You know, we have sheep? When we'd sell lambs he would give us free food and shoes, clothes, or quilts. I remembered all that and that's why I said I cried when he died. Yes, he was like that. And he used to do whatever we asked him, even money. We asked to borrow $100.00 and he would loan it to us. But today traders aren't that reliable.[20]

Evelyn Curley's statement followed the same pattern.

He [Bill Young at Hubbell Trading Post] was the most helpful. He was very nice and so was his son. He was a good trader. When

you brought him a rug and named your price, he would try his best to meet your price, whatever that might be. He was like that. This trader now is different.[21]

These descriptions of past trade relationships offer a glimpse of ideal Navajo trading relations, such as gift-giving, loans, and meeting the weaver's price, as they were remembered from past experiences. Further, they offer the opportunity to indirectly criticize present traders for not exhibiting cooperative or helping behaviors. This indirect criticism is similar to the way the Navajos can criticize a relative for not helping while still respecting their individual autonomy.

Through stories, weavers recounted to me a set of what I call "ideals" that constitute trader "help." These ideals are illustrated by comments from several weavers.

1. Traders (and customers) help by buying all rugs offered to them.

 A long time ago you just had to bring it in. It didn't matter if it was ugly or not. The man just wanted to help people out. He used to buy them a lot just so he can help people. Today everything is different.[22]

2. Traders help by offering good prices for the rugs they buy. This, in return, demonstrates their respect for the weavers' hard work.

 They buy our rugs cheap and in return they sell it several times more. I wish it wasn't like that. That's what I think and say sometimes, so it seems like we really pull the traders a lot.[23]

3. Traders help by not overcharging their customers and keeping the textiles circulating, thus operating within the ideology of moderation.

 I thank the traders for buying rugs from us. Who would give that much money away in one day? I just sometimes think they think that way. And here we bargain for prices we want, but on top of that they double, triple their prices. That's why their rugs are just stacked there. . . . I told the traders not to do that all the time but with the high prices they don't sell much. They're just stacked there. I told them, "It's your doing, that's why they're just stacked there. Don't give them that much in price, just add a little to what

we sell them for. Maybe that way you'll sell more rugs. Right now you're tripling your prices."[24]

4. Traders help by appreciating hard work over and above the market standard of quality.

Today I talk about how it was back then. I find that our rugs are priceless. It is hard and a lot of work and yet it costs less. The traders don't see all the work the weavers put into their weaving. These traders don't appreciate all the work we put into rugs. You have to go out and gather the dyes. It takes a lot of water just to wash the wool.[25]

5. Traders help by allowing credit against rugs in progress.

They would get credit against rugs they were weaving. And for myself I do the same. When I run out of money I get a loan from Sedona. That's how we helped one another. That trader is fond of us. When I ask for a loan he lends me about five hundred dollars. This is against my rug I'm weaving, and when I finish, I pay back and I get a little bit of money. I stand there about to cry [laughs]. They really respect my rugs. He sells wedding baskets. He adds on a basket for me. He likes my weaving.[26]

Jeehkał [Roman Hubbell] helped out my parents to get food through credit. That's how he helped them. He used to help them a lot, and in return my father paid him back. Like when we run out of money, he would lend us money. It's still like that with that white man, Bill [Malone]. That's how he used to help my mother and my father. And they would pay him back with lambs and they helped each other. I don't know how many years they've been helping each other.[27]

6. Traders help by giving something after the transaction is complete. The transaction should not end with the exchange of a rug for money. The process of giving should continue.

Sometimes it's the right price. What you think it would cost and then it's more with bracelets and necklaces he would give you or even a pin. He would add that with it. The ones that are good. And that would just be a thank you.[28]

He helps me, too. He gives me sodas. That's how we know each other.[29]

Why are traders expected to conform their business practices to the Navajo ideology of helping? In the Navajo view, all the spheres of circulation within which textiles move are part of the process of weaving. These encompass production, sale, consumption, and use. All spheres build and maintain relationships and function for the good of the whole process. Weavers with their looms produce living rugs that, through exchange, provide life's material necessities. Traders sell rugs to buyers and continue to buy other rugs.

Rugs are often woven in homes where family members assist with such activities as constructing looms and tools, gathering plants for dyes, as well as shearing, washing, carding, and spinning wool fleece into yarn. Design motifs and layout are often discussed by family members.[30] The process of weaving, called *dah'iistł'ǫ́*, is also a process of creation. The resulting textile then embodies the weaver's "thinking" and her work. Throughout the production of the textile, many weavers take precautions to insure both the success of the rug-in-progress and their ability to continue the weaving process with the next rug. The often-discussed "Spirit Line" or "Weavers' Pathway" is one such precaution.[31] The resulting rug is then a person, created by the weaver and loom, and is a part of both. "Your design is your thinking, so you don't border that up. It's your home and all that you have. And so, if you close that up you close everything up, even your thinking and your work."[32] For many weavers, the pathway offers a means to complete one rug while insuring that they will continue the process by creating another rug. It is important to note that this belief about the pathway is not universally shared. Some weavers say that the pathway was required in their designs "or the white people won't buy them."

While weaving, each person thinks about how to price her rug. Pricing is an individual and private matter. Many weavers shared rug prices with me, yet asked that I not publish them. For weavers, pricing depends on both quantitative and qualitative factors. While a few weavers mentioned the amount of time, materials "and the light bills because I sit up weaving from night till dawn," many strategized according to other criteria. One important criterion is the weaver's opinion of the quality of the rug. Darlene Shirley explained:

Well, when I weave a rug, you know, I think about how much design to put in and then from there, you know, I look at it that way. And then to make sure my edges are kind of straight now and how much design I put in there, and I usually go by that and set up a price.[33]

Other weavers price their work according to the amounts they had previously received for similar rugs.

Finally, other pricing criteria are directly related to a Navajo preference for movement over accumulation. Many weavers view money not as wealth to accumulate, but as a means to another end, like school clothes, tuition payments, or ceremonial or other family needs. In some cases, a weaver may ask a very specific price for her rug, such as $278.91, which will enable her to achieve a specific end, like making a vehicle payment.

Still other weavers practice an ideology of moderation in which they do not believe they should earn high prices for their work. Martha Tsosie explains how material success can be brought into balance within the ideology of moderation.

I know I have woven lots of rugs. I probably made thousands of dollars from weaving and they say you are supposed to be thankful for it. Every so often you are supposed to—maybe in peyote or maybe you are in that—you go in. Maybe you bought something that cost a lot of money. You are supposed to tell these things about yourself. Then whatever amount of money you made, you are happy and you thank the Lord. Then you feel good and everything is good for you again. From then on the money will grow for you, and you will be living good again, I hear. And then in Navajo way they say that if you make more than you normally do, then you are supposed to get a medicine man and make a prayer for you. Just for that you have that done.[34]

Often those weavers who do earn high prices take other steps to maintain harmony and balance.

By the time the weaver has brought her rug into Hubbell Trading Post, she has labored many hours and much of her "thinking" is embodied in the muslin-wrapped bundle. She approaches the trader with wariness and discomfort similar to that when a Navajo person faces a possible

denial of their request for help. She wonders whether the trader will buy her rug or just say *"Béeso ádin"* ("No money!") the moment he sees her enter the door. If he buys her rug, will he pay the price she wants? Will he appreciate that her weaving enables him to make a living as well? Will he give her "something else," such as jewelry or soda pop— gifts that signal his gratitude for the exchange? Many weavers describe this sense of discomfort. As Helen Kirk explains,

> Well, it depends on the rug. If you weave it nice and for the dah'iistł'ǫ́, when you want it to be right it never comes out right. There's always something wrong with it, and it bugs you. Sometimes you think if he'll see all the mistakes. "Will he measure it?" You think all these things.[35]

If the trader does not immediately say "Béeso ádin!" he is likely to ask, "What do you want for your rug, shimá?" Trading etiquette dictates that further negotiations are carried out in private. If the conversation occurs in a large open area of the trading post, other local customers and trading post workers will often move away to a different section of the counter or a different room in the post. If tourists are present the discussion usually continues in the Navajo language. The weaver names her desired price and the negotiations begin.

Trader negotiations have often included a series of nonverbal actions the trader uses to communicate to the weaver that he is assessing the quality of her rug according to market standards. Adams wrote that a trader would not make elaborate gestures in scrutinizing a rug, lest he betray his lack of experience in evaluating a textile. In my experience, though, traders refrain from such gestures mostly when in the company of other traders and those knowledgeable about textiles and the market. But in the company of weavers wanting to sell their work, elaborate gestures of measuring and scrutinizing have often been used to justify the amount of an offer. Traders might take the rug and hold the sides along a straight edge of the trading post counter to check for precision straightness. They might lay the rug out flat on a counter or floor and examine sides, corners, and tension. They might look closely at specific motifs or colors. All of these actions were designed to communicate to the weaver, who often waits in silence, that her rug is being carefully evaluated.

Some weavers say they receive the price they want for their rug. Most, however, ask one price and the trader offers a lower amount. When this occurs, weavers generally exercise one of several options. Some weavers accept the trader's offer whether or not they find it satisfactory. Helen Kirk voiced her opinion about not negotiating.

> I don't really know how to negotiate. I just set one price and he sets it down lower. Then I just say, "Okay." That's all he says. People tell me "You should say like this," and I just say, "He won't buy it from me for that much."[36]

Others refuse to accept an offer that is not satisfactory. They then "take it around" to other posts or dealers, and sell it to the business that offered the highest price. Evelyn Curley often used this strategy.

> *"Yah di la olyei!"* There's usually several words exchanged. It's kind of difficult to say exactly what you say. You just try your best to stick to your cost. If that's not possible sometimes you have to just take your rug back and then you try again at other places.[37]

Still other weavers manipulate the "cash and trade" system by asking the trader for additional credit when their cash price is decreased. Mary Sadie Gorman said, "If they go down on the price I tell them to move up my trade."[38] Juanita Paul justifies her price to the trader by asking him to respect her labor.

> Like this one, if I finish I take it in and then before looking at it, they ask me, you know, "How much do you want for that rug?" And then you give them the price and then just like I said this one. If I take it in and I'll say $800.00. And they'll say, "No, how about $300.00," or less than that. Just like that Teec Nos Pos in there. That was a 3' by 5' and there was a lot of colors in there. I took it up to Twin Buttes somewhere up there in Utah, and there was an announcement on the radio that if you take your rug it sells good up there. "I can give you $75.00 for it," he said. "No," I said, "It's got a lot of work in there and it's a most expensive rug. . . . It's got a lot of work in it, and it's real hard to weave, sit at it. I like my work," I said. "When I sell it, give me a good price. I really enjoy it and I just want to keep on making another one. You've really encouraged me if you give me a good price."[39]

Other weavers ask the trader to add something like jewelry or groceries after the transaction is completed.

Finally, in their most powerful argument, some weavers employ the relational aspects of the ideology of helping. One weaver who practices relational negotiation is Sadie Curtis.

> When he says "I'll pay you this much," and I want $2,000.00, he'll say $1,600.00 or $1,700.00. That's what I meant, we negotiate and demand for that price. I would stand there and say, "This is how much I want. Please, my son, I want my rug to cost this much." That's how I persuade him and get my way."[40]

The most persuasive part of this argument is the phrase "Please, my son." By establishing a familial relationship, making the trader her son, the weaver puts the trader in a position of obligation. As discussed, a cooperative person should not deny a request. This applies all the more with kin relationships, especially between mothers and their children and mothers-in-law and sons-in-law. If the trader in question is at all familiar with Navajo kin relationships and values, then he or she would understand the obligation implied by the creation of that particular kin relationship. In fact, trader Bruce Burnham stressed that being put in this position makes it impossible to decline the request.

Many traders have developed formal and informal strategies for participating in the Navajo ideology of helping. Here is one noteworthy example that illustrates the ambiguity of contemporary trader positions and actions. One afternoon a Navajo weaver was asking for advice about pursuing a lawsuit against a trader. "You white people sue each other all the time and I think I need to sue someone." After she had been referred to a legal organization, she shared her story. It seems that an area trader had purchased one of her rugs. She was paid a cash amount, her charge account at that post was marked paid, and her sister's overdue account was marked paid as well. The weaver in question wondered whether she was responsible for her sister's debt and was upset about the matter. She has since tried to collect the difference from either the trader or, more often, her sister. She was not successful in collecting the money. Later I happened to be talking with a trader who provided me with a trader's view of the situation and explained how a trader might decide to handle this type of transaction. The weaver's sister had

a long-overdue account on the trader's books. The trader explained to me that he would have paid the weaver the price he would normally pay her for a rug of that quality. He would pay her in cash and credit her account. He would then price the rug high enough to cover the amount of the weaver's sister's account merely to "get it off the books."

Contemporary trading post economic relations maintain the unique hybrid character that they had in the late nineteenth century. The above example is one of helping through manipulating value in ways similar to those advocated by Lorenzo Hubbell, Jr., in his defense of tin money. However, the forms that "helping" and exchange take now are constructed by weavers' and traders' positions in a modern world.

CHAPTER SEVEN

Exchanging Places

Traveling to Teach and Trade

It was a hot July day in 1992 as I waited inside the cool chrome-and-glass interior of the Denver Art Museum. The event was the opening of an exhibition called "Reflections of the Weavers' World: The Gloria F. Ross Collection of Contemporary Navajo Weaving." I was to be contact person, guide, and coordinator for the Navajo weavers invited to Denver for the opening festivities. In the weeks leading up to the event, I had learned about the individual weavers and their work. In addition, I kept track of which weavers planned to come to Denver and how many family members they were bringing with them on their journey. I made arrangements with local hotels and assembled packets of information about the exhibits as well as other Denver attractions. I had learned the appropriate gentle handshake to offer a Navajo person, and now I stood poised to greet our southwestern visitors.

I am now aware that in journeying to Denver these weavers were reworking a hundred-year-old tradition of traveling to introduce non-Navajo people to their work. Since that exhibit I have pondered the ways that intercultural situations are sites for reworking traditions and negotiating not only cultural understandings of the individual but also concepts of value, and a venue for constructing market relationships.

Navajo weavers consider travel and demonstration to be "contact zones"—social spaces where people from disparate cultural traditions come together and negotiate situations. My perspective privileges the ways Navajo weavers constitute themselves and are constituted in relation to others who value their products.[1] While these encounters often

objectify Navajo weavers as spectacle, and thus potentially exploit them, they also enable Navajo travelers the opportunity to subvert stereotypes and actively construct their own identities on terms more or less of their own choosing. These encounters also reveal a complex web of relationships and appropriations of knowledge, experience, and authority among dealers, consumers, museum professionals, scholars, and weavers.[2]

In the Navajo traditional world, travel and experience are activities in which the exchange of knowledge and power are cosmologically authenticated through ceremonies and oral traditions. Thus, many weavers approach their traveling and demonstrating—as well as the travels of their rugs—with a great deal of interest and respect. Published accounts and stories told by Navajos reveal the social relations of travel, like networks, family connections, connections to new places, new experiences, and new meanings, during the early twentieth century when weavers, silversmiths, and chanters traveled widely and demonstrated their activities for Euro-American tourists. Some contemporary weavers also discuss traveling, demonstrating, and educating non-Navajos as fundamental responsibilities in their lives as weavers.

I am not the first to consider the significance of travel for Navajo people. Margaret Astrov analyzed motion and travel within a larger Navajo concern for the life process. Astrov emphasized motion to counter a representation that stereotyped Navajos as semi-nomadic, diffuse, scattered, and dynamic, in contrast to their compact, static, and centralized Pueblo neighbors. The concept of motion and travel permeates Navajo language, and creation stories, oral traditions, and travel themes are an integral part of healing and restoration ceremonies.

The Navajo language, which is constituted of hundreds of verbs and relatively few nouns, emphasizes process. Haile observed that for Navajos, "doing it so" is more important than "being something."[3] In the Navajo language, objects are most often referred to by "handling verbs," which are generally descriptors relating to an object's physical characteristics, such as size, shape, material, function, quantity, or containment. An entire volume of Father Berard Haile's two-volume dictionary of the Navajo language is dedicated to words and phrases connoting motion, movement, travel, and means of transportation. During my field research, I heard narratives of travel filled with detailed descriptions of a journey. I was initially interested in hearing of the events that took place at a

destination, but I learned the pattern of lengthy narratives. Stories included such details as which vehicle was used, who drove the vehicle, what roads they traveled, what landmarks they passed, where they stopped along the way, who they met, and what they discussed. The stories emphasized sequences of relationships between people, places, and actions leading up to events or conditions. These narratives then became stories sometimes shared as remembrances among family or friends who had journeyed together in the past, recreating the experience of traveling together.

The process of the journey is also emphasized in Navajo creation and emergence stories, in which the Navajos come from the First World through the Second, Third, and Fourth Worlds, finally, into the Fifth World—the Glittering World—our present shared material world.[4] In emergence stories, creation is by means of wind—motion—that perpetually transforms people and things already in existence.[5] These transformations occur through journeys from place to place, with the stories emphasizing the process of the journey rather than a particular destination. Journeys described in the creation stories delineate the boundaries of Navajo sacred geography by defining the six directions and the six sacred mountains. Army surgeon Washington Matthews wrote that the process of delineating the sacred geography was practiced in late-nineteenth-century Navajo life and that "this is the reason why the Navajos wander ever from place to place."[6]

Ritually directed movement in Mountainway and Nightway ceremonies results in ceremonial sanctification and restoration. Astrov described these ceremonies as travelogues, and cites numerous traveling songs that are included in both. Through stories about a series of travels, the Mountainway defines the boundaries of Navajo sacred geography and Navajos' attachments to the land. The Mountainway traveler receives power and knowledge from traveling and recognizes these as at once a source of great good and potential danger. The Mountainway establishes the traveler as a symbol of what is most sacred and most powerful. It offers purification from the dangers of a journey through a reenactment of the journey by storytelling. The ceremony then brings the patient back into relationship with other Navajo persons and the land. Travel also sanctifies through the Nightway ceremony. According to Nightway

narratives, a person is holy while they travel and their movement is associated with growth, fertility, and life.

The Navajo creation stories also exemplify the relationship between travel, place, and Navajo identity. The stories delineate the position of 'Asdzą́ą́ Nádleehé, "Changing Woman," as the primary deity and model for the life process of Navajo people, defining her task as that of keeping the universe in flux by way of motion. 'Asdzą́ą́ Nádleehé has an aversion to fixation and stasis of any kind. The stories also describe the origins of many clans through adoption of non-Navajos encountered during journeys. Eugene Bahe told me one such story.

> Years, probably years and years before the Long Walk, my family, a Navajo family, had lived at Canyon de Chelly and they decided to go and move out into the Jeddito area, they wanted to move out that way. When they were going out they found a Hopi lady who had a chain on her leg. It was all sore and swollen and she couldn't walk, and they found her because she had escaped from the Mexican slave raiders. They had her not too long and while they were sleeping she escaped and by herself, and somehow her family got taken. And she ran off from them . . . and she was trying to make her way back and the chain was heavy and infected her leg and it was puffy. The chain, these people found it and found her and finally cut the chain off and nursed her wounds. And so, she's not far from the village of Polacca. She just wanted to stay with the Navajo family because they had saved her life. Several times they went back to her relatives, but she went and stayed with them and became part of the family. The Navajo used to call her 'Asdzą́ą́ 'Adee', or "Lady With the Horns." Heh, heh, I guess the way she used to put up her hair—on both sides of her head, and she was very pretty. And she got into a man, she got married. And about that time, about the 1860s, she married and had her first child. She was a girl. Just about four days after she had the child the Long Walk had started and a lot of the Navajo people started moving. Even the starving, the ones who were hungry, well, they went along with it. And they went all the way to Bosque Redondo. And she stayed with them four years. When they came back, I guess they moved up to Canyon de Chelly. By that time

she had another daughter. I guess the other one was four years old when she had another daughter. And they lived on the south side of Canyon de Chelly right near the mouth of the Canyon. And they stayed there for fifteen years. And the girl was nineteen and the young one was fifteen. And they became very beautiful ladies, and there was a medicine man who was pretty well known at that time, probably about 1870 or 1880, and he became interested in the two girls and wanted them for his wife. The Hopi lady thought they didn't want to do it, so one night she got out her donkey and put all of her belongings on it and hid the two girls in her belongings. And the man went first and she went second, the man who was driving the sheep that they had, and she was driving the donkey. The two girls were hiding in the basket on both sides. It was kind of like a hide basket. So they stole away at night. And the next morning, the guy caught up with them. Way across, probably near Salina, around that area. They tried to hide up on top of the mesa, and he caught up with them. He searched and wanted to know where the girls were. And he threatened to witch them and kill all his family or their livestock so they told him that they just didn't have them, that they were just driving past there and the horses were at the sheep camp and the girls had stayed behind. They should be herding sheep for somebody down in the Canyon, she told him. And he went back, and that's the last time she heard of him. By that time 'Asdzą́ą́ Adee' was speaking real good, fluent Navajo. And the two ladies, the two girls, grew up, and one of them became my great-great-grandmother, the first one. She was part Hopi at that time. And they moved out to Antelope Canyon out near Jeddito. A little bit just near their people but she was about ten miles west of that. . . . Missionary there'd built a little mission about 1700 during the Pueblo Revolt in 1680, 1690 when a lot of the Hopi people were uh, were uh, a lot of the Hopi people had migrated to that. . . . And a lot of the missionaries were killed, it was during that period also. Ah, I'm trying to think back, it was probably late 1600s, and the Hopi had driven there and it was up to about 1700, that's when they destroyed the mission, burned the whole mission down and killed all the priests and all the Hopi that were converted. Lot of history there, too. At that

time they lived nearby, right down the hill on the west on Ante-
lope Canyon, [by] a small spring they call "Talahooghan." And a
lot of the Navajo and the Hopi, they farmed there together, and
today they've still got a lot of these natural springs that come out
and a lot of orchards, all kinds of fruit trees, and the fruit that was
planted there was planted by the group, my family, my great-great-
grandmother, and right about that time she also married and she had
children, and my grandmother was born around about that time.[7]

This story exemplifies Navajo identity formation as a relationship among
persons, places, and journeys, and as interrelationships with non-Navajo
people. 'Asdzą́ą́ 'Adee' was the mother/founder of the Tobacco Clan of
Navajos, who identify themselves as Navajo descendants of Hopi people.
In addition to telling the story of the origins of a Navajo clan, the travels
of 'Asdzą́ą́ 'Adee' encode historical narratives such as Spanish slave
raiding, the Long Walk and return to Navajo sacred land, as well as the
growth of the Navajo population.

 Astrov's argument for the primacy of motion in the Navajo worldview
is based on esoteric information not known to all Navajo people and
not freely discussed with outsiders. Nevertheless, some understanding
of travel as a means of obtaining power and knowledge illuminates some
of the meanings that travel may hold for Navajo weaver-demonstrators.
Navajos traveled and demonstrated at the growing number of Fred
Harvey Company tourist concessions. In addition, Navajos and other
indigenous people traveled to major United States cities to participate
in world's fair and exposition displays. Navajos made most of their
necessary travel arrangements through the local trader.

 One brief narrative likely describes the journey taken by Yanabah
Winker of Ganado, who in 1909 may have traveled to the 1909–1910
Chicago Land and Irrigation Exposition with her husband and their
small children.

 Naakaii Sání took us in his car to Gallup, then by train to Albu-
 querque. There we were met by one *bilagáana* ["white person"]
 and stayed in Albuquerque for three days under his care, then by
 train again to Chicago. I am glad I went among the white people,
 ate their food and had the experience of traveling, when some of
 these women tell me they have never been to Gallup.[8]

Winker's comments emphasize the process of the journey, places visited, and relationships with people. She highlights the value of their experiences, no matter how different from familiar ones at home, and the distinction travelers had within their home community. Even Winker's method of travel can be seen as significant—a number of weavers prefer to travel by automobile rather than plane because air travel is physically disconnected from the places they pass on the way to their destination. Ground travel at least affords travelers some experience of the places they pass through.

With the expansion of the railroad into the Southwest in the 1880s, the region became more accessible to greater numbers of travelers. A specific image of the American Southwest was emerging from travel, tourism, and government policy toward American Indians. These were founded on a theory of social evolution with the attendant belief that American Indians were remnants of rapidly dying cultures. The railroad also facilitated the exchange of vast quantities of consumer goods. Euro-Americans viewed this expansion as opportunity for both enterprise and entertainment. Expositions, fairs, Wild West shows, and the Fred Harvey Company seized the opportunity to entertain Euro-Americans by displaying indigenous people.

In 1876, Frederick Henry Harvey started a railroad food-service chain, opening his first location at the Topeka, Kansas, depot. Harvey restaurants and railroad hotels eventually played a central role in the opening of the American Southwest to Euro-American tourists. The Harvey Company's tour guides and waitresses were young, white, single women from the East and Midwest, whose presence and image assured potential travelers of the safety of the exotic Southwest.[9]

In 1901 J. F. Huckel established the Indian Department of the Fred Harvey Company. He later hired Herman Schweizer as its manager. Schweizer had managed a Fred Harvey Company concession at Coolidge, New Mexico, from 1887. While in Coolidge, Schweizer had begun buying and selling American Indian products. He spent extensive amounts of time riding on horseback around the Navajo and neighboring reservations, getting to know traders, weavers, potters, and silversmiths. By 1902 Schweizer was managing the Indian Department located at the Harvey Company's Alvarado Hotel in Albuquerque.

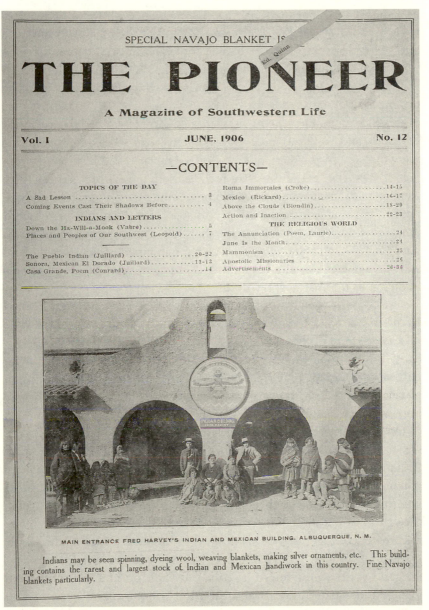

MAIN ENTRANCE FRED HARVEY'S INDIAN AND MEXICAN BUILDING. ALBUQUERQUE, N. M.

Indians may be seen spinning, dyeing wool, weaving blankets, making silver ornaments, etc. This building contains the rarest and largest stock of Indian and Mexican handiwork in this country. Fine Navajo blankets particularly.

FIGURE 17. Cover of *The Pioneer* magazine, 1906, showing Tom and Elle Ganado and other demonstrators at the Fred Harvey Alvarado Hotel in Albuquerque, New Mexico. Photograph by Milan Sklenar, 2004.

The Indian Department had a dual mission, both to build a collection of rare and outstanding American Indian items and to promote and sell American Indian products. Schweizer drew on his connections with traders to purchase those products he viewed as the finest (and most marketable) available. He likely originated the Fred Harvey practice of employing Native demonstrators. Schweizer relied extensively on Hubbell in a long-term business relationship that involved the exchange of goods and Native demonstrators. Schweizer's selections of goods were dictated by the demands of a tourist market, and his choices were sometimes a source of pressure for Hubbell, whose preferences were motivated by an anti-modernist interest in the primitive and the authentic. Schweizer discouraged the production of such Hubbell-promoted items as women's garments, stating that they would not sell at any price. And, in 1908 and 1909, Schweizer also complained of not being able to sell Navajo rugs containing certain design elements, like the swastikas and crosses that Hubbell favored.[10]

In 1935, Schweizer claimed that "millions of people have been enabled to see Indians and Indian exhibits on their way through Albuquerque who would not otherwise have had this opportunity."[11] What, specifically, did this opportunity afford the tourist? The genre of commodifying cultures through display was fundamentally situated in relationship to government policy for American Indians, and the Harvey Company demonstrators occupied a particular niche—they symbolized the success of the government's civilizing mission.

The government had worked aggressively to assimilate American Indians to Euro-American society by attempting to change them from tribal or communal persons into self-interested individuals. The effort was orchestrated through boarding schools, the Dawes Act—which converted land from tribal ownership to individual private ownership—and the encouragement of farming to reinforce the idea of the single nuclear family's ownership of property. Within an assimilationist policy, arts and crafts were viewed as culturally appropriate labor. Regional fairs like those in Shiprock and the Inter-tribal Indian Ceremonial at Gallup offered Indian agents and traders the opportunity to display Native products that they believed demonstrated assimilation's success. Expositions and demonstrations offered a Euro-American public the opportunity to see "before and after" glimpses of the government's

assimilating efforts. Expositions presented displays of past cultures through their archaeological remains and through glimpses of contemporary customs believed to be fast disappearing. Wild West shows presented demonstrations of an authentic savagery tamed and presented as performance.[12] While the Wild West Shows illustrated Indian savagery, the Harvey Company demonstrations modeled successful assimilation efforts. Schweizer eagerly presented the Euro-American public with visual proof of the successful transformation of American Indians from the stereotypical wild, lazy, communal peoples into tame and industrious, albeit primitive, nuclear families. He reinforced the perceived natural simplicity of Navajos' lives through displays that imitated outdoor reservation environments.

In both the collection and display of goods and people, Euro-American ideas about authenticity and originality were paramount but not easily maintained. Hopi House at the Grand Canyon posed a particular challenge for the Harvey Company. Most of the demonstrators, particularly Hopis, scheduled their travel around seasonal ceremonial cycles and family responsibilities. Their community responsibilities took priority over the demonstrating jobs. Thus demonstrators rarely stayed as long at their jobs as the Harvey Company would have preferred, and the company often had to find replacements on sudden notice. The struggle to maintain authenticity is shown in a January 24, 1907, letter from Huckel to Schweizer. "The original idea of the Hopi House was to show the Indians whom the public practically had never seen on account of their living at such a distance. The Hopi House filled with Navaho [*sic*] Indians is inconsistent."[13]

Schweizer and Huckel modeled their demonstrations on the 1893 Field Columbian Exposition in Chicago. They displayed Navajos in groups reminiscent of the "life groups" used at the 1893 Exposition and employed by anthropologist Franz Boas at the American Museum of Natural History. Schweizer preferred married couples—women who were weavers and whose husbands were silversmiths and/or chanters who would demonstrate sand painting or perform other tasks. To complete the domestic group—and because the demonstrators would not travel without them—Schweizer also included children in the displays. However, he preferred only the minimum number of children required to create the desired image, one that corresponded to an emerging Euro-American,

middle class, nuclear family. In a May 1906 request to J. L. Hubbell for both goods and demonstrators, Schweizer asked for "any four men and a couple of women . . . perhaps two children, not more than three. . . . There are 11 children here now and people cannot walk around without stepping on some of them."[14]

With the necessary women, men, and children, Schweizer then created the sort of setting that showed both a primitive connection to the natural world and a laborer who comfortably demonstrated capitalist values like industriousness and patience. The message is particularly evident in the text and photographs of a 1904 Harvey Company brochure:

> In another room a summer hogan of the Navahos [sic] has been cunningly wrought, and there may be seen patient Navaho squaws [sic] weaving blankets; their men engaged in fashioning showy bracelets, rings and trinkets; Indians from Acoma, Laguna making pottery; skillful Pueblos plaiting baskets; and workers in hair, leather and cloth. Undisturbed by the eager gaze of the tourist, the stoic works on as unconcernedly as though in his reservation home.[15]

The simulated natural environment involved more than just the presence of a summer hogan. Large looms were constructed from tree trunks. Small trees were then tied to the upright beams of the looms to simulate weaving among trees in the outdoors. Also included were large tree trunk segments used as anvils in the silversmithing process. In a move that seemed to conflate indoor and outdoor environments, large Navajo rugs were placed on the floor, creating a hybrid natural environment suggestive of a Euro-American home. In the display, Navajo women and young girls in fine traditional attire carded, spun wool, and wove, reinforcing for tourists the idea of primitive labor and an aesthetic more closely tied to nature and primitive spirituality. In addition, a few men practiced constructing silver jewelry. The image was one of American Indian men, women, and children in an idyllic natural setting, working at one of the forms of labor that government policy deemed culturally appropriate—the production of arts and crafts.

These displays sent multiple messages. They represented primitive labor while also constructing a representation of primitive home life. As Howard and Pardue note, newspapers of the era promoted the idea of "colonies" of American Indians living and working at Harvey's

Alvarado Hotel in Albuquerque. "The unique Indian Colony in the Harvey Collection rooms is increasing rapidly . . . the colony workshop represents a busy scene and throngs of visitors are greatly interested in the manipulations of the artisans."[16]

No doubt the Harvey Company found a practical benefit in hiring families, since the correspondence with Hubbell indicates that Navajos who had their families with them were more likely to stay with their employment for longer periods of time.[17] But by employing small families, the Harvey Company also had the benefit of communicating the government's agenda of successful conversion from communal groups to individual nuclear families.

Demonstrators often lived in hogans adjacent to the Alvarado Hotel. Some demonstrators, like Tom and Elle of Ganado, worked more or less continuously for the Harvey Company for more than twenty years, while others, like Miguelito and Gabidaan, worked more intermittently. The Harvey Company had expectations that few of their demonstrators could uphold.

Labor For Spectacle and Sale

Correspondence among Huckel, Schweizer, and Hubbell reveals the desires, expectations, satisfactions, frustrations, and negotiations of all the businessmen and the Navajo travelers they employed. Huckel, Schweizer, and Hubbell saw American Indian labor (indeed, Native people themselves) as a commodity they controlled exclusively in exchange for monthly wages that they sometimes managed for the demonstrators. Further, the Harvey Company indicated that they expected the demonstrators to perform as authentic cultural icons. They occasionally promoted individuals, such as Navajos Tom and Elle of Ganado and Hopi-Tewa potter Nampeyo. Expectations on the part of the Harvey Company sometimes clashed with the understandings and values of the demonstrators. Correspondence between Hubbell and Schweizer describes desired conduct, problem situations, and Hubbell and Schweizer's manipulations of the demonstrators. Whereas the Harvey Company compartmentalized individuals and labor, the demonstrators believed that their work was enmeshed in a larger process of creation, albeit sometimes outside the Navajo sacred geography.

Initially, the Harvey Company established work requirements for the demonstrators that were similar to those of a contemporary industrial society. The company required a work schedule that coincided with the arrival of tourists. On March 13, 1903, Schweizer wrote to Hubbell that "it is the principal thing for them to be at work when trains are in. They should be working from 7:30 A.M. to noon. They can work as much or as little as they want in the afternoon but must come back after supper for about one hour for evening trains."[18] Huckel and Schweizer even spoke about the Native demonstrators using the same terminology they would to order merchandise. "I note this new lot of Indians and not the Nampeyo party. I presume Mr. Lemmon decided to send a new lot."[19]

Just as they traveled as families, the Navajos worked as families. Men often produced silver jewelry and repaired jewelry from the company inventories. They constructed looms and made weaving tools for the weavers and performed other tasks, such as farming, organizing the display and work area, and other tasks not immediately connected to the displays. Women and girls worked at the various tasks associated with producing their crafts. For weavers, tasks included carding wool, spinning yarn, and, of course, the weaving itself. Young girls often helped their mothers; in fact, this is the context in which some learned to weave. "That's where my daughter started, learned weaving in Albuquerque. That's Clara Kinlicheenie. She was about five years old when she started weaving."[20]

A January 24, 1907, letter from J. F. Huckel to J. B. Epp of the Oraibi Mission further outlines the sorts of arrangements and expectations the Harvey Company held for the demonstrators.

> We can give work to at least two of the men on a salary basis per month, and we will pay the other two men for weaving and the women will be paid for basket making and anything else they do. They would be given very good food and supplied with comfortable quarters in the Hopi House and they would pick up considerable revenue from tourists. In other words, as far as the food goes and the financial part of the matter is concerned they would be, I am sure, satisfied as Nampeyo and his [sic] family were quite content on these points, as well as the other Hopi families we have had.

> We could not put four men to work on salary, and, besides that,
> we would want to have two at other work as an interesting feature
> for the tourists. We would also like to have the women do some
> weaving or basket-making or something of this nature as a matter
> of interest.[21]

While many of the men apparently worked at "behind the scenes" tasks,
regular demonstrators like Tom Ganado or Naaltsóós Neiyéhé, "Mail
Carrier," apparently interacted with tourists. Tom Ganado was fluent
in Navajo, Hopi, Spanish, and English, which greatly enhanced his
value as a freighter for Hubbell (who spoke the same four languages)
and the Harvey Company. In 1904 the *Albuquerque Morning Journal* des-
cribed Tom and his work:

> Tom has been with the Harvey system here for nearly two years,
> and in that time has become one of the most useful men about the
> big establishment. He is not merely a picturesque ornament. He
> works, knows the details of the business thoroughly and but for
> his frankness in dealing with customers, would make an excellent
> salesman. Tom, however, sticks rigidly to the truth and has no hesi-
> tancy in speaking his convictions accordingly when a prospective
> purchaser comes to the curio department. Tom's opinion of the
> individual is quietly formed and as quickly announced. Numerous
> amusing incidents are told of his estimates of tourists and others
> who come onto the place. And usually they are right.[22]

Tom would hardly seem to be a passive, submissive Navajo demonstra-
tor. As seen below, the newspaper's representation of Tom's interactions
with tourists, if accurate, did not reflect the Harvey Company's view of
the ideal American Indian demonstrator, though his industriousness
and hard work were valued and remembered in his home community
of Ganado.

Tom Ganado's grandson, Descheenie Nez Tracey, told this story about
his grandfather's work:

> A busload of tourists would come in every day, and they would
> look through the different rugs the ladies have woven. The tourists
> would take the rugs out, lay them out, look at them, and leave them.

My grandfather, Naaltsoos Neiyehe, used to fold and restack these rugs. That was his job.[23]

In any case, Tom and Elle Ganado proved to be valuable Harvey Company employees who worked as demonstrators for over twenty years. Tom acted as interpreter for the company and other demonstrators. Elle was regarded as "the boss of the weaving outfit."

In addition to keeping regular hours at the "little factory," as Schweizer referred to the work, Native demonstrators were expected to be "the right kind of Indians."[24] They were expected to demonstrate a Euro-American model of industriousness, submissiveness, and gratitude. Hubbell initially determined who might be acceptable within Huckel's parameters.

> Of course, a great deal depends on getting the right kind of Indians—I mean by that men who would not quarrel and would work well together and women that would be clean and attractive and would appreciate good treatment at the Canyon and would not give our Manager there any trouble.[25]

Hubbell, in turn, recommended some Navajos for work as demonstrators, but used the opportunities as a system of punishment and reward for the Navajos he employed at the trading post.

> I know full well that Capitan is by far the most trusty man that you ever had there of the indians [sic]. He worked for me nearly thirty years and I ought to know him. I always want you to have the best, of men and only when I have to discipline them a little for your good and mine, so I request no employment for some of them.[26]

Demonstrators' intelligence and communication abilities were also concerns. On January 24, 1907, Huckel wrote to Schweizer, "If Hubbell cannot arrange to get Nampeyo and her group, I hope he will succeed in getting some other intelligent Indians, with an interpreter."[27] Such "intelligent," "right" kinds of Indians—in the Harvey Company's view—worked exclusively for the company and according to company expectations of scheduling and tasks. As we shall see, this was not always the case, and Native demonstrators often made their own decisions about their labor, trade, and interaction with tourists.

Conflicts between Harvey Company standards and Navajo demon-strators' understandings of their own rights are particularly evident in an April 26, 1905, letter from Huckel to Hubbell:

> As I wrote to you, we cannot control Taos. He is making silver for other Indians and they are selling it and also selling it to our guests on the quiet, no matter how closely we watch him. I find he has been doing this ever since he has been at Albuquerque. It is a bad precedent for our other Indians and is spoiling them and I think it best that he should return. As I have already advised you, Taos has been spoiled by his experience at St. Louis.[28]

The passage suggests that Taos traveled to the 1904 St. Louis World's Exposition, where he had a level of autonomy in selling his work and interacting with visitors. Huckel, on the other hand, expected that Taos' work produced in the little factory belonged exclusively to the Harvey Company and could be sold only through the company's outlets. Taos and other Navajo demonstrators operated from a perspective that involved something like a labor theory of value, in which ownership was vested through labor and was not alienated by payment of a salary. For the demonstrators, the disposition of their products and the use of their knowledge were by all rights "up to them," and they acted accordingly.

> However there are two others who speak English[,] one in partic-ular a man they call Preston speaks perfect but didn't admit it until we caught him dead to rights talking to some tourists just as good as you or I. He is a bad one through & through. I want to simply tell you this for your own information for he'll steal and do everything that's bad. We had to threaten to throw him in the Canyon to keep him away from the Navaho squaws [sic] [as] he went after them one at a time and we even had complaints of his bothering white women, and he has been going over sneaking away to our competitors store and working over there. He was cautioned about this and threatened to be sent home, but didn't mind that—as he said he wanted to go anyway. He was the only bad egg in the crowd but bad enough to make up for all.[29]

Since, in the Navajo view, both the process and the products of labor are inalienable, criticizing demonstrators was likely to be taken as an affront and a violation of the person.

More than a little conflict about merchandise quality sometimes ensued.

> Night before last Charley brought some spoons which he had
> made and Mr. Smith accepted them all but one. I was present at
> the time. This spoon was bent and needed a little more polishing.
> Mr. Smith asked him to polish it a little more and Charley became
> saucy and stated he would buy it himself or else go over to the
> hotel and sell it. Mr. Smith told him he must not sell it at the hotel
> and to please fix it up. The next morning he told Mr. Smith he
> was going to leave and handed back a lot of silver dollars that
> had been given him to make silverware. He is now making silver-
> ware in his own hogan and has been attempting since that time to
> sell these goods to tourists.[30]

Conflict, or at least ambiguity, often surrounded arrangements for
paying salaries and the demonstrators' options for using their earnings.
Some salaried demonstrators were paid thirty dollars per month and
provided with food and housing. However, these arrangements appar-
ently varied from demonstrator to demonstrator and according to the
conditions at the time. The demonstrators, of course, had families, lands,
and other responsibilities in their home communities. Enticing them to leave
home for extended periods was not always easy. Planting, harvesting,
and lambing seasons were particularly difficult times for demonstrators
to leave, and they were sometimes offered extra incentives during these
seasons. Family illness or other circumstances often required demonstra-
tors to leave their employment abruptly, leaving few or none performing
for tourist arrivals. In these cases, Harvey officials and Hubbell scram-
bled to find replacements quickly and made concessions to hesitant
demonstrators. These complicated arrangements sometimes resulted
in some confusion among Hubbell, the Harvey Company, the Indian
agent (whose permission to employ demonstrators was required), and
the demonstrators.

> By the way, I would be grateful if you would let me know by
> return mail just what promises or arrangements were made with
> these Indians by Mr. Lemmon, you or Mr. Lorenzo Hubbell. The
> main points are clear, viz.: We will transfer them from from [sic]
> Keam's Canon to the [Grand] Canyon and return, give them a

warm place to live in, good, suitable food and pay them satisfactory prices for what they make, etc. Was any arrangement made with any of the women to give any of them work on salary, and if so, what was it? I would be glad if you would advise me as soon as possible regarding this matter.[31]

The ambiguity was not necessarily resolved when arrangements were agreed upon by all parties. And while, at first blush, payment of moneyed wages might appear to contribute toward the government's agenda to convert Navajo people to a cash economy, this was not completely the case. For the demonstrators during the early part of the twentieth century, money was not a completely useful or satisfactory exchange medium. Money was only useful in so far as it could be immediately converted to goods that would contribute to the continued life of the family. Since Hubbell controlled both goods and his clientele through credit and tin currency, demonstrators were often content to have the trader receive and manage their money for them with their counsel. So money often moved between Hubbell and the Harvey Company in the names of demonstrators.

The ways that money moved between the two businesses illuminate the uneven intersections of differing economies. It is often unclear exactly who determined the way the monies were used. Demonstrators sometimes designated part or all of their salary be sent to Hubbell to apply to their own trading post accounts or to the accounts of relatives. For example, on December 1, 1908, Herman Schweizer sent a check for sixty dollars to Hubbell. Thirty dollars was designated for payment on Silversmith's account at Hubbell Trading Post, and the remainder went to Joe Tippecanoe's wife's account. This weaver requested twenty dollars be paid toward her account with an extra ten dollars for her mother to use to obtain supplies from the trading post. However, demonstrators also apparently manipulated their situations to particular advantage in their "helping" economy. In the above example, Joe Tippecanoe also exercised control over the way money was given to his mother-in-law by advising Schweizer to instruct Hubbell that she not be given the whole ten dollars' worth of supplies at once, "as she'll only give it away."[32]

The demonstrators exercised their own understandings of these payment and exchange relationships, sometimes to the consternation

of both Hubbell and Schweizer. On April 14, 1909, Hubbell wrote to Schweizer:

> I guess that Bitzidi Lashi is with you by this time[.] He left here in time. I wish you would ask him where the thirty dollars are that he said he had paid you. The rascal worked me for more money while here on the strength that he had paid the amount there to you.[33]

By such acts, the demonstrators tried to change their working conditions, or to speed their return home when they were otherwise urged to stay. Interviews with demonstrators and their descendants reveal a variety of challenges, rewards, and understandings resulting from their work. Demonstrators who left their homes faced numerous compromises. While the income earned from demonstrating was a major and important contribution to their families' livelihoods, demonstrating was not viewed as the kind of "work" that directly contributed to making a living. Individuals had other, more important obligations to relatives and to their land. The land and the sheep were, of course, inextricably tied to the persons and the continuation of life, and neither could be neglected. As one woman expressed it, the demonstrators' lands on the reservation were going to waste, so they had to come back. They also had to care for their sheep. On the other hand, demonstrators could be the targets of jealousy due to their material success. The Hubbell–Harvey Company correspondence reveals some of the demonstrators' difficulties.

> I am just advised on my return that the Hopis at the Canyon have left for their home. One of the woman [sic] was ill and really should not have come on that account, and they learned that their horses had run away and some of their goods had been stolen, ate, [sic] they had also got out of clay (which was en route to them), and our manager let them go.[33]

And,

> Mr. Smith, at the Canyon, writes that the Hopis got a letter that their house had fallen in, and their burros had run away, and someone had stolen their bedding, and as they had no clay to work with anyway, they went home.[34]

As we have seen, American Indian demonstrators were faced with complex and often difficult negotiations of value, autonomy, and understandings of self. The complexity of these two-way negotiations cannot be fully explained by one-dimensional Marxist approaches that emphasize only the fact that travelers were drawn into a web of exploitation from which it was difficult to extricate themselves. The relation appears more to be one of disjuncture. Moreover, while it is undeniable that demonstrating was difficult and in many ways exploitative, it was also self-defining, empowering, and constructive for those Navajos who traveled and showed their work.

Travel and demonstrating offered opportunities for self-expansion through connections to new places, people, and experiences. Importantly, travel and demonstrating provided new stories to share. Yanabah Winker was not alone in emphasizing the significance of travel to her sense of personal identity. Travel to distant places also generated relationships. Many demonstrators developed relationships with the American Indians and non-Natives they encountered on their journeys. Travel involved negotiating new practices and values and transforming familiar practices and values. For Navajo travelers, meals were significant life-sustaining gifts, but receiving these gifts required an adjustment to Euro-American practices like eating with utensils at a dining table. And while Euro-American organizers and the viewing public exploited travelers by objectifying ideas about labor and home, Navajo travelers saw opportunities for demonstrating the processes through which they created and sustained life. They were acknowledged for the ways they utilized their knowledge, constructed their lives, and for distinguishing themselves through contact with people and places. Even the young children who sometimes traveled with their parents were aware of the significance of travel. During my field research, several persons told me of traveling as small children with their demonstrator parents. Verona Begay traveled to the Catalina Islands with her mother, father, and two brothers.

> I remember parts of it over across the ocean. . . . People used to go there. I remember the name of that place. My mother used to talk about it all the time. We went across on the boat over there. I remember when we were in the boat. I think it was a window that was beside us. People were looking out and they were saying,

"Look at that!" We could see all the fishes swimming in the water. I guess they did some weaving over there and that's what they're going by. Some went with those that live around them. All I remember was that in the dining room there was a table here and they would feed us there. When they handed us the spoons they would tell us to eat right. That's where we learned to eat at the table. Yes, that's all I remember because they gave us something to eat and we started vomiting. The ship made us vomit. That happened to my brother. . . . We got sick for a while. . . . Through an interpreter we were told thanks for the demonstration and for knowing the art. They thank us for that. That's how they used to talk to us. . . . My mother used to say, "I've seen a far away place on the ocean."[36]

Traveling in the New Millennium

Weavers continue to travel and demonstrate today. In the 1990s, Navajo weavers' activity networks included kin and clan relationships and Euro-American traders, dealers, scholars, museum professionals, and consumers. Many weavers appreciate that their work enables them to work at home on their Navajo Nation land, tend sheep, and spend time with children and grandchildren. For many it is a welcome alternative to off-reservation wage labor.[37] Paradoxically, some weavers who have made decisions to stay at home and live a "traditional" life find themselves thus engaged in global relationships. Through their work, weavers travel to locations as near as Ganado and as far as Hong Kong, and through their travels they gain a sense of the relational nature of their production and exchange markets. Mary Lee Begay said, "I demonstrate weaving and tourists buy rugs. That's the way I go places."[38] And some weavers who do not often travel express interest in knowing and telling of the faraway places to which their rugs travel.

For some weavers, there is a parallel between constructing a loom and demonstrating their work: both involve the creation of a person. Sadie Curtis discusses preparing herself, building new looms specifically for traveling (see figure 18), and also describes one unusual trip she made while unaccompanied by relatives.

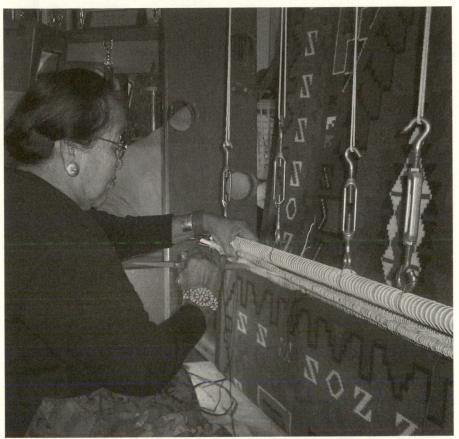

FIGURE 18. Sadie Curtis weaving in her home. Photograph by Teresa J. Wilkins, 2004.

When they tell me to go over there from here, I start getting ready from my feet to my head. I make new clothes to wear and get my jewelry together that would match my clothes. I take different kinds of clothes. That's how I work at it. I warp up a loom, get my yarns together, my tools like weaving comb and batten. I gather all that and I leave. I enjoy doing that. I set up a loom about this size. My husband Jack makes a loom from fresh logs. I sell the whole thing there. That's how they usually want it. . . . That's what I weave over there. I would weave about this much and by that time the rug show would be over. After that somebody would buy it. . . . That's what I do. I just took them there. I don't

know if they learned it all by now. That's what I do over there. I don't weave all the time. They tell me to take my time and they give me a break of thirty minutes. I start weaving when more people come in. If there aren't any people then I don't weave. They want me to demonstrate for them. I take my spindles there and spin wool. We tell them how weaving is done. I do the same thing when I start for home. I gather all my stuff, except for my loom. The rug show takes no more than two days. You get restless. I got homesick when I went to New Jersey. I cried when I called back. That was the only place that happened. I thought to myself, "Why am I doing this? Without thinking about it, why am I in the midst of these Anglos? I'll never do this again," I thought after I cried. And that is true. I never did that again. They're probably thinking, "She's stupid for coming out here and crying." I was sitting in the motel all by myself when my daughter called me. That was the only time I did that. I cried because I was out there all by myself and I didn't know anybody. I mostly like to see new places. I see our elderly in nursing homes and I don't think they've been to faraway places to see things. For me, I like to take advantage of seeing other places, so that I won't be in that situation. I mostly like to see new places, but it's difficult to see these places because you're flying up in the air. You can see many places when you're driving a car.[39]

Curtis's story illustrates the relationship between traveling and demonstrating and constituting the Navajo personhood and body. It also suggests the way in which relationships are formed between Navajos and non-Navajos, and reveals the types of negotiations that occur at the intersections of Euro-American and Navajo understandings of value, labor, and appropriation. It further reveals the significance of travel and places in distinguishing persons. While traveling and demonstrating may be constitutive of the person at each of these junctures, these actions also offer opportunities for resistance and subversion.

As Curtis describes an embodied process of preparing for travel by "getting ready from my feet to my head," she recreates the interconnection of her person with earth and sky. Central to creating and communicating her identity to others is her choice of clothing and jewelry. These function

as symbolic media that she employs to construct her identity as a Navajo woman. Photographs of Navajo women wearing flowing and gathered skirts and blouses made of colorful prints and lush velveteens, accompanied by turquoise and silver jewelry, are ubiquitous in magazine ads, posters, and visual media that promotes Navajo weaving. While weavers are most often represented to non-Navajos in traditional attire, this is an individual choice. Some weavers, like Sadie Curtis, wear their traditional clothing for any significant occasion at which they want to both demonstrate and command respect, whether inside or outside Navajo land. Thus it follows that many weavers would choose to wear traditional attire when demonstrating their work to non-Navajos. Other weavers employ traditional attire as an auto-ethnographic statement positioning themselves as subjects in a history of interaction between Navajo weavers and non-Navajos. Brenda Spencer emphasized, "When I'm demonstrating [within Navajo sacred geography] I wear traditional clothes. That is appropriate, because people see in books and magazines everywhere—a Navajo woman dressed in traditional clothes while she's weaving."[40]

However, some weavers are sensitive to the objectification of Navajo weavers' images, and view traditional attire as constraining and objectifying. Rather than emphasize their difference in intercultural encounters, these weavers choose sameness.

In addition to constructing their persons via clothing and jewelry in preparation for travel, some weavers create a loom and rug person with whom they work during demonstrations. For Curtis and others, this process is modeled after the creation of the first Navajo loom for Spider Woman. Itself a Navajo person, the body of the loom is also connected to Mother Earth and Father Sky in a reproductive relationship. Mrs. Curtis and her husband reenacted the traditional relationship as they, male and female humans, participated in the construction of looms and tools.

Many ideas expressed by past Navajo traders and by Sadie Curtis resonated with the weekend's events at the 1992 exhibition of the Gloria F. Ross collection at the Denver Art Museum. Navajo weavers whose works are in the Gloria F. Ross Collection of Contemporary Navajo Weaving were invited to Denver for the opening festivities associated with an exhibition of the collection. These weavers were specifically invited

as visiting artists, and the exhibition's curator, Ann Lane Hedlund, deliberately arranged the collection, the exhibition, and the opening events to forefront the weavers themselves as creative persons living and working in the same twentieth-century world as the exhibition's visitors. This was a departure from many exhibitions that depict weavers in a primitive or mythical past. Most of the visiting weavers had previously traveled and demonstrated their work, and many expected to set up looms and perform their work for the museum's visitors. They faced and responded to the new situation in different ways.

Travel for demonstration includes obligations to relatives and the opportunity to form new relationships. The Denver Art Museum's exhibition opening offered an opportunity to observe the intersection of two concepts of the person—a Euro-American individual and a Navajo relational person. Sadie Curtis expressed her discomfort with the rare trip to New Jersey on which she was unaccompanied by any relatives. She was not alone in her desire for company—each weaver who attended the Denver Art Museum's opening events brought at least one relative. One weaver brought twenty-one family members. When each weaver arrived at the museum, she was asked to pose for a photograph in front of her rug. Without hesitation, each weaver and the accompanying family members gathered in front of the rug, demonstrating that the creation of the rug was done in relationship to the family and was not the work of a single, isolated individual. Only one weaver asked whether the museum wanted her family in the photograph. Clearly, the individual status of artists in the Euro-American tradition did not negate or compartmentalize the significance of Navajo family relationships.

While traveling is an opportunity to experience new places with relatives, it also presents opportunities to establish new relationships with non-Navajos. Some weavers are well aware of the relational nature of the Navajo textile market and they value their non-Navajo "friends." Some of these weavers employ fictive kin relationships and obligations to create and sustain friendships. In the midst of a festive museum atmosphere with visitors enjoying food, drinks, and the opening of the exhibition, weaver Irene Clark shared with me the story of her life. She talked of her grandmother and her mother. She told me about her husband, how they met and married, the names of her children and their spouses, and her grandchildren. Then, assuming the role of teacher, she

said, "That's my story. Now, you will tell me your story, and that's the way we become relatives."

Establishing relationships through travel and demonstration not only includes exchanging personal stories but also fulfilling responsibilities and exchanging knowledge across the cultural divide. Most demonstrators take their work seriously and feel a responsibility to educate non-Navajos and Navajos about the importance of the weaving tradition. This is part of the relational approach to production, in which weavers produce rugs and consumers buy them. Many weavers are aware that without buyers, they would not be able to continue their present lifestyle. Educating potential customers and encouraging young weavers is thus an important way to reproduce themselves. When weavers make the effort to educate non-Navajos about their process, they strive to communicate that Navajo weaving is much more than a commodity. While many non-Navajos often see rugs merely as aesthetically pleasing material objects, some weavers like Lena Lee Begay strive to transcend this commodification and teach consumers about weaving's place in a larger Navajo history:

> It was really nice to be in and to demonstrate and to talk about Navajo weaving, how it originated and what it's like today. There are a lot of people out there who don't know much about weaving and they just think it's just, you know, like a painting. It is there but you really don't know the background and you don't know a lot of detail."[41]

However, there is a paradox inherent in these educational efforts. In the Navajo world, knowledge is a powerful possession, and this is especially true of weaving. For many weavers, their process is life-creating and -sustaining. Thus, many demonstrators are concerned about balancing the need to give knowledge (in order to continue the practice) with the need to keep knowledge (in order to continue the life process). Sadie Curtis stated, "I don't know if they learned it all by now." Her sister Mae Jim explained her strategy for negotiating the paradoxical situation:

> They call it a "rug show." I've been to a lot of those, and then over to London. I took all different colors of wool and a Ganado Red, Two Grey Hills, Burntwater. And I wove over there. Lot of people

ask me questions at a rug show. "How is it done?" I tell them what I know but I really don't go into detail. I . . . don't want to tell them everything I do . . . because if they learn, what are we going to get our money from then? The white man understands things right away. Then they will lower the prices on our rugs if they learn. I think about all these things. I want the Navajo weaver to get lots of money for their weaving. I go several places to teach that.[42]

While their efforts work to sustain a system that ultimately provides them a living, many demonstrators view themselves as teachers. And because giving knowledge through demonstrating is part of exchange, others involved in the demonstration situation are obligated to help facilitate the exchange. This is occasionally manifested in very practical situations, such as negotiating the sale of a rug. Many demonstrators accept cash and personal checks, but fewer are equipped to accept credit card payments. Often they expect those organizing the demonstrations to facilitate these transactions. When that does not occur, there is a sense that the organizers have not completely fulfilled their obligation in the "helping" economy.

Although demonstrating weavers often want to teach the significance of a creative lifestyle and practice, the questions Euro-American observers ask reflect a different point of view. When in the presence of a weaver and a loom with a rug in progress, most Euro-American observers ask questions framed within quantitative understandings of work, labor, and time. These are some of the questions I repeatedly heard when attending demonstrations:

> How long does it take for a certain size?
> How long did it take you to weave that far?
> How many rugs have you woven?
> How many months will it take you to finish the whole rug?
> When did you start?
> How old were you when you started?
> How many inches did you do today?
> How long have you been sitting there?
> Do you ever take a break?

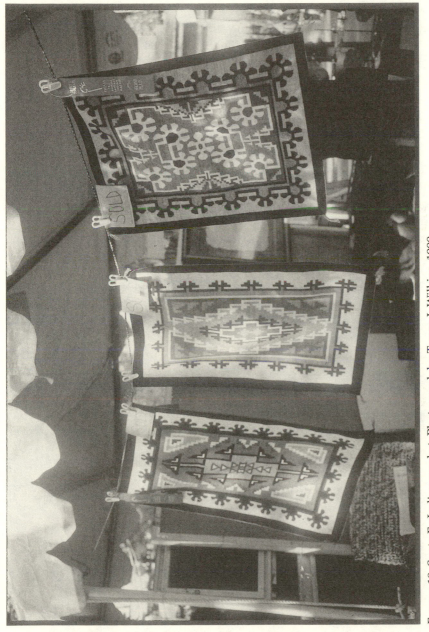

FIGURE 19. Santa Fe Indian market. Photograph by Teresa J. Wilkins, 1999.

187

These are not the questions weavers generally reflect on. Most weavers do not quantify their work. During my field study, I met many weavers who kept photographs of their rugs, but not one weaver had counted them. One weaver did keep a ledger-type list of each rug she had sold with style name, price, and date sold, yet the entries were not numbered and she did not know how many rugs she had woven.

Though the preceding questions often do not seem important to weavers, they usually answer them with reasonable accuracy and a share of good-natured teasing. For example, Helen Kirk told me that when she is asked how long she sits, "We tease them and say, 'One hour!' It was right for them, and they say, 'We can't even sit that long!'"[43] (See color plate 8.)

As Winker, Curtis, and others discussed, traveling to new places is an important mark of distinction at home. It is important to have traveled and seen places before one grows old. New places, new foods, and new relationships are significant enough to make the intercultural negotiations and the complications of leaving home worthwhile.

CONCLUSION

The ethnographic present is 2007. I will soon begin my eleventh year as professor of anthropology at the University of New Mexico's Gallup Campus. I now live in Gallup, one of the reservation border towns that have figured so prominently in trading history. Gallup is said to have a population of roughly 20,000 during the week and 100,000 on weekends, an indication of its importance as a shopping center for people from the nearby Indian reservations.[1] The small town has a complex mix of people from a surprisingly large number of cultural backgrounds. The questions that motivated my original study are still very much in the forefront of my thinking, and my understanding becomes more nuanced as I share ideas with students, weaver friends, traders, colleagues, and community members. What were these trading relationships about, and why have they remained important when there are so many other options available today? My questions have also become more nuanced. Daily life in Gallup revolves around the ebb and flow of the local economy in ways that provoke my continued reflection on the intersections of capitalism and a helping economy.

As I wrote an earlier draft of this book, Gallup became home to a Wal-Mart Supercenter. The new store replaced a Wal-Mart that was locally rumored to be the highest grossing store in the chain. Despite highly publicized exploitative labor practices, Wal-Mart is locally described by Navajos and non-Navajos in terms like "Navajo Heaven" and "Our Friend." Recently, two Navajo comedians called Wal-Mart "the gathering of nations." I wondered how a helping economy could so easily embrace

such a display of conspicuous and alienating consumption. In 1999, with the opening of the Wal-Mart Supercenter, I began to understand.

Wal-Mart opened its huge store amid festivities that included hot dogs, candy, special sales, and other customer incentives. The parking lots and store aisles were jammed with people around the clock for many days. But a sequence of rumors suggested a degree of ambivalence on the part of Navajos. Within weeks of its opening, a rumor quickly spread that the store had been struck by lightning. In the traditional Navajo world, a lightning strike is associated with death and signals spiritual and physical danger, which would then be inherent in the store and any goods held there. (During his time, J. L. Hubbell had to remove and replace the entire inventory of his Cornfields trading post because the area had been struck by lightning.) The alleged lightning strike was the subject of a call-in radio broadcast on Navajo Nation radio KTNN. The store manager denied that lightning had struck and tried to reassure customers. Many traditional people took themselves and their merchandise to healers for their own protection. The discussion began to abate.

Two weeks after the rumored lightning strike, a person was said to have died in the store. This rumor set off a similar set of concerns about physical and spiritual well-being and the safety of the place and merchandise. Two weeks after the rumored death, a headline appeared in the local newspaper, the *Gallup Independent*: "Wal-Mart Built on Ancient Burial Ground." A closer read of the article showed that it was about a *proposed* store in an Arizona location far from Gallup. However, the headline succeeded in reviving concerns about the new Gallup store. Despite all concerns, though, the Wal-Mart parking lots and store aisles remained crowded with shoppers.

Clearly, area residents were ambivalent about the opening of the Wal-Mart Supercenter. I found this intriguing. The rumors about the store may have described actual occurrences or been fueled by local competitors. Whatever the case, the concerns took on a life of their own. As discussed, the helping economy is not without its own tensions and contradictions. And Navajos, like most people, value greater choices and lower prices. I suggest that Wal-Mart embodied one or more contradictions that necessitate a negotiation of values at the intersections

of economy. Today's complex relationships are still grounded in history as they adapt to global forces.

◆ ◆ ◆

This book has examined relationships between Navajo weavers and reservation traders, the ways these relationships were and are carried out, the ways they are constituted, and why they have remained important. I conclude by addressing two points—the ways anthropological concepts of culture may illuminate or obscure the trade relationships, and the conditions of the weaving trade in a new millennium.

Generally, Navajo reservation traders have been motivated by Euro-American senses of individualism and economy, while Navajo weavers' approaches have been more relational. However, through the years of trading post economy, both have accommodated one another. Traders sometimes built multi-generational family businesses that maintained multi-generational connections with Navajo families. While there have been extreme tensions between the two groups, particularly during the early trading period when the government and many traders were more coercive in their assimilationist agendas, trader-weaver relationships have often been close, strong, and enduring. Moreover, weaver-trader interactions, whether aesthetic, political, or economic, have resulted in a unique cultural economy. The culture of Navajo weaving and trade, just like the contemporary styles of the textiles themselves, is a hybrid form created out of the encounter between Navajo and Euro-American cultural values.

The traditional use of the concept of culture in anthropology refers to the lifeways of geographically separated, bounded groups of people divided from other similarly bounded groups. In this configuration, each group or culture has its own system of meaning, holistic logic, and set of unique practices. This anthropological view resulted in the production of representations of groups of people as homogenous and isolated from others, and, when combined with their romantic longings, has sent anthropologists on a never-ending search for the authentic, pure culture. This was not unlike the longings of early collectors. This concept of culture continually emphasized what was shared, agreed upon, and orderly to the exclusion of what is marginal, contested, and ambiguous. It should be clear that these classic anthropological views of culture do not capture

the reality of trading post culture. There, places, spaces, and interactions are hybrid and marginal. They are not, and probably never have been, either purely capitalist or purely cooperative. Thus, a study of trading post exchange that takes into account both Navajo and Euro-American practices and values requires a reconfiguration of culture as ambiguous, creolized, and dynamic.

This is not to say that there is no "culture" there. Rather it is to reconceptualize the concept of culture, less as an overarching coherent system and more as contested, combinatory, and lived. The culture of Navajo reservation trade results from a long and multidirectional process of learning and teaching, and of experience and expression. At the same time that traders in the 1870s learned that wool sales might be very profitable and set out to develop business relationships with Navajos, Navajo people learned new and different ways to rebuild their economies with resources they could obtain from the government and traders. During that early period, livelihoods were at stake for all parties. This is why Navajos repeatedly told me, "They were all in it together." This certainly must have spurred the efforts of some traders and some Navajos to build continuing relationships. Moreover, as each struggled to understand the aims and objectives of the other, new aesthetic, economic, and social relationships emerged. For example, Hubbell learned to create kin relationships with his Navajo customers. Navajo weavers, in turn, learned that he preferred heavy rugs and wool sacks, since they were able to obtain more goods in exchange. They responded with strategies for increasing the weight of their goods.

If culture is configured as process, it is also, for Navajos, tied to memory. This explains the importance Navajos attach to storytelling. The stories tell of past places, people, and events, but they are rarely told without some present significance. Navajo stories of trading posts and traders echo themes of hardship and struggle, hard work and prosperity, and survival and celebration. The stories focus on continuity, not in the sense of continuing out-moded practices in the face of enormous change, but in the sense of learning the wisdom to live successfully in the present. The stories focus on the continuation of the life process with respect for the past while living in the present. For example, the original Coyote Canyon Trading Post building was constructed in the late nineteenth century and is now a ruin immediately connected to the

newer and currently closed convenience store. While the ruins have not been salvaged, they remain in place. "That place has survived a lot," I was told. "They should not tear it down."

I interpret many weavers' stories as expressions of the trading tradition. They focused primarily on the theme of "helping" through gifts of groceries, firewood, livestock, and respect for their work. Sometimes the stories contradict historical memory. For example, Hubbell apparently went to great lengths to encourage quality standards in Navajo textiles. He encouraged his sons Lorenzo, Jr., and Roman not to purchase rugs that did not meet his standards. Yet, I was repeatedly told that Naakaii Sání never turned a weaver away. He purchased every rug regardless of quality. In this sense, weavers invoke a trading tradition to communicate models for ideal trade relationships in the present.

I began this study with a sense, albeit a partial one, of why these relationships were important one hundred years ago. As I have suggested, weaving was a primary way of making a living for Navajo people after Hweeldí, and also at that time, some traders played pivotal roles in the development and continuation of textile production. Nevertheless, the reasons for continuing significant trade relationships were less apparent to me. Now I understand, however, that weaving and trading are not only ways to make a living but also ways to construct memories that in turn construct the present. For some Navajo weavers and reservation traders, stories of past trading relationships profoundly shape their present experiences, perceptions, and memories.

In the new millennium, textile exchange continues to assume new forms. While Navajo rugs and other products are still marketed through trading posts, the businesses are often owned by people from diverse cultural and ethnic backgrounds, including Euro-Americans, Middle Easterners, and Navajos. Moreover, the sites at which Navajo products are sold are diversifying as well. In addition to trading posts, auctions, art exhibitions, and galleries, Navajo rugs are also marketed over the Internet by weavers and non-weavers.

Today's market for Navajo textiles is global. Traders, dealers, and weavers themselves sell to collectors from many parts of the United States as well as from places like France, Germany, and Japan. Textiles are also sold to local Navajos and Zunis and given as gifts within families and friends. Some weavers still exchange their products at reservation

trading posts for cash and groceries. A few posts still deal in credit. Other weavers exchange rugs as down payments for vehicles and other items. Others sell in local informal markets found at the university, neighboring hospitals, and schools. Still others accept only cash and travel extensively to obtain the best prices for their work. Other weavers market exclusively through commissions and art exhibitions. Some weavers are also involved in writing about their work and curating museum exhibitions.

Today, there are markets for antique and contemporary textiles, generally made up of different collectors whose interests are multi-faceted. Authenticity is still of paramount concern for both collectors and weavers. Antique Navajo textiles are generally authenticated through materials, techniques, and collection histories, so these factors are often important to collectors. Contemporary textiles are authenticated through the identities of the weavers and, in today's world, collectors are often interested in meeting weavers and knowing their home communities.

There is an abundance of information available to textile collectors. Books, leaflets, and Internet websites offer consumers tips on identifying textiles. Navajo textiles are categorized according to their stylistic changes during the nineteenth and early- and middle-twentieth centuries. From about the 1930s to present, textiles were categorized according to patterns named after reservation regions like Ganado, Two Grey Hills, and Wide Ruins. In textile art markets, we now find Navajo textiles that defy these categorizations as weavers continue to push the art in new creative directions.

Not only is there both continuity and change in market venues, but also in the factors that influence Navajo weavers' aesthetic choices. J. L. Hubbell's "revival" of Classic Period textiles is perhaps the first of many revivals. During the early- to mid-twentieth century, there were "revivals" of vegetal dyeing traditions that had not previously been found in Navajo textiles.[2] The last quarter of the twentieth century has seen revivals of regional styles in color combinations pulled from contemporary decorating trends, revivals in the late-nineteenth-century Germantown color and design aesthetic, and revivals of the use of sacred sandpainting imagery in rug designs. Interestingly, one of the most significant revivals for the future of Navajo weaving is the revival of the "Old Navajo" churro sheep breed that provided straighter, coarser,

and less greasy wool. Wheat argued that after the 1860s internment of Navajos at Hweeldí, only approximately 1,100 head of churro sheep survived, most in the remote western Navajo mountain country.³ During the 1970s Dr. Lyle McNeal initiated the Navajo Sheep Project to locate and conserve what was left of the hardy little breed. Some traders encouraged the project—conducted through Utah State University— and worked to place churro sheep in the hands of weavers. This effort continues today through Navajo organizations like the Ramah Navajo Weavers Association and *Diné Be'inná*,⁴ and has become successful enough that churro sheep can now be found in a range of colors that Two Grey Hills trader Les Wilson is fond of calling a "Two Grey Hills rug-on-the-hoof."⁵

Significantly, as these new forms and sites of exchange proliferate, Euro-American interest in trading posts (and traders) as dying ways of life has begun to intensify. Trading posts are being "revived" into museum-like reproductions of older establishments. Navajo interest in trading posts has intensified as well. At a time when Navajos, like other Americans, have come to rely on large national chain stores—and welcome the lower prices and wider selection they often find there— they nevertheless speak articulately of the alienation they experience while shopping in a very large store, and come to value all over again stories of the intimacy and relationality of the trading post experience.

APPENDIX

THE HUBBELL BLANKET PAINTINGS

Listed here are the paintings that J. L. Hubbell commissioned as "examples" of Navajo weaving. Most were produced between 1897 and 1905 unless otherwise indicated. They are now cataloged at the Hubbell Trading Post National Historic Site.

NEAR COPIES OF CLASSIC STYLE BLANKETS

Catalog Number	Artist	Medium
HTR 2325	E. A. Burbank	oil
HTR 2756	unsigned	oil
HTR 2757	E. A. Burbank	oil
HTR 2758	E. A. Burbank	oil
HTR 2760	Bertha Little	oil
HTR 2765	H. G. Maratta	oil
HTR 2766	Bertha Little	oil
HTR 2767	E. A. Burbank	oil
HTR 2770	E. A. Burbank	oil
HTR 2774	unsigned	oil
HTR 2776	H. G. Maratta	oil
HTR 2778	E. A. Burbank	oil
HTR 2780	E. A. Burbank	oil
HTR 2781	E. A. Burbank	oil
HTR 2785	Bertha Little	oil
HTR 2786	H. G. Maratta	watercolor
HTR 2787	Bertha Little	oil
HTR 2788	E. A. Burbank	oil
HTR 2791	E. A. Burbank	oil

Catalog Number	Artist	Medium
HTR 2794	unsigned	watercolor
HTR 2797	E. A. Burbank	oil
HTR 2799	Bertha Little	oil
HTR 2800	E. A. Burbank	oil
HTR 2804	Bertha Little	oil
HTR 2805	E. A. Burbank	oil
HTR 2811	E. A. Burbank	oil
HTR 2812	unsigned	watercolor
HTR 2813	unsigned	oil
HTR 3517	E. A. Burbank	oil
HTR 3519	E. A. Burbank	oil
HTR 3522	Bertha Little	oil
HTR 3523	Bertha Little	oil
HTR 3524	E. A. Burbank	oil
HTR 3525	E. A. Burbank	oil
HTR 3526	E. A. Burbank	oil
HTR 3527	E. A. Burbank	oil
HTR 3529	E. A. Burbank	oil
HTR 4227	unsigned	oil
HTR 11731	unsigned	oil
HTR 16165	unsigned	oil
NMAI 3915	E. A. Burbank/George Pepper	oil/photograph
NMAI 3918	E. A. Burbank/George Pepper	oil/photograph
NMAI 3933	Bertha Little/George Pepper	oil/photograph
NMAI 3934	Bertha Little/George Pepper	oil/photograph
NMAI 3935	E. A. Burbank/George Pepper	oil/photograph

ADAPTATIONS OF CLASSIC STYLES

Catalog Number	Artist	Medium
HTR 2755	unsigned	oil
HTR 2759	Bertha Little	oil
HTR 2761	Bertha Little	oil
HTR 2762	unsigned	oil
HTR 2769	E. A. Burbank	oil
HTR 2772	Bertha Little	oil
HTR 2775	E. A. Burbank	oil
HTR 2777	E. A. Burbank	oil
HTR 2779	Bertha Little	oil
HTR 2782	Bertha Little	oil
HTR 2783	E. A. Burbank	oil

Catalog Number	Artist	Medium
HTR 2789	Bertha Little	oil
HTR 2790	E. A. Burbank	oil
HTR 2792	Bertha Little	oil
HTR 2796	unsigned	oil
HTR 2801	unsigned	oil
HTR 2806	Bertha Little	oil
HTR 2808	unsigned	oil
HTR 2809	Bertha Little	oil
HTR 2810	unsigned	oil
HTR 3514	E. A Burbank	oil
HTR 3518	E. A. Burbank	oil
HTR 3520	unsigned	oil
HTR 3521	E. A. Burbank	oil
NMAI 3909	Bertha Little/George Pepper	oil/photograph
NMAI 3923	Bertha Little/George Pepper	oil/photograph
NMAI 3927	unsigned/George Pepper	oil/photograph
NMAI 3939	Bertha Little/George Pepper	oil/photograph

New Forms

Catalog Number	Artist	Medium
HTR 2763	H. G. Maratta	watercolor
HTR 2764	E. A. Burbank	oil
HTR 2768	E. A. Burbank	oil
HTR 2773	H. B. Judy	watercolor
HTR 2784	unsigned	watercolor
HTR 2793	Bertha Little	oil
HTR 2795	E. A. Burbank	oil
HTR 2798	unsigned	oil
HTR 2807	E. A. Burbank	oil
HTR 3515	E. A. Burbank	oil
HTR 3516	unsigned	oil
HTR 3528	E. A. Burbank	oil
HTR 11719	Waldo Mootzka (1930s)	watercolor
HTR 11720	Waldo Mootzka (1930s)	watercolor
HTR 11726	Raymond Pearson (1935)	watercolor
HTR 11727	Raymond Pearson (1935)	watercolor
HTR 11728	Raymond Pearson (1935)	watercolor
HTR 16166	unsigned	tempera

NOTES

CHAPTER 1. INTRODUCTION

1. Appadurai 1986, 1990, 1991; Gregory 1982; Gupta and Ferguson 1997b; Hannerz 1992; Humphrey and Hugh-Jones 1992; Marcus 1992; Parry and Bloch 1989; Schiller et al. 1992; Strathern 1986, 1992; Thomas 1991; Weiner 1992.

2. Adair and Vogt 1949; Graburn 1976; M'Closkey 2002; McPherson 1988, 1992; Spicer 1962; Vogt 1956; Volk 1988.

3. M'Closkey 2002.

4. Appaduria 1990; Comaroff and Comaroff 1997; Donham 1985, 1990; Gregory 1982; Gupta and Ferguson 1997a, 1997b; Hannerz 1992; Humphrey and Hugh-Jones 1992; Hutchinson 1996; Nash 1979,1993; Piot 1999; Roseberry 1989; Schiller et al. 1992; Shipton 1989; Strathern 1992, 1986; Taussig 1987; Thomas 1991; Wallerstein 1974; Wilk 1996.

5. Redfield, Linton, and Herskovits 1936:149, as quoted in Graburn 1976.

6. Kent 1976, 1985; Vogt 1956.

7. Amsden 1934; Hedlund 1983, 1992, 1994; James 1974; Kent 1976, 1985; Wheat 1977, 1981, 1996, 2004.

8. Appadurai 1986, 1990, 1991; Gupta and Ferguson 1997a; Hannerz 1992; Schiller et al. 1992:ix.

9. Farella 1984.

10. Hedlund 1983, 1992, 1994; Reichard 1934, 1936, 1939.

11. Adams 1963, 1993; M'Closkey 2002; McNitt 1989; McPherson 1988, 1992; Volk 1988.

12. Babcock 1990; Hinsley 1992; Wade 1976; Wilkins 2004.

13. Comaroff and Comaroff 1992, 1997.

14. Blomberg 1988; Rodee 1981, 1987; Wheat 1977, 1981, 1988, 1990, 1994, 1996, 2004.

CHAPTER 2. EXCHANGING SPACES

1. Adams 1963; Ford 1983; Hill 1948; Wheat 1988.
2. Ford 1983; Wheat 1988.
3. Ford 1983; Hill 1948.
4. Ford 1983.
5. Ibid.
6. Ibid.; Hill 1948.
7. Dozier 1970; Wheat 1988.
8. Hammond and Rey 1953:667, quoted in Wheat 1988:58.
9. Wheat 1988:57.
10. Wheat 1977, 1981, 1988, 1994, 1996, 2004.
11. Wheat 1988, 2004.
12. Kluckhohn and Leighton 1962; Underhill 1956.
13. Adams 1963; Ford 1983; Hill 1948; McNitt 1989; Wheat 1988, 2004.
14. Wheat 1988, 2004.
15. Hill 1948.
16. Roessel 1983.
17. Ibid.
18. Brugge 1993a; Graves 1998.
19. Wheat 1977, 1981, 1988, 1994, 1996, 2004.
20. Adams 1963.
21. Ibid.
22. Wheat 2004.
23. Brugge 1993a.
24. Adams 1963; Brugge 1993a; Kelley 1977; Underhill 1956.
25. Adams 1963; Kelley 1977.
26. Adams 1963; Brugge 1993a; McNitt 1989.
27. Adams 1963; Brugge 1993a; M'Closkey 2002; McPherson 1992; Volk 1988; Weiss 1984. Only Brugge 1993a discussed trader roles in assimilation.
28. Adams1963:153.
29. Adams 1963; Brugge 1993a; McNitt 1989.
30. Alyse Neundorf, personal communication, notes in the author's files.
31. Adams 1963:153.
32. Morris 1997; O'Bryan 1956; Yazzie 1984; Zolbrod 1984.
33. Brugge 1993a, 1993b; Timothy Begay, personal communication, notes in the author's files.
34. Hubbell Trading Post Ethnohistory Project, Yanabah Winker, interview by David M. Brugge, 1971.
35. Ibid.
36. Hubbell Papers, box 93; McNitt 1989; Williams 1989.
37. Bailey and Bailey 1986; M'Closkey 2002.

38. Anonymous Ganado Elder interviewed by Teresa Wilkins, 1996, recording in the author's files.

39. McNitt 1989.

40. Gilpin 1968:88.

41. McNitt 1989:ix.

42. G. W. Sampson to Assistant Commissioner of Indian Affairs F. H. Abbott, 1911, in Report to Assistant Commissioner of Indian Affairs F. H. Abbott, 1911.

43. Joe Reitz and Ed Davies to Assistant Commissioner of Indian Affairs F. H. Abbott, 1911, in Report to Assistant Commissioner of Indian Affairs F. H. Abbott, 1911.

44. McNitt 1989:vii–ix.

45. Amsden 1934; Faunce 1934; Forrest 1970; James 1974; Reichard 1936; Youngblood 1935.

46. Blue 1986; Brugge 1993a; Clark 1993.

47. Eddington and Makov 1995; James 1988; Mercurio and Peschel 1994.

48. Forrest 1970:25.

49. Ibid.:51.

50. Guterson 1994:82–83.

51. Eddington and Makov 1995:1.

CHAPTER 3. THE CREATION OF A USABLE PAST

1. Hinsley 1981; Kern 1983; Lears 1981.

2. Battaglia 1995; Piot 1996, 1999; Schwarz 1997; Thomas 1996.

3. Kern 1983; Lears 1981.

4. Postmodern approaches to consumption replacing experience include Breckenridge 1995; Clifford 1988; Friedman 1994; Miller 1987, 1995; Stewart 1984.

5. Wheat 2004.

6. Pepper 1903:13.

7. Williams 1989:73.

8. Brugge 1993a:47.

9. Moore 1987:53.

10. Barnes 1902:17.

11. Williams 1989:69,73.

12. Hubbell Papers, boxes 19, 20, 21, 93.

13. As quoted in Williams 1989:18–19.

14. Williams 1989:81.

15. Ibid.

16. Ibid.:69.

17. Ibid.:79.

18. Ibid.:91.

19. Ibid.:57.

20. Ibid.:69.

21. James 1974:48.

22. Hubbell Papers, box 55.

23. Hubbell 1902:2.

24. Ibid.

25. Ibid.:5.

26. Ibid.:2.

27. Ibid.

28. Boyd 1979; McNitt 1976; Rodee 1987; Simmons 1977.

29. Moore 1987:9.

30. Jonathan Batkin, personal communication, 1995, notes in the author's files.

31. Joe Ben Wheat, personal communication, 1996, recordings in the author's files.

32. Wheat 1977, 1981, 1994, 1996, 2004.

33. Boyd 1979; Simmons 1977.

34. Joe Ben Wheat, personal communication, 1996, recordings in the author's files.

35. Moore 1987:23.

36. Ibid.:24.

37. Bennett 1981; Kent 1985; Wheat 1977, 1981, 1988, 1996, 2004.

38. Moore 1987:53.

39. Joe Ben Wheat, personal communication, 1996, recordings in the author's files.

40. J. B. Moore to Assistant Commissioner of Indian Affairs F. H. Abbott, 1911, in Report to Assistant Commissioner of Indian Affairs F. H. Abbott, 1911.

41. Rodee 1981.

42. James 1988; Kent 1985; Rodee 1981, 1987.

43. Hubbell Papers, box 60.

44. Begay 1996:87.

45. Boyd 1979; McNitt 1976.

46. Boyd 1979:78.

47. Boyd 1979; McNitt 1976.

48. Barnes 1902:17.

49. Ibid.

50. Ibid.:16.

51. Harvey 1989.

52. Pepper 1903:10.

53. Ibid.
54. Hinsley 1981.
55. Joe Ben Wheat, personal communication, 1996, recordings in the author's files.
56. Hyde Exploring Expedition, vol. 1 no. 2, 1903:4–5.
57. Ibid.:10.
58. Ibid.
59. Ibid.
60. Ibid.
61. Pendleton Woolen Mills 1987:11.
62. Interview with Roger Curley by Teresa Wilkins, 1995, transcript in the author's files.

CHAPTER 4. "WE WOVE THE DESIGN WE WANTED"

1. Amsden 1934; Boles 1977; Brugge 1993a; Hedlund 1983, 1992; James 1974; Kent 1985; McNitt 1976; Rodee 1981, 1987; Wilkins 1993.
2. Hubbell Papers, box 41.
3. Ibid., box 95.
4. Ibid.
5. Wheat 2004:138.
6. Bailey and Bailey 1986; M'Closkey 2002.
7. Hubbell Papers, box 92.
8. Joe Ben Wheat, personal communication, 1988, 1989, recordings in the author's files.
9. Wheat 1994, 1996, 2004.
10. J. L. Hubbell, 1907, quoted in Blue 1986:16.
11. Clifford 1988:1.
12. Burbank 1946:54.
13. James 1974:49.
14. Wheat 2004.
15. James 1974:49.
16. J. L. Hubbell, 1907, quoted in Blue 1986:16.
17. Ibid.
18. Bauer n.d.; Wheat personal communication, 1992, notes in the author's files; Wilkins 1993.
19. Hubbell Papers, boxes 12, 95.
20. Hubbell 1902.
21. Wilkins 1993, 1999b.
22. Hubbell Trading Post Ethnohistory Project, Peter Hubbard, interview by David M. Brugge, 1971.

23. Hubbell Papers, boxes 37, 38, 74; Rodee 1981, 1987.

24. Burbank 1946:206.

25. Ibid.

26. Battaglia 1995; Piot 1996, 1999; Strathern 1986.

27. Schwarz 1997.

28. Farella 1984, 1993; Reichard 1936; Witherspoon 1977.

29. Marcus 1992.

30. Hubbell Trading Post Ethnohistory Project, Mike Daughter Frank, interview by Clarenda Begay, 1983.

31. Schwarz 1997.

32. Witherspoon 1977.

33. Schwarz 1997.

34. Hubbell Trading Post Ethnohistory Project, Mae Jim, interview by Clarenda Begay, 1983.

35. Schwarz 1997.

36. Reichard 1936:frontispiece, adapted from Franciscan Fathers 1910:222.

37. Hedlund 1992.

38. Hubbell Trading Post Ethnohistory Project, Yanabah Winker, interview by David M. Brugge, 1971.

39. Ibid.

40. Ibid.

41. Evelyn Curley, interview by Teresa Wilkins, 1995, transcript in the author's files. Helen Kirk, interview by Teresa Wilkins, 1995, transcript in the author's files. Juanita Paul, interview by Teresa Wilkins, 1995, transcript in the author's files.

42. Ibid.

43. Helen Kirk, interview by Teresa Wilkins, 1995, transcript in the author's files.

44. Evelyn Curley, interview by Teresa Wilkins, 1995, transcript in the author's files.

45. Helen Kirk, interview by Teresa Wilkins, 1995, transcript in the author's files.

46. Appadurai 1986; Dilworth 1996; Fabian 1983; Handler 1986; Lears 1981.

CHAPTER 5. TRADE "A LONG TIME AGO"

1. Hassell n.d.; Hill 1948; Wheat 1988; Wilkins 1999b.

2. Blanchard 1977; Francisconi 1998; Gilbreath 1973; Hill 1948; M'Closkey 2002; McPherson 1992; Weiss 1984. These analyses largely draw on the earlier theories of Marx (1977) and Mauss (1967).

3. Gregory 1982; Hedlund 1992; Lamphere 1977; Piot 1999; Schwarz 1997; Strathern 1986, 1992; Wilkins 1999b.

4. Thomas 1991.

5. Humphrey and Hugh-Jones 1992.

6. Clark 1993; Hassell n.d.; Wilkins 1999b.

7. Brugge 1993a, n.d.; Hill 1948; Wheat 1988.

8. Bolton 1967; Brugge 1983, n.d.; Ford 1983; Hammond and Rey 1953; Hill 1948; Wheat 1988, 2004.

9. Blue 1986; Brugge 1993a, n.d.; Humphrey and Hugh-Jones 1992; M'Closkey 2002; McNitt 1989.

10. Brugge 1993a; Hedlund 1992; Hubbell Papers; M'Closkey 2002; Wilkins 1999b.

11. Appadurai 1986; Gregory 1982; Humphrey and Hugh-Jones 1992; Strathern 1986.

12. Blue 1986; Hubbell Papers; Wilkins 1999b.

13. Hubbell Papers; Anonymous Ganado elder, interview by Teresa Wilkins, 1996, recording in the author's files.

14. Hubbell Trading Post Ethnohistory Project, Mae Jim, interview by Clarenda Begay, 1983.

15. Appadurai 1986; Hannerz 1992; Humphrey and Hugh-Jones 1992; Weiner 1992.

16. Moore 1987:35, 71.

17. Joe Ben Wheat, personal communication, 1995, recording in the author's files.

18. Hedlund 1983, 1992, 1994; Reichard 1936.

19. Boles 1977; Hedlund 1992, 1994; Kent 1985; Rodee 1981, 1987; Wheat 1981.

20. Francisconi 1998; Kelley and Whiteley 1989; Parezo 1983.

21. Adams 1963; Francisconi 1998; Kelley and Whiteley 1989.

22. Adams 1963, 1993; Brugge n.d.; Francisconi 1998; Kelley and Whiteley 1989; McNitt 1989; Powers 2000.

23. Farella 1984, 1993; Humphrey and Hugh-Jones 1992; Parry and Bloch 1989; Pred and Watts 1993.

24. Hedlund 1992, 1994.

25. Farella 1984.

26. Hubbell Trading Post Ethnohistory Project, Martha Tsosie, interview by Clarenda Begay, 1983.

27. Marx 1977.

28. Hedlund 1992, 1994.

29. Appadurai 1986; Wilkins 1999b.

30. Adams 1963; Brugge 1993a; M'Closkey 2002; Powers 2000; Roberts 1987.

31. Lamphere 1977.

32. Ibid. Lamphere's analysis of generalized reciprocity was drawn from Sahlins 1972.

33. Hubbell Trading Post Ethnohistory Project, Zonnie Lincoln, interview by David Brugge, 1971.

34. Hill 1948.

35. Adams 1963.

36. Anonymous Ganado elder, interview by Teresa Wilkins, 1996, transcript in the author's files.

37. Hubbell to C. I. A. Sells, February 12, 1916, Hubbell Papers, box 101; Brugge n.d.:7.

38. Brugge n.d.; McNitt 1989:86.

39. Brugge n.d.:27.

40. Ibid.:24.

41. Sam Day to J. L. Hubbell, 1905, Hubbell Papers, box 23.

42. Federal Trade Commission (FTC) 1973; M'Closkey 2002; Southwest Indian Development, Inc. (SWID) 1969.

43. Wheat 1977, 1981, 1990, 1996, 2004.

44. Adams 1963:183.

45. FTC 1973.

46. Grace Henderson Nez, interview by Teresa Wilkins, 1995, transcript in the author's files.

47. Adams 1963.

48. Ibid.

49. Ibid.

50. FTC 1973.

51. Ibid.:3

52. Hubbell Papers, box 60.

53. Adams 1963; James 1974; James 1988.

54. Kluckhohn and Leighton 1946:39.

55. Adams 1963:174.

56. Adams 1963; FTC 1973; SWID 1969.

57. Weiner 1992.

58. Hubbell Trading Post Ethnohistory Project, Dorothy Hubbell, interview by Lawrence Kelly, 1969.

CHAPTER 6. "PLEASE, MY SON, MY RUG IS WORTH THAT MUCH"

1. Adams 1963; Blue 1986; Clark 1993; Faunce 1934; Hannum 1945; Hegemann 1963; M'Closkey 2002; Richardson 1986; Roberts 1987.

2. Lamphere 1977.

3. Based upon Faunce 1934 and personal knowledge.

4. Faunce 1934:98–101.

5. Grace Henderson Nez, interview by Teresa Wilkins, 1995, transcript in the author's files.

6. Ibid.

7. Ibid.

8. Laura Cleveland, interview by Teresa Wilkins, 1995, transcript in the author's files.

9. Ibid.

10. Mary Lee Begay, interview by Teresa Wilkins, 1995, transcript in the author's files.

11. Laura Cleveland, interview by Teresa Wilkins, 1995, transcript in the author's files.

12. Blue 2000; Graves 1998.

13. Gutierrez 1991.

14. Anonymous Navajo weaver, interview by Teresa Wilkins, 1995, transcript in the author's files.

15. Ibid.

16. Francisconi 1998; Gilbreath 1973; M'Closkey 2002; McPherson 1992; Volk 1988; Weiss 1984.

17. Birt 1970.

18. Marcus 1998:xiv.

19. Hubbell Trading Post Ethnohistory Project, Martha Tsosie, interview by Clarenda Begay, 1983.

20. Marie T. Begay, interview by Teresa Wilkins, 1995, transcript in the author's files.

21. Evelyn Curley, interview by Teresa Wilkins, 1995, transcript in the author's files.

22. Helen Kirk, interview by Teresa Wilkins, 1995, transcript in the author's files.

23. Marie T. Begay, interview by Teresa Wilkins, 1995, transcript in the author's files.

24. Sadie Curtis, interview by Teresa Wilkins, 1995, transcript in the author's files.

25. Betty Shirley, interview by Teresa Wilkins, 1995, transcript in the author's files.

26. Sadie Curtis, interview by Teresa Wilkins, 1995, transcript in the author's files.

27. Katherine Tapaha, interview by Teresa Wilkins, 1995, transcript in the author's files.

28. Magdalene Roanhorse, interview by Teresa Wilkins, 1995, transcript in the author's files.

29. Betty Shirley, interview by Teresa Wilkins, 1995, transcript in the author's files.

30. Hedlund 1983, 1992, 1994; Wilkins 1999b.

31. Bennett 1975; Kent 1985.

32. Hubbell Trading Post Ethnohistory Project, Mae Jim, interview by Clarenda Begay, 1983.

33. Darlene Shirley, interview by Teresa Wilkins, 1995, transcript in the author's files.

34. Hubbell Trading Post Ethnohistory Project, Martha Tsosie, interview by Clarenda Begay, 1983.

35. Helen Kirk, interview by Teresa Wilkins, 1995, transcript in the author's files.

36. Ibid.

37. Evelyn Curley, interview by Teresa Wilkins, 1995, transcript in the author's files.

38. Mary Sadie Gorman, interview by Teresa Wilkins, 1995, transcript in the author's files.

39. Juanita Paul, interview by Teresa Wilkins, 1995, transcript in the author's files.

40. Sadie Curtis, interview by Teresa Wilkins, 1995, transcript in the author's files.

CHAPTER 7. EXCHANGING PLACES

1. Clifford 1997; Pratt 1992.

2. For other analyses of spectacle and demonstration see Babcock 1990; Dilworth 1996; Howard 1996; Moses 1996; Weigle and Babcock 1996.

3. Haile 1942:16–17, as quoted in Astrov 1950:46.

4. Astrov 1950; Morris 1997; O'Bryan 1956; Yazzie 1984. There is no universal agreement among Navajo spiritual leaders about whether we are currently in the fourth or the fifth world.

5. Schwarz 1997.

6. Matthews 1897:64, quoted in Astrov 1950:47.

7. Eugene Bahe, interview by Teresa Wilkins, 1996, tape recording in the author's files.

8. Hubbell Trading Post Ethnohistory Project, Yanabah Winker, interview by David M. Brugge, 1971.

9. Howard and Pardue 1996.

10. Hubbell Papers, box 37.

11. Herman Schweizer to C. E. Faris, 1935, quoted in Howard and Pardue, 1996.

12. Moses 1996.

13. Hubbell Papers, box 37.

14. Ibid.

15. Howard and Pardue 1996:18.

16. *Albuquerque Journal-Democrat*, February 11, 1903, quoted in Howard and Pardue 1996:57.

17. Hubbell Papers, box 37.

18. Ibid.

19. Huckel to Hubbell, January 27, 1906, Hubbell Papers, box 37.

20. Hubbell Trading Post Ethnohistory Project, Joe Tippecanoe, interview by David M. Brugge, 1971.

21. Hubbell Papers, box 37.

22. Pardue and Howard 1996:67–68.

23. Hubbell Trading Post Ethnohistory Project, Descheenie Nez Tracey, interview by Kathy Howard, 1994.

24. Blomberg 1988:15; Schweizer to Epp, January 24, 1907, Hubbell Papers, box 37.

25. Schweizer to Epp, January 24, 1907, Hubbell Papers, box 37.

26. Hubbell to Schweizer, March 29, 1909, Hubbell Papers, box 95.

27. Hubbell Papers, box 37.

28. Ibid.

29. Schweizer to Hubbell, April 14, 1906, Hubbell Papers, box 37.

30. Huckell to Schweizer, May 19, 1910, Hubbell Papers, box 37.

31. Huckel to Hubbell, January 27, 1906, Hubbell Papers, box 37.

32. Hubbell Papers, box 37.

33. Ibid.

34. Schweizer to Epp, January 24, 1907, Hubbell Papers, box 37.

35. Schweizer to Hubbell, January 22, 1907, Hubbell Papers, box 37.

36. Verona Begay, interview by Teresa Wilkins, 1996, transcript in the author's files.

37. Francisconi 1998; Hedlund 1992.

38. Mary Lee Begay, interview by Teresa Wilkins, 1995, transcript in the author's files.

39. Sadie Curtis, interview by Teresa Wilkins, 1995, transcript in the author's files.

40. Wilkins 1997:36.

41. Lena Lee Begay, interview by Teresa Wilkins, 1995, transcript in the author's files.

42. Hubbell Trading Post Ethnohistory Project, Mae Jim, interview by Clarenda Begay, 1983.

43. Helen Kirk, interview by Teresa Wilkins, 1995, transcript in the author's files.

CONCLUSION

1. Quote from the Gallup, N.Mex., Chamber of Commerce 2007.
2. Wheat 2004.
3. Ibid.
4. Hedlund 1992; Nabhan 2006.
5. Les Wilson, personal communication, 1998, notes in the author's files.

BIBLIOGRAPHY

Adair, John and Evon Z. Vogt. 1949. Navaho and Zuni veterans: A study of contrasting modes of culture change. *American Anthropologist* 51:547– 62.

Adams, William Y. 1963. *Shonto: A study of the role the trader in a Navaho community.* Washington, D.C.: Smithsonian Institution Press.

———. 1993. The image of the trader. Paper presented at Seventh annual Navajo Studies Conference in Tsaile, Navajo Nation, Ariz.

Amsden, Charles Avery. 1934. *Navaho Weaving: Its technic and history.* Reprint, Salt Lake City, Utah: Peregrine Smith, Inc., 1975.

Appadurai, Arjun. 1986. *The social life of things: Commodities in cultural perspective.* Cambridge, N.Y.: Cambridge University Press.

———. 1990. Disjuncture and difference in the global cultural economy. *Public Culture* 2, no.2: 1–24.

———. 1991. Global ethnoscapes: Notes and queries for a transnational anthropology. In *Recapturing anthropology: working in the present,* ed. Richard Fox. Santa Fe, N.Mex.: School of American Research Press.

Astrov, Margot. 1950. The concept of motion as the psychological leitmotif of Navaho life and literature. *Journal of American Folklore* 63:45–56.

Babcock, Barbara A. 1990. A New Mexican Rebecca: Imaging Pueblo women. *Journal of the Southwest* 32, no.4:400–37.

Bailey, Garrick and Roberta Glenn Bailey. 1986. *A history of the Navajos: The reservation years.* Santa Fe, N.Mex.: School of American Research Press.

Barnes, Thomas F. 1902. Our first cry. In *The Papoose.* Journal of the Hyde Exploring Expedition. New York. 1, no. 1:17–18.

Battaglia, Debbora. 1995. *On the bones of the serpent: Person, memory, and mortality in Sabarl Island society.* Chicago, Ill.: University of Chicago Press.

Bauer, Elizabeth. n.d. Research for a catalog of the Navajo textiles of the Hubbell Trading Post. Unpublished manuscript in the files of Hubbell Trading Post National Historic Site, Ganado, Ariz.

Begay, D. Y. 1996. *Shi' Sha' Hane'*: My story. In *Woven by the grandmothers: Nine-teenth-century Navajo textiles from the National Museum of the American Indian*, ed. Eulalie H. Bonar. Washington, D.C.: Smithsonian Institution Press.

Bennett, Kathleen Whitaker. 1981. The Navajo chief blanket: A trade item among non-Navajo groups. *American Indian Art* 1:62–9.

Bennett, Noel. 1975. *The weavers' pathway: A clarification of the "spirit trail" in Navajo weaving*. Flagstaff, Ariz.: Northland Press.

Birt, Hal, Jr. 1970. Arizona Indian trade tokens. N.p.

Blanchard, Kendall A. 1977. *The economics of sainthood: Religious change among the Rimrock Navajos*. Cranbury, N.J.: Associated University Presses, Inc.

Blomberg, Nancy. 1988. *Navajo textiles: The William Randolph Hearst collection*. Tucson: University of Arizona Press.

Blue, Martha. 1986. A view from the bullpen: A Navajo ken of traders and trading posts. *Plateau* 57, no. 3:10–18.

———. 2000. *Indian trader: The life and times of J. L. Hubbell*. Walnut, Calif.: Kiva Publishing.

Boles, Joann Ferguson. 1977. The development of the Navaho rug, 1880–1920, as influenced by trader J. L. Hubbell. Ph.D. dissertation, Ohio State University.

Bolton, Herbert E., ed. [1908] 1967. *Spanish exploration in the Southwest, 1542–1706*. New York: Barnes and Noble.

Boyd, Dennis. 1979. Trading and weaving: An American-Navajo symbiosis. Masters thesis, University of Colorado.

Breckenridge, Carol A., ed. 1995. *Consuming modernity: Public culture in a South Asian world*. Minneapolis: University of Minnesota Press.

Brugge, David M. 1963. *Navajo pottery and ethnohistory*. Window Rock, Navajo Nation, Ariz.: Navajoland Publications.

———. 1983. Navajo prehistory and history to 1850. In *Handbook of North American Indians*, ed. Alfonso Ortiz. Washington, D.C.: Smithsonian Institution Press.

———. 1993a. *Hubbell Trading Post National Historic Site*. Tucson, Ariz.: South-west Parks and Monuments Association.

———. 1993b. Traditional history of Wide Reed. In *Wide Reed Ruin: Hubbell Trading Post National Historic Site*, eds. James E. Mount, Stanley J. Olsen, John W. Olsen, George A. Teague, B. Dean Treadwell. Southwest Cultural Resources Center: Department of Interior, National Park Service.

———. n.d. Tin money. Unpublished manuscript in the files of Hubbell Trading Post National Historic Site, Ganado, Ariz.

Burbank, E. A. 1946. *Burbank among the Indians*. Caldwell, Idaho: Caxton Printers, Ltd.

Clark, H. Jackson. 1993. *The owl in Monument Canyon and other stories from Indian country*. Salt Lake City: University of Utah Press.

Clifford, James. 1988. *The predicament of culture: Twentieth century ethnography, literature, and art*. Cambridge, Mass.: Harvard University Press.

Clifford, James. 1997. *Routes: Travel and translation in the late twentieth century.* Cambridge: Harvard University Press.

Clifford, James and George E. Marcus, eds. 1988. *Writing culture: The poetics and politics of ethnography.* Berkeley: University of California Press.

Comaroff, John and Jean Comaroff. 1992. *Ethnography and the historical imagination.* Boulder, Colo.: Westview Press.

————. 1997. *Of revelation and revolution.* Volume 2. Chicago: University of Chicago Press.

Cousins, Jean and Bill. 1996. *Tales from wide ruins.* Lubbock: Texas Tech University Press.

Dilworth, Leah. 1996. *Imagining Indians in the Southwest: Persistent visions of a primitive past.* Washington, D.C.: Smithsonian Institution Press.

Donham, Donald L. 1985. *Work and power in Maale, Ethiopia.* Ann Arbor, Mich.: UMI Research Press.

————. 1990. *History, power, ideology: Central issues in Marxism and anthropology.* Cambridge, N.Y.: Cambridge University Press.

Dozier, Edward P. 1970. *The Pueblo Indians of North America.* Austin, Tex.: Holt Rhinehart and Winston.

Eddington, Patrick and Susan Makov. 1995. *Trading post guidebook.* Flagstaff, Ariz.: Northland Publishing.

Fabian, Johannes. 1983. *Time and the other: How anthropology makes its object.* Chicago: University of Chicago Press.

Farella, John R. 1984. *The main stalk: A synthesis of Navajo philosophy.* Tucson: University of Arizona Press.

————. 1993. *The wind in a jar.* Albuquerque: University of New Mexico Press.

Faunce, Hilda. 1934. *Desert Wife.* Boston, Mass.: Little, Brown and Company.

Federal Trade Commission. 1973. The trading post system on the Navajo Reservation: Staff report to the Federal Trade Commission. Washington, D.C.: U.S. Government Printing Office.

Ford, Richard I. 1983. Inter-Indian exchange in the Southwest. In *Handbook of North American Indians,* ed. Alfonso Ortiz. Washington, D.C.: Smithsonian Institution Press.

Forrest, Earle R. 1970. *With a camera in old Navaholand.* Norman: University of Oklahoma Press.

Franciscan Fathers. 1910. *An ethnologic dictionary of the Navaho language.* St. Michaels, Ariz.: Franciscan Fathers.

Francisconi, Michael Joseph. 1998. *Kinship, capitalism, change: The informal economy of the Navajo, 1868–1995.* New York: Garland Publishing.

Friedman, Jonathan, ed. 1994. Consumption and identity. Switzerland: Harwood Academic Publishers.

Gabriel, Kathryn, ed. 1992. *Marietta Wetherill: Reflections on life With the Navajos in Chaco Canyon.* Boulder, Colo.: Johnson Books.

Gilbreath, Kent. 1973. *Red capitalism: An analysis of the Navajo economy.* Norman: University of Oklahoma Press.

Gillmor, Frances and Louisa Wade Wetherill. 1934. *Traders to the Navajos: The Wetherills of Kayenta.* Albuquerque: University of New Mexico Press.

Gilpin, Laura. 1968. *The enduring Navaho.* Austin: University of Texas Press.

Graburn, Nelson H. H. 1976. Introduction. In *Ethnic and tourist arts: Cultural expressions from the fourth world,* ed. Nelson H. H. Graburn. Berkeley: University of California Press.

Graves, Laura. 1998. *Thomas Varker Keam: Indian trader.* Norman: University of Oklahoma Press.

Gregory, C. A. 1982. *Gifts and commodities.* London: Academic Press.

Gupta, Ahkil and James Ferguson. 1997a. Introduction. In *Culture, power, place: Ethnography at the end of an era,* eds. Ahkil Gupta and James Ferguson. Durham, N.C.: Duke University Press.

———. 1997b. Beyond "culture": Space, identity, and the politics of difference. In *Culture, power, place: Ethnography at the end of an era,* eds. Ahkil Gupta and James Ferguson. Durham, N.C.: Duke University Press.

Guterson, Ben. 1994. The vanishing trading post. *New Mexico Magazine* 72, no. 8:76–83.

Gutierrez, Ramon A. 1991. *When Jesus came the corn mothers went away: Marriage, sexuality, and power in New Mexico, 1500–1846.* Palo Alto, Calif.: Stanford University Press.

Haile, Father Berard. 1942. *Learning Navaho. Volume 2.* St. Michaels, Ariz.: Franciscan Fathers.

Hammond, George P. and Agapito Rey. 1953. *Don Juan de Oñate, colonizer of New Mexico, 1595–1628.* Albuquerque: University of New Mexico Press.

Handler, Richard. 1986. Authenticity. *Anthropology Today* 2 no. 1:2–4.

Hannerz, Ulf. 1992. The global ecumene as a network of networks. In *Conceptualizing society,* ed. Adam Kuper. London: Routledge.

Hannum, Alberta. 1945. *Spin a silver dollar: The story of a desert trading post.* New York: Viking Press.

———. 1958. *Paint the wind.* London: Michael Joseph, Ltd.

Harvey, David. 1989. *The condition of postmodernity: An inquiry into the origins of cultural change.* Cambridge, Mass.: Basil Blackwell.

Hassell, Sandy. n.d. *Navaho rugs.* Unpublished manuscript in the files of Joe Ben Wheat.

Hedlund, Ann Lane. 1983. Contemporary Navajo weaving: An ethnography of a native craft. Ph.D. dissertation, University of Colorado.

———. 1990. In *Beyond the loom: Keys to understanding early southwestern weaving,* eds. Teresa Wilkins and Diana Leonard. Boulder, Colo.: Johnson Books.

———. 1992. *Reflections of the weavers' world: The Gloria F. Ross Collection of Contemporary Navajo Weaving.* Denver, Colo.: Denver Art Museum.

————. 1994. *Contemporary Navajo weaving: Thoughts that count.* Flagstaff: Museum of Northern Arizona.

————. 1996. "More of survival than an art": Comparing late nineteenth and late twentieth-century lifeways and weaving. In *Woven by the grandmothers: nineteenth century Navajo textiles from the National Museum of the American Indian,* ed. Eulalie H. Bonar. Washington, D.C.: Smithsonian Institution Press.

————. 2004. *Navajo weaving in the late twentieth century: Kin, community, and collectors.* Tucson: University of Arizona Press.

Hegemann, Elizabeth Compton. 1963. *Navajo trading days.* Albuquerque: University of New Mexico Press.

Hill, W. W. 1948. Navaho trade and trading ritual: A study in cultural dynamics. *Southwestern Journal of Anthropology* 4:371–96.

Hinsley, Curtis M. 1981. *The Smithsonian and the American Indian: Making a moral anthropology in Victorian America.* Washington, D.C.: Smithsonian Institution Press.

————. 1992. Collecting cultures and the cultures of collecting: The lure of the American Southwest, 1880–1915. *Museum Anthropology* 16, no. 1:12–20.

Hogg, John Edwin. 1930. Fifty years an Indian trader. In *Touring Topics* 51:24:29.

Howard, Kathleen. 1996. A most remarkable success: Herman Schweizer and the Fred Harvey Indian Department. In *The Great Southwest of the Fred Harvey Company and the Santa Fe Railway,* eds. Marta Weigle and Barbara A. Babcock. Phoenix, Ariz.: Heard Museum.

Howard, Kathleen L. and Diana F. Pardue. 1996. *Inventing the Southwest: The Fred Harvey Company and Native American art.* Flagstaff, Ariz.: Northland Publishing.

Hubbell, John Lorenzo. 1902. *Catalogue and price list: Navajo blankets and Indian curios.* Ganado, Ariz.

Hubbell Papers. University of Arizona Special Collections. Tucson, Ariz.

Hubbell Trading Post Ethnohistory Project.
 Mike Daughter Frank, interview by Clarenda Begay, 1983;
 Peter Hubbard, interview by David M. Brugge, 1971;
 Dorothy Hubbell, interview by Lawrence Kelly, 1979;
 Mae Jim, interview by Clarenda Begay, 1983;
 Zonnie Lincoln, interview by David Brugge, 1971;
 Descheenie Nez Tracey, interview by Kathleen Howard, 1994;
 Joe Tippecanoe, interview by David Brugge, 1971;
 Martha Tsosie, interview by Clarenda Begay, 1983;
 Yanabah Winker, interview by David M. Brugge, 1971. Transcripts accessed 1993–1995, filed at Hubbell Trading Post National Historic Site, Ganado, Ariz.

Humphrey, Caroline and Stephen Hugh-Jones, eds. 1992. *Barter, exchange, and value: An anthropological approach.* Cambridge, N.Y.: Cambridge University Press.

Hutchinson, Sharon E. 1996. *Nuer dilemmas: Coping with money, war, and the state.* Berkeley: University of California Press.

Hyde Exploring Expedition. 1902–1903. *The Papoose.* New York: Hyde Exploring Expedition.

James, George Wharton. 1974. *Indian blankets and their makers.* New York: Dover Publications.

James, H. L. 1988. *Rugs and posts: The story of Navajo weaving and Indian trading.* West Chester, Pa.: Schiffer Publishing.

Karp, Ivan and Steven D. Levine. 1991. *Exhibiting cultures: The poetics and politics of museum display.* Washington, D.C.: Smithsonian Institution Press.

Kelley, Klara Bonsack. 1977. Commercial networks in the Navajo-Hopi-Zuni region. Ph.D. dissertation, University of New Mexico.

Kelley, Klara B. and Peter M. Whiteley. 1989. *Navajoland: Family and settlement and land use.* Tsaile, Ariz.: Navajo Community College Press.

Kennedy, Mary Jeannette. 1963. *Tales of a trader's wife.* Albuquerque: University of New Mexico Press.

Kent, Kate Peck. 1976. Pueblo and Navajo weaving traditions and the western world. In *Ethnic and tourist arts: Cultural expressions from the fourth world,* ed. Nelson H. H. Graburn. Berkeley: University of California Press.

———. 1985. *Navajo weaving: Three centuries of change.* Santa Fe, N.Mex.: School of American Research Press.

Kern, Stephen. 1983. *The culture of time and space, 1880–1918.* Cambridge, Mass.: Harvard University Press.

Kluckhohn, Clyde and Dorothea Leighton. 1962. *The Navaho.* New York: American Museum of Natural History.

Ladd, John. 1957. *The structure of a moral code: A philosophical analysis of ethical discourse applied to the ethics of the Navaho Indians.* Cambridge, Mass.: Harvard University Press.

Lamphere, Louise. 1977. *To run after them: Cultural and social bases of cooperation in a Navajo community.* Tucson: University of Arizona Press.

Lears, T. J. Jackson. 1981. *No place of grace: Antimodernism and the transformation of American culture, 1880–1920.* Chicago: University of Chicago Press.

Marcus, George. 1992. Past, present, and emergent identities: Requirements for ethnographies of late twentieth-century modernity worldwide. In *Modernity and Identity,* eds. Scott Lash and Jonathan Friedman. Cambridge, Mass.: Basil Blackwell Publishers.

Marcus, George E. and Michael M. J. Fischer. 1986. *Anthropology as cultural critique: An experimental moment in the human sciences.* Chicago: University of Chicago Press

Marcus, Laura. 1998. Moving towards Nizaad: Exploring the dynamics of Navajo-Anglo interaction through trading and art. Ph.D. dissertation, Indiana University.

Marx, Karl. 1977. *Capital: A critique of political economy. Volume One.* New York: Random House.

Matthews, Washington. 1882. *Navajo weavers.* Washington, D.C.: Smithsonian Institution Press.

———. 1897. *Memoirs of the American Folklore Society, Navajo Legends.* Volume 5. New York: American Folklore Society.

Mauss, Marcel. 1967. *The gift: Forms and functions of exchange in archaic societies.* New York: W. W. Norton and Company.

M'Closkey, Kathleen Cross. 2002. *Swept under the rug: A hidden history of Navajo weaving.* Albuquerque: University of New Mexico Press.

McNitt, Frank. 1989. *The Indian traders.* Norman: University of Oklahoma Press. (Orig. pub. 1962.)

McPherson, Robert S. 1988. *The northern Navajo frontier, 1860–1900: Expansion through adversity.* Albuquerque: University of New Mexico Press.

———. 1992. Naalyehe Ba Hooghan—"House of Merchandise": The Navajo trading post as an institution of cultural change, 1900–1930. *American Indian Culture and Research Journal* 16, no.1:23–42.

Mercurio, Gian and Maxymilian L. Peschel. 1994. *The guide to trading posts and pueblos.* Cortez, Colo.: Lonewolf Publishing.

Miller, Daniel A. 1986. *Material culture and mass consumption.* London: Routledge.

Miller, Daniel A., ed. 1995. *Acknowledging consumption: A review of new studies.* London: Routledge.

Moon, Samuel. 1992. *Tall sheep: Harry Goulding, Monument Valley trader.* Norman: University of Oklahoma Press.

Moore J. B. 1987. *The catalogues of fine Navajo blankets, rugs, ceremonial baskets, silverware, jewelry, and curios.* Albuquerque: University of New Mexico Press.

Moore, John H., ed. 1993. *The political economy of North American Indians.* Norman: University of Oklahoma Press.

Morris, Irvin. 1997. *From the glittering world: A Navajo story.* Norman: University of Oklahoma Press.

Moses, L. G. 1996. *Wild west shows and the images of American Indians, 1883–1933.* Albuquerque: University of New Mexico Press.

Nabham, Gary Paul. 2006. The return of Navajo-Churro sheep to loom and table. Flagstaff: Northern Arizona University Center for Sustainable Environments.

Nash, June. 1979. *We eat the mines and the mines eat us: Dependency and exploitation in Bolivian tin mines.* New York: Columbia University Press

Nash, June, ed. 1993. *Crafts in the world market: The impact of global exchange on middle America.* Albany, N.Y.: SUNY Press.

Nemerov, Alex. 1991. Doing the Old America: The image of the American West, 1880–1920. In *The west as America,* ed. William Truettner. Washington, D.C.: Smithsonian Institution Press.

Newcomb, Franc Johnson. 1964. *Hosteen Klah: Navaho medicine man and sand-painter.* Norman: University of Oklahoma Press.

O'Bryan, Aileen. 1956. The Dine: Origin myths of the Navaho Indians. Bureau of American Ethnology Bulletin 163. Washington, D.C.: Smithsonian Institution Press.

Pardue, Diana F. and Kathleen L. Howard. 1996. Making art, making money: The Fred Harvey Company and the Indian artisan. In *The Great Southwest of the Fred Harvey Company and the Santa Fe Railway,* ed. Marta Weigle and Barbara A. Babcock. Phoenix, Ariz.: Heard Museum.

Parezo, Nancy. 1983. *Navajo sandpainting: From religious act to commercial art.* Tucson: University of Arizona Press.

Parry, Jonathan and Maurice Bloch. 1989. Introduction: Money and the morality of exchange. In *Money and the morality of exchange,* eds. Jonathan Parry and Maurice Bloch. New York: Cambridge University Press.

Pendleton Woolen Mills. 1987. *Pendleton Woolen Mills catalogue.* Albuquerque, N.Mex.: Avanyu Publishing. (Orig. pub. ca. 1915.)

Pepper, George. 1902. An ethnological study of the Navajo Indians. In *The Papoose.* Journal of the Hyde Exploring Expedition. New York. 1, no. 1:1–9.

Piot, Charles D. 1996. Of slaves and the gift: Kabre sale of kin during the era of slave trade. *Journal of African History* 37:31–49.

————. 1999. *Remotely global: Village modernity in west Africa.* Chicago: University of Chicago Press.

Powers, Willow Roberts. 2000. *Navajo trading: The end of an era.* Albuquerque: University of New Mexico Press.

Pratt, Mary Louise. 1992. *Imperial eyes: Travel writing and transculturation.* New York: Routledge.

Pred, Allen and Michael John Watts. 1993. *Reworking modernity: Capitalisms and symbolic discontent.* New Brunswick, N.J.: Rutgers University Press.

Reichard, Gladys. 1934. *Spider woman: A story of Navajo weavers and chanters.* New York: MacMillan Company.

————. 1936. *Navajo shepherd and weaver.* New York: J. J. Augustin Publisher.

————. 1939. *Dezba: Woman of the desert.* New York: J. J. Augustin Publisher.

Report to Assistant Commissioner of Indian Affairs F. H. Abbott, 1911. Records relating to the President's inquiry regarding economy and efficiency, 1910–1912. Records of the Office of the Commissioner of Indian Affairs, Series B 75.5.1, U.S. National Archives.

Richardson, Gladwell. 1986. *Navajo trader.* Tucson: University of Arizona Press.

Roberts, Willow. 1987. *Stokes Carson: Twentieth century trading on the Navajo reservation.* Albuquerque: University of New Mexico Press.

Rodee, Marian E. 1981. *Old Navajo rugs: Their development from 1900 to 1940.* Albuquerque: University of New Mexico Press.

————. 1987. *Weaving of the Southwest*. Westchester, Pa.: Schiffer Publishing.

Roessel, Robert A. Jr. 1983. Navajo history, 1850–1923. In *Handbook of North American Indians*, ed. Alfonso Ortiz. Washington, D.C.: Smithsonian Institution Press.

Roseberry, William. 1989. *Anthropologies and histories: Essays in culture, history, and political economy*. New Brunswick, N.J.: Rutgers University Press

Sahlins, Marshall. 1972. *Stone Age economics*. New York: Aldine Atherton.

Schiller, Nina Glick, Linda Basch, and Cristina Blanc-Szanton. 1992. Transnationalism: A new analytic framework for understanding migration. In *Towards a transnational perspective on migration: Race, class, ethnicity, and nationalism reconsidered*, eds. Nina Glick Schiller, Linda Basch, and Cristina Blanc-Szanton. New York: New York Academy of Sciences.

Schwarz, Maureen. 1997. *Molded in the image of changing woman: Navajo views on the human body and personhood*. Tucson: University of Arizona Press.

Shipton, Parker MacDonald. 1989. *Bitter money: Cultural economy and some African meanings of forbidden commodities*. Washington, D.C.: American Anthropological Association.

Simmons, Katina. 1977. Oriental influences in Navajo rug design. In *Ethnographic Textiles of the Western Hemisphere*, eds. Irene Emery and Patricia Fiske. Washington, D.C.: Textile Museum.

Southwestern Indian Development, Inc. 1969. Traders on the Navajo Reservation: A report on the economic bondage of the Navajo people. Window Rock, Ariz.: Southwestern Indian Development, Inc.

Spicer, Edmund H. 1962. *Cycles of conquest: The impact of Spain, Mexico, and the United States on the Indians of the Southwest, 1533–1960*. Tucson: University of Arizona Press.

Stewart, Susan. 1984. *On longing: Narratives of the miniature, the gigantic, the souvenir, and the collection*. Baltimore, Md.: Johns Hopkins University Press.

Strathern, Marilyn. 1986. *The gender of the gift: Problems with women and problems with society in Melanesia*. Berkeley: University of California Press.

————. 1992. Qualified value: the perspective of gift exchange. In *Barter, exchange, and value: An anthropological approach*, eds. Caroline Humphrey and Stephen Hugh-Jones. New York: Cambridge University Press.

Taussig, Michael. 1987. *Shamanism, colonialism, and the wild man: A study in terror and healing*. Chicago: University of Chicago Press.

Thomas, Nicholas. 1991. *Entangled objects: exchange, material culture, and colonialism in the Pacific*. Cambridge, Mass.: Harvard University Press.

Thomas, Wesley. 1996. *Shił Yóół T'ool: Personification of Navajo weaving*. In *Woven by the grandmothers: Nineteenth-century Navajo textiles from the National Museum of the American Indian*, ed. Eulalie H. Bonar. Washington, D.C.: Smithsonian Institution Press.

Underhill, Ruth. 1956. *The Navajos*. Norman: University of Oklahoma Press.

Vogt, Evon S. 1956. The Navaho. In *Perspectives in American Indian Culture Change*, ed. Edward H. Spicer. 278–336. Chicago: University of Chicago Press.

Volk, Robert W. 1988. Barter, blankets, and bracelets: The role of the trader in the Navajo textile and silverwork industries, 1868–1930. *American Indian Culture and Research Journal* 12, no.4:39–63.

Wade, Edwin L. 1976. The history of the Southwest Indian ethnic art market. Ph.D. dissertation, University of Washington.

Wagner, Sallie. 1997. *Wide ruins: Memories from a Navajo trading post*. Albuquerque: University of New Mexico Press.

Wallerstein, Immanuel. 1974. *The modern world system I: Capitalist agriculture and the origins of the European world-economy in the sixteenth century*. New York: Academic Press.

Weigle, Marta and Barbara A. Babcock, eds. 1996. *The great southwest of the Fred Harvey Company and the Santa Fe Railway*. Phoenix, Ariz.: Heard Museum.

Weiner, Annette B. 1992. *Inalienable possessions: The paradox of keeping while giving*. Berkeley: University of California Press.

Weiss, Lawrence David. 1984. *The development of capitalism in the Navajo nation: A political-economic history*. Minneapolis: MEP Publications.

Wheat, Joe Ben. 1976. Three centuries of Navajo weaving. *Arizona Highways*, no. 7:12–45.

———. 1977. Documentary basis for materials changes and design styles in Navajo blanket weaving. In *Ethnographic textiles of the western hemisphere*, eds. Irene Emery and Patricia Fiske. Washington, D.C.: Textile Museum.

———. 1981. Early Navajo weaving. *Plateau* 52, no.4:2–8.

———. 1988. Early trade and commerce in southwestern textiles before the curio shop. In *Reflections: Papers on southwestern culture history in honor of Charles H. Lange*, ed. Anne Van Arsdall Poore. Santa Fe, N.Mex.: Ancient City Press.

———. 1990. Introduction. In *Beyond the loom: Keys to understanding early southwestern weaving*. Boulder, Colo.: Johnson Books.

———. 1994. Yarns to the Navajo: The materials of weaving. In *A burst of brilliance: Germantown, Pennsylvania and Navajo weaving*, ed. Lucy Williams. Philadelphia: University of Pennsylvania.

———. 1996. Navajo blankets. In *Woven by the grandmothers: Nineteenth-century Navajo textiles from the National Museum of the American Indian*, ed. Eulalie H. Bonar. Washington, D.C.: Smithsonian Institution Press.

———. 2004. *Blanket weaving in the Southwest*, ed. Ann Lane Hedlund. Tucson: University of Arizona Press.

Wilk, Richard. R. 1996. *Economies and cultures: Foundations of economic anthropology*. Boulder, Colo.: Westview Press.

Wilkins, Teresa J. 1993. Unexpected histories: The cultural biographies of two Navajo blankets. In *Why museums collect: Papers in honor of Joe Ben Wheat,* eds. Meliha Durhan and David Kilpatrick. Albuquerque: Archaeological Society of New Mexico.

————. 1998a. Historic farming and contemporary collaboration at Hubbell Trading Post National Historic Site. Unpublished manuscript in the files of the author.

————. 1998b. Brenda Spencer, Navajo weaver. *Indian Artist.* Winter 1998, 32–6.

————. 1999a. The creation of a useable past. In *Diné Baa Hané Bi Naaltsoos: Collected papers from Seventh through Tenth Navajo Studies Conferences,* ed. June-el Piper. Window Rock, Ariz.: Navajo Nation Historic Preservation Department.

————. 1999b. Producing culture across the colonial divide: Navajo reservation trading posts and weaving. Ph.D. dissertation, University of Colorado, Boulder.

————. 2004. Collectors of nineteenth-century southwestern textiles. In *Blanket weaving in the southwest: Joe Ben Wheat,* ed. Ann Lane Hedlund. Tucson: University of Arizona Press.

Williams. Lester. 1989. *C. N. Cotton and his Navajo blankets.* Albuquerque, N.Mex.: Avanyu Publishing.

Witherspoon, Gary. 1977. *Language and art in the Navajo universe.* Ann Arbor: University of Michigan Press.

Wolf, Eric. 1982. *Europe and the people without history.* Berkeley: University of California Press.

Yazzie, Alfred W. 1984. *Navajo oral tradition. Volumes II and III.* Cortez, Colo.: Mesa Verde Press.

Young, Robert W. and William Morgan, Sr. 1987. *The Navajo language: A grammar and colloquial dictionary.* Albuquerque: University of New Mexico Press.

Youngblood, B. 1935. Navajo trading. A report to the office of experiment stations, United States Department of Agriculture.

Zolbrod, Paul G. 1984. *Diné Bahane': The Navajo creation story.* Albuquerque: University of New Mexico Press.

INDEX